WITHDRAWN

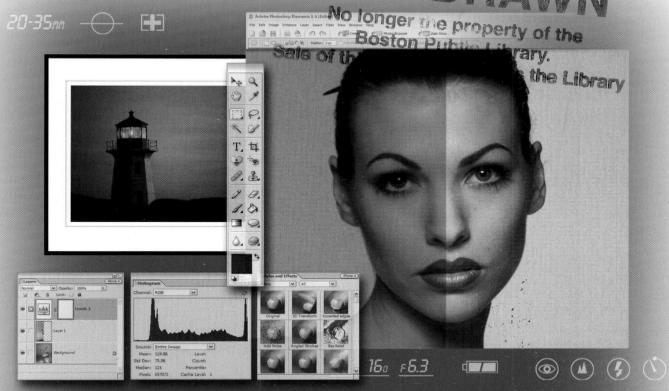

the photoshop Company Compan

for digital photographers

Scott Kelby

THE PHOTOSHOP® ELEMENTS 3 BOOK FOR DIGITAL PHOTOGRAPHERS

The Photoshop Elements 3 Book for Digital Photographers Team

CREATIVE DIRECTOR
Felix Nelson

TECHNICAL EDITOR
Polly Reincheld

COPY EDITOR
Chris Main

PRODUCTION EDITOR
Kim Gabriel

PRODUCTION MANAGER

Dave Damstra

PRODUCTION DESIGNERS

Dave Korman

Taffy Orlowski

COVER DESIGNED BY Felix Nelson

COVER PHOTOS AND STOCK IMAGES The royalty-free stock images used in this book are courtesy

Published by
New Riders / Peachpit

Copyright © 2005 by Scott Kelby

First edition: September 2004

All rights reserved. No part of this book may be reproduced or transmitted in any form, by any means, electronic or mechanical, including photocopying, recording, or by any information storage and retrieval system, without written permission from the publisher, except for inclusion of brief quotations in a review.

Composed in Cronos, Helvetica, and Apple Garamond Light by NAPP Publishing

Trademarks

All terms mentioned in this book that are known to be trademarks or service marks have been appropriately capitalized. New Riders / Peachpit cannot attest to the accuracy of this information. Use of a term in the book should not be regarded as affecting the validity of any trademark or service mark.

Photoshop Elements is a registered trademark of Adobe Systems, Inc. Windows is a registered trademark of Microsoft Corporation.

Warning and Disclaimer

This book is designed to provide information about Adobe Photoshop Elements for digital photographers. Every effort has been made to make this book as complete and as accurate as possible, but no warranty of fitness is implied.

The information is provided on an as-is basis. The author and New Riders / Peachpit shall have neither liability nor responsibility to any person or entity with respect to any loss or damages arising from the information contained in this book or from the use of the discs or programs that may accompany it.

ISBN 0-321-26905-5

987654

Printed and bound in the United States of America

www.peachpit.com www.scottkelbybooks.com For my wonderful wife Kalebra, and my precious little boy Jordan. It's amazing just how much joy and love these two people bring into my life. irst, I want to thank my amazing wife Kalebra. As I'm writing this, she's lying on the couch across from me reading a book (not one of mine, sadly), but I have to say that just looking at her makes my heart skip a beat, and again reminds me how much I adore her, how genuinely beautiful she is, and how I couldn't live without her. She's the type of woman love songs are written for, and I am, without a doubt, the luckiest man alive to have her as my wife.

Secondly, I want to thank my 7-year-old son Jordan, who spent many afternoons with his adorable little head resting on my lap as I wrote this book. God has blessed our family with so many wonderful gifts, and I can see them all reflected in his eyes. I'm so proud of him, so thrilled to be his dad, and I dearly love watching him grow to be such a wonderful little guy, with such a tender and loving heart. (You're the greatest, little buddy.)

I also want to thank my big brother Jeffrey for being such a positive influence in my life, for always taking the high road, for always knowing the right thing to say, and just the right time to say it, and for having so much of our dad in you. I'm honored to have you as my brother and my friend.

My heartfelt thanks go to the entire team at KW Media Group, who every day redefine what teamwork and dedication are all about. They are truly a special group of people, who come together to do some really amazing things (on really scary deadlines) and they do it with class, poise, and a can-do attitude that is truly inspiring. I'm so proud to be working with you all.

Thanks to my layout and production crew. In particular, I want to thank my friend and Creative Director Felix Nelson for his limitless talent, creativity, input, cover design, overall layout, and just for his flat-out great ideas. To Chris Main and our new way-cool tech editor Polly Reincheld for putting every technique through rigorous testing and keeping me on my toes through the whole process. To Kim Gabriel for keeping us all on track and organized, so we could face those really scary deadlines. To Dave Damstra and his amazing crew for giving the book such a tight, clean layout.

Thanks to my compadre Dave Moser, whose tireless dedication to creating a quality product makes every project we do better than the last. Thanks to Jim Workman, Jean A. Kendra, and Pete Kratzenberg for their support, and for keeping a lot of plates in the air while I'm writing these books. A special thanks to my Executive Assistant Kathy Siler for all her hard work and dedication, and for not rubbing it in my face that her Redskins trounced my Bucs this year.

Thanks to my Publisher Nancy Reunzel and the incredibly dedicated team at Peachpit Publishing Group. You are very special people doing very special things, and it's a real honor to get to work with people who really just want to make great books. Also many thanks to the awesome Rachel Tiley, Peachpit's "Secret Weapon," and to marketing maverick Scott Cowlin.

I owe a special debt of gratitude to my friends Kevin Ames and Jim DiVitale for taking the time to share their ideas, techniques, concepts, and vision for a Photoshop Elements book for digital photographers that would really make a difference. Extra special thanks to Kevin for spending hours with me sharing his retouching techniques, as well.

I want to thank all the photographers, retouchers, and Photoshop experts who've taught me so much over the years, including Jack Davis, Deke McClelland, Ben Willmore, Julieanne Kost, Robert Dennis, Helene DeLillo, Jim Patterson, Doug Gornick, Manual Obordo, Dan Margulis, Peter Bauer, Joe Glyda, and Russell Preston Brown.

Thanks to the brilliant and gifted digital photographers who graciously lent their photos to this book, including Carol Freeman, Jeannie Theriault, David Cuerdon, and Dave Moser.

Also thanks to my friends at Adobe Systems: Terry White, Kevin Connor, Addy Roff, Mark Dahlman, Karen Gauthier, John Nack, Bryan Lamkin, Russell Brady, Julieanne, and Russell. Gone but not forgotten: Barbara Rice, Jill Nakashima, and Theresa Ojeda.

Also an extra special thanks to Elements Product Manager Mark Dahm for taking my frantic late-night calls, going above and beyond to help make this book a reality, and helping to make Elements 3 one kick-butt editing app.

Thanks to my mentors whose wisdom and whip-cracking have helped me immeasurably, including John Graden, Jack Lee, Dave Gales, Judy Farmer, and Douglas Poole.

Also, my personal thanks to Jeffrey Burke at Brand X Pictures for enabling me to use some of their wonderful photography in this book.

Thanks to my friend Steve Weiss for helping me so much in this business, and for all your support and guidance over these past few years. It really meant a lot.

Most importantly, I want to thank God, and His son Jesus Christ, for leading me to the woman of my dreams, for blessing us with such a special little boy, for allowing me to make a living doing something I truly love, for always being there when I need Him, for blessing me with a wonderful, fulfilling and happy life, and such a warm, loving family to share it with.

ABOUT THE AUTHOR

Scott Kelby

Scott is Editor-in-Chief and co-founder of *Photoshop User* magazine, Editor-in-chief of Nikon's *Capture User* magazine, Executive Editor of *Photoshop Elements Techniques*, and Editor-in-Chief of *Mac Design Magazine*. He is President of the National Association of Photoshop Professionals (NAPP), the trade association for Adobe® Photoshop® users, and he's President of KW Media Group, Inc., a Florida-based software education and publishing firm.

Scott is author of the best-selling books *Photoshop CS Down & Dirty Tricks, Photoshop Photo-Retouching Secrets, The Photoshop CS Book for Digital Photographers* and co-author of *Photoshop CS Killer Tips,* all from New Riders Publishing. He's a contributing author to the books *Photoshop Effects Magic,* also from New Riders; *Maclopedia, the Ultimate Reference on Everything Macintosh* from Hayden Books; and *Adobe Web Design and Publishing Unleashed* from Sams.net Publishing. Scott has authored two best-selling Macintosh books: *Mac OS X Panther Killer Tips,* and the award-winning *Macintosh: The Naked Truth,* both also from New Riders; and the new *Mac OS X Conversion Kit: 9 to 10 Side-by-Side* from Peachpit Press.

Scott introduced his first software title in 2003 called "Kelby's Notes for Adobe Photoshop" which adds the answers to the 100 most-asked Photoshop questions, accessed from directly within Photoshop.

Scott is Training Director for the Adobe Photoshop Seminar Tour, Conference Technical Chair for the PhotoshopWorld Conference & Expo, and he is a speaker at graphics trade shows and events around the world. He is also featured in a series of Adobe Photoshop training videos and DVDs and has been training Adobe Photoshop users since 1993.

For more background info on Scott, visit www.scottkelby.com.

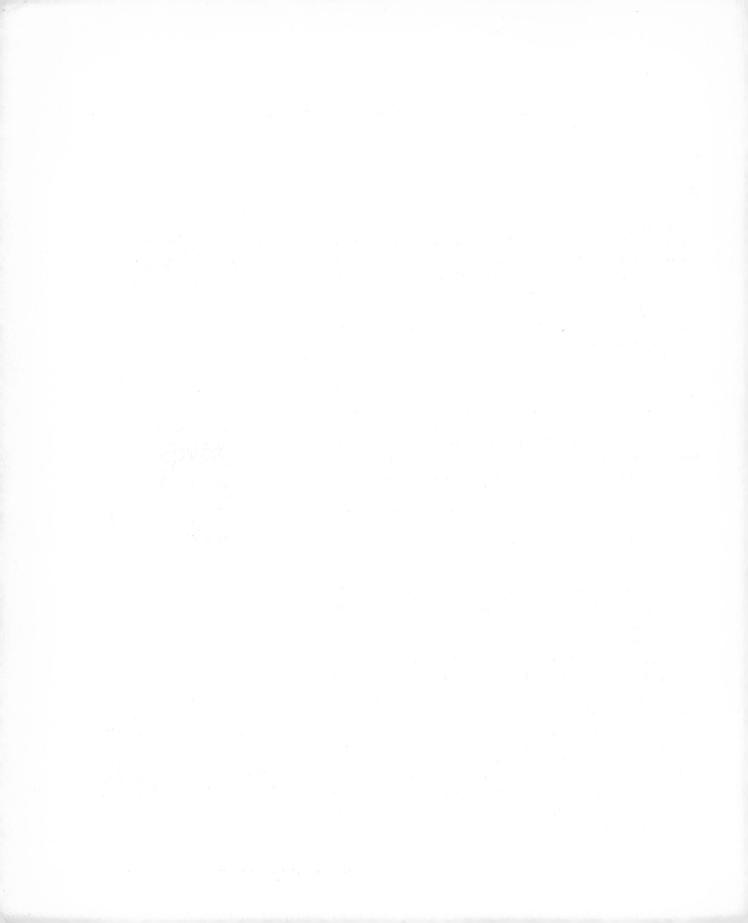

CHAPTER 1
Start Me Up
Mastering the File Browser
Saving Your Digital Negatives
Creating a Contact Sheet for Your CD6
Dealing with the Welcome Screen11
How to Make Elements 3 Look and Act Like Elements 214
It's Decision Time: File Browser or Organizer?
Accessing the File Browser
Navigating to Your Photos Using the File Browser21
Previewing Your Images23
Getting Info (Called Metadata) on Your Photos25
Setting Up How You'll View Your Photos26
Renaming Individual Photos
Batch Renaming Your Files31
Rotating Photos
Sorting and Arranging Your Photos
Searching for Photos
Deleting Files from within the File Browser
CHAPTER 241
Organized Chaos
Managing Photos Using the Organizer
Importing Photos from Your Scanner42
Automating the Importing of Photos by Using Watched Folders 43
Changing the Size of Your Photo Thumbnails44
Seeing Full-Screen Previews46
Sorting Photos by Date47
Adding Scanned Photos? Enter the Right Time and Date48
Finding Photos Fast by Their Month and Year49
Tagging Your Photos (Tags are Keywords)50
Tagging Multiple Photos52
Assigning Multiple Tags to One Photo53
Combining (Merging) Tags54
Sharing Your Tags (or Collections) with Others55
Sharing Your Tags (or Collections) with Others
Collections: It's How You Put Photos in Order One by One56

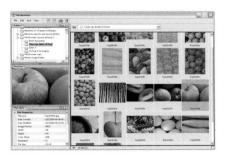

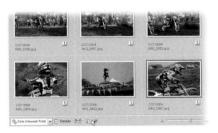

Adding Your Own Info to Photos
Finding Photos Using the Date View
Seeing an Instant Slide Show
Comparing Photos
Comparing Photos by Zooming and Panning70
Reducing Clutter by Stacking Your Photos
CHAPTER 3
Cream of the Crop
Cropping and Resizing
Cropping Photos
Auto-Cropping to Standard
Cropping to an Exact Custom Size81
Cropping into a Shape84
Auto-Cropping Gang-Scanned Photos87
Cropping without the Crop Tool88
Using the Crop Tool to Add More Canvas Area91
Straightening Crooked Photos93
Using a Visible Grid for Straightening Photos
Resizing Digital Camera Photos98
Resizing and How to Reach Those Hidden Free Transform Handles 101 $$
The Cool Trick for Turning Small Photos into Poster-Sized Prints102
CHAPTER 4
The Big Fixx
Digital Camera Image Problems
Compensating for "Too Much Flash" or Overexposure106
Removing Digital Noise (Method #1)109
Removing Digital Noise (Method #2)112
Opening Up Shadow Areas That Are Too Dark115
Fixing Areas That Are Too Bright117
Fixing Photos Where You Wish You Hadn't Used the Flash119
Fixing Underexposed Photos123
When You Forget to Use Fill Flash126
Instant Red-Eye Removal130
Removing Red Eye and Recoloring the Eye133
Repairing Keystoning138
Opening and Processing RAW Images
Working with 16-bit Images147

CHAPTER 5
Color Me Badd
Color Correction for Photographers
Before You Color Correct Anything, Do This First!
Photo Quick Fix152
Getting a Visual Readout (Histogram) of Your Corrections157
Color Correcting Digital Camera Images
Drag-and-Drop Instant Color Correction
Warming Up or Cooling Down a Photo169
Adjusting Flesh Tones171
Color Correcting One Problem Area Fast!174
Getting a Better Conversion from Color to Black-and-White178
CHAPTER 6
The Mask
Selection Techniques
Selecting Square, Rectangular, or Round Areas
How to Select Things that Aren't Round, Square, or Rectangular 190
Softening Those Harsh Edges192
Selecting Areas by Their Color194
Making Selections Using a Brush196
Selecting Everything On a Layer at Once197
Saving Your Selections
Getting Elements to Help You Make Tricky Selections199
CHAPTER 7
Head Games
Retouching Portraits
Removing Blemishes
Removing Dark Circles Under Eyes
Lessening Freckles or Facial Acne211
Removing or Lessening Wrinkles214
Dodging and Burning Done Right218
Colorizing Hair222
Whitening the Eyes224
Making Eyes that Sparkle228
Enhancing Eyebrows and Eyelashes231
Whitening and Brightening Teeth236
Pemoving Hot Spots 240

Glamour Skin Softening24	4
Transforming a Frown into a Smile24	7
Digital Nose Job25	0
CHAPTER 8	5
Invasion of the Body Snatchers	
Body Sculpting	
Slimming and Trimming25	6
Removing Love Handles	
Slimming Buttocks, Thighs, and Arms26	2
CHAPTER 9	9
38 Special	
Photographic Special Effects	
Blurred Lighting Vignette	
Using Color for Emphasis	
Adding Motion Where You Want It	
Changing an Object's Color	
Replacing the Sky	
Putting One Photo Inside Another	
Creating Photo Montages	
Simple Depth-of-Field Effect	
Advanced Depth of Field	
Creating the Classic Vignette Effect	
Sepia Tone Effect	
Creating a Photo Backdrop	
Photo to Sketch in 60 Seconds Flat	
Getting the Polaroid™ Look	
Automated Pano Stitching with Photomerge	1
CHAPTER 10	,
Get Back	/
Photo Restoration Techniques	
Photo Restoration Techniques	
Repairing Washed-Out Photos	Ω
Colorizing Black-and-White Photos	
Removing Specks, Dust, and Scratches	
Repairing Damaged or Missing Parts	
Repairing Rips and Tears	
nepailing nips and rears	4

CHAPTER 11
Sharp Dressed Man
Sharpening Techniques
Basic Sharpening350
Luminosity Sharpening
Edge Sharpening Technique360
Sharpening with Layers to Avoid Color Shifts and Noise363
CHAPTER 12
The Show Must Go On
Showing It to Your Clients
Watermarking and Adding Copyright Info
Putting Your Photos Up on the Web
Getting One 5x7", Two 2.5x3.5", and Four Wallet Size Photos on One Print
Using Picture Package Layouts with More Than One Photo385
Sending a PDF Presentation to a Client
How to Email Photos
CHAPTER 13
Create (or Die)
How to Make Presentations with Your Photos
Creating with Your Photos
Making Full-Blown Slide Shows
Creating Photo Album Pages407
Creating Greeting Cards or Postcards412
Creating Calendars416
Creating Your Own Photo Website419
Creating a Video CD422

READ THIS FIRST, BEFORE SOMETHING BAD HAPPENS

I had no intentions of writing this book

(Actually, I mean the book that led to this book. Here's the story.) So here it was, about four weeks before I would be flying up to New York City to teach a one-day seminar to more than 1,200 professional Photoshop junkies. (Okay, it was more like 1,160 pros, 42 people who just wanted a paid day off from work, and one total freak who kept asking me if I'd ever been in prison. I told him unequivocally, "Not as far as you know.")

Anyway, the seminar was just four weeks away, and there was one session that I still didn't have an outline for. It was called "Correcting Photos from Digital Cameras" (which is dramatically better than my original working title for the class, "Die, Traditional Camera User, Die!").

I knew what I needed to cover in the session because for the past ten years I've trained thousands of traditional photographers on how to use Photoshop. Most of them either have now gone digital or are in the process of going digital, and all these digital photographers generally seem to have the same type of Photoshop questions, which I'm actually thankful for, because now I can give them the answers. If they constantly asked different questions, I'd get stumped from time to time, and then I'd have to resort to "Plan B" (providing answers that sound good, but are in reality just wild-ass guesses).

So I knew what I had to cover, but I wanted to do some research first, to see if other people in the industry were addressing these questions the same way I was, or did they have a different take on them, different techniques or ideas? So I went out and bought every single book I could find about digital photography and Photoshop. I spent nearly \$1.2 million. Okay, it wasn't quite that much, but let's just say for the next few months I would have to cut out some luxuries such as running water, trash collection, heat, etc.

I started reading through all these books, and the first thing I thought I'd look up was how they dealt with digital noise (High ISO noise, Blue channel noise, color aliasing, etc.), but as I went through them, I was amazed to find out that not one single book addressed it. Not a one. Honestly, I was shocked. I get asked this question many times at every single seminar, yet not one of these books even mentioned it. So then I started looking for how they work with 16-bit photos. Nothing. Well, one book mentioned it, but they basically said "it's not for you—it's for high-end pros with \$15,000 cameras." I just couldn't believe it—I was stunned. So I kept up my search for more topics I'd been asked about again and again, with the same results.

Well, I went ahead with my New York session as planned, and by all accounts it was a big hit. I had photographer after photographer coming up to tell me, "Thank you so much—those are exactly the things I was hoping to learn." That's when I realized that there's a book missing—a book for people who already know how to shoot, they even know what they want to do in Photoshop; they just need somebody to show them how to do it. Somebody to show them how to deal with the special challenges (and amazing opportunities) of using digital photos with Photoshop. I was so excited, because I knew in my heart I could write that book.

So now I had intentions

The day after the seminar I flew home and immediately called my editor at New Riders and I said, "I know what I want my next book to be—a Photoshop book for digital photographers." There was a long uncomfortable pause, and then he politely said, "Really, a digital photography book, huh?" It was clear he wasn't nearly as excited about this concept as I was (and that's being kind). He finally said, "Ya know, there are already plenty of digital photography books out there," and I agreed with him, because I just about went broke buying them all. So now I had to convince my editor that not only was this a good idea, but that it was such a good idea that he should put our other book projects on hold so I could write this book, of which there are (as he put it), "already plenty of digital photography books out there."

continued

Here's what I told my editor what would be different about my digital photography book:

- (1) It's not a digital photography book; it's a Photoshop book. There'd be no discussion of film (gasp!), f-stops, lenses, or how to frame a photo. If they don't already know how to shoot, this book just won't be for them. (*Note:* Editors hate it when you start listing the people the book won't be appropriate for. They want to hear, "It's perfect for everybody! From grandma right up to White House press photographers," but sadly, this book just isn't.)
- (2) I would skip the "Here's What a Digital Camera Is" section and the "Here's Which Printer to Buy" section, because they were in all those other books that I bought. Instead, I'd start the book at the moment the photo comes into Photoshop from the camera.
- (3) It would work the way digital photographers really work—in the order they work—starting with sorting and categorizing photos from the shoot, dealing with common digital photography problems, color correcting the photos, selecting areas to work, retouching critical areas, adding photographic special effects, sharpening their photos, and then preparing the photo to be output to a print.
- (4) It wouldn't be another Photoshop book that focuses on explaining every aspect of every dialog box. No sirree—instead, this book would do something different—it would show them how to do it! This is what makes it different. It would show photographers step-by-step how to do all those things they keep asking at my seminars, sending me e-mails about, and posting questions about in our forums—it would "show them how to do it!"

For example, I told my editor that about every Photoshop book out there includes info on the Unsharp Mask filter. They all talk about what the Amount, Radius, and Threshold sliders do, and how those settings affect the pixels. They all do that. But you know what they generally don't do? They don't give you any actual settings to use! Usually, not even a starting point. Some provide "numerical ranges to work within," but basically they explain how the filter works, and then leave it up to you to develop your own settings. I told him I wouldn't do that. I would flat-out give them some great Unsharp Mask filter settings—the same settings used by many professionals, even though I know some highfalutin Photoshop expert might take issue with them. I would come out and say, "Hey, use this setting when sharpening people. Use this setting to correct slightly out-of-focus photos. Use this setting on landscapes, etc." I give students in my live seminars these settings, why shouldn't I share them in my book? He agreed. I also told him that sharpening is much more than just using the Unsharp Mask filter, and it's much more important to photographers than the three or four pages every other book dedicates to it. I wanted to do an entire chapter showing all the different sharpening techniques, step-by-step, giving different solutions for different sharpening challenges.

I told him about the File Browser, and how there's so much to it, it's just about a separate program unto itself, yet nobody's really covering the things photographers are telling me they need to know—like automatically renaming their digital camera photos with names that make sense. Other books mention that you can do that in the File Browser—I want to be the guy that "shows them how to do it!" I want a whole chapter just on the File Browser.

He was starting to come on board with the idea. What he didn't want was the same thing I didn't want—another digital photography book that rehashes what every other digital photography and Photoshop book has already done. Well, he went with the idea, and thanks to him, you're holding the second version of the book that I am so genuinely excited to be able to bring you. But the way the book was developed beyond that took it further than I had planned.

How the book was developed

When my editor gave me the final approval (it was more like, "Okay, but this better be good or we'll both be greeting people by saying, 'Would you like to try one of our Extra Value Meals today?""), I sat down with two of the industry's top digital

photographers—commercial product photographer Jim DiVitale and fashion photographer Kevin Ames—to get their input on the book. These two guys are amazing—they both split their time between shooting for some of the world's largest corporations, and teaching other professional digital photographers how to pull off Photoshop miracles at events such as PhotoshopWorld, PPA/PEI's Digital Conference, and a host of other events around the world. We spent hours hammering out which techniques would have to be included in the book, and I can't tell you how helpful and insightful their input was, and this book is far better than it would have been thanks to their contributions.

New and improved (with the same great taste!)

When we first released *The Photoshop Book for Digital Photographers* it became a huge hit overnight, and became not only the best-selling Photoshop book, not only the best-selling digital photography book, but one of the top selling of all computer books on Amazon.com, and it has ranked as high as #12 of ALL books on Amazon.com. Pretty freaky!

In short—the concept worked, and that's why I knew I had to do a special version of the book for Photoshop Elements users because Elements was designed from the beginning as a tool for digital photography. Best of all, I learned a lot from writing that original book, and I've learned a lot of new techniques since I wrote it; and you're getting the benefit of both in this new version of the book just for Elements users.

This version has a secret weapon

Although Elements does offer some cool digital photography features that Photoshop CS doesn't even offer, obviously there are plenty of features that Photoshop CS has that Photoshop Elements 3 still doesn't have (things like Layer Masking, Channel Mixer, etc.). But here's the cool part: The single thing that I'm most proud of in this Elements book is that I've been able to figure out workarounds, cheats, and some fairly ingenious ways to replicate some of those Photoshop features from right within Elements. In some cases, it may take a few more steps to get there than it does in Photoshop CS, but son-of-a-gun, the result looks pretty darn close, and you'll be the only one who'll know the effect was created in Elements, not in Photoshop CS. This will test how good you are at keeping secrets.

So what's not in this book?

There are some things I intentionally didn't put in this book. Like punctuation marks (kidding). No, seriously, I tried not to put things in this book that are already in every other Photoshop book out there. For example, I don't have a chapter on the Layers palette, or a chapter on the painting tools, or a chapter showing how each of Elements' 102 filters looks when it's applied to the same photograph. I also didn't include a chapter on printing to your color inkjet because (a) every Photoshop book does that, and (b) every printer uses different printer driver software, and if I showed an Epson color inkjet workflow, you can bet you'd have an HP or a Canon printer (or vice versa) and then you'd just get mad at me.

Is this book for you?

I can't tell you that for sure, so let's take a simple yet amazingly accurate test that will determine without a doubt if this book is for you.

Please answer the following questions:

- (1) Do you now, or will you soon have a digital camera?
- (2) Do you now, or will you soon have Photoshop Elements?
- (3) Do you now, or will you soon have \$34.99 (the retail price of this book)?

Scoring: If you answered "Yes" to question #3 then yes, this book is for you. If you answered yes to questions 1, or 2, that certainly is a good indicator, too.

continued

Is this book for Windows users, Mac users, or both?

It's really just for Windows users, which is sad because the previous version of this book was for both Mac and PC, but this one just couldn't be. Here's why: When Adobe created Elements 3, they left quite a few major (and minor) features out of the Mac version. In fact, the entire Organizer (which is one of the most compelling features of Elements 3) isn't in the Mac version at all. When I looked at how much the two versions differed (feature wise, interface wise, etc.), I realized I had to make a decision. I could either make a really confusing, disjointed, book that lamely attempted to cover both versions, or I could make a kick-ass version that only covered the PC side and be able to add more pages and more content. The fact that the overwhelming majority of existing Elements users are PC-based made the decision a bit easier, but I'm still disappointed that I couldn't do both. So, will the book work at all for Mac users? Yup. Just completely skip Chapter 2 (the Organizer chapter), and every time you see the keyboard shortcut "Alt," as a Mac user you press the Option key. When you see the shortcut "Control," just press the Mac's Command key, and when you see me say "hit Backspace," it's just the Mac's Delete key. Knowing that, you'll still run into a feature here and there that you just don't have, and sometimes an item is under a different menu, but some stuff will still be the same.

How should you use this book?

You can treat this as a "jump-in-anywhere" book because I didn't write it as a "build-on-what-you-learned-in-Chapter-1" type of book. For example, if you just bought this book, and you want to learn how to whiten someone's teeth for a portrait you're retouching, you can just turn to that technique, and you'll be able to follow along and do it immediately. That's because I spell everything out. Don't let that throw you if you've been using Elements since version 1; I had to do it because although some of the people who will buy this book are talented traditional photographers, since they're just now "going digital," they may not know anything about Elements. I didn't want to leave them out, or make it hard for them, so I really spell things out like "Go under the Image menu, under Adjust Color, and choose Levels" rather than just writing "Open Levels." However, I did put the chapters in an order that follows a typical correction, editing, and retouching process; so you might find it useful to start with Chapter 1 and move your way through the book in sequence.

The important thing is that wherever you start, have fun with it, and even more importantly, tell your friends about it so I can recoup the \$1.2 million I spent on all those digital photography books. Also, although the official name of the software is Adobe Photoshop Elements 3.0, just to keep things short and simple I usually refer to it as just "Elements 3" in the book.

Wait, one more thing! You can download the photos used in the book.

Another thing I wanted to do was to feature beautiful photographic images throughout the book. I was able to convince some of my very favorite photographers to lend some of their work for the book (learn more about them on the contributing photographers pages in the back of this book). I also asked what I feel is today's best high-quality royalty-free stock provider, Brand X Pictures (www.brandxpictures.com), to lend some of their wonderful images for the book, and they graciously agreed. I couldn't be more delighted with their breadth of imagery and their wonderful photography that goes far beyond the standard "businessman-shaking-hands" stock photos that permeate the rest of the market. They're really doing something special in royalty-free stock and I'm indebted to them for their generosity.

Thanks to these photographers and Brand X Pictures, most of the photos used in this book are available for you to download from the book's companion website at www.scottkelbybooks.com/elements3photos.html. Of course, the whole idea is that you'd use these techniques on your own photos, but if you want to practice on these, I won't tell anybody. Okay, now turn the page and get to work!

At first, you might not think that Photoshop Elements' File Browser deserves its own chapter, but when you look at all the things it's done for the community (including taking meals to other software applications

Start Me Up mastering the file browser

that are less fortunate), you realize it probably does deserve it after all. Especially when you take into consideration the fact that the File Browser all by itself is probably more powerful than many standalone products, like the Whopper (that computer in the movie War Games with Matthew Broderick) or Microsoft Office 2000. Sure, the Whopper could simulate a Soviet First Strike, but frankly, it was pretty lame at sorting and categorizing your photos (as is Microsoft Office). In fact, I'm not sure the Whopper could sort or categorize photos at all, which is probably why no Photoshop Elements book to date has a chapter on the Whopper; but you'd think that with all the cool things the File Browser does, surely at least one Photoshop Elements book out there would dedicate a chapter to it, right? Well, not as far as I've found. So I set out to do just that—really dig into to the meat of the Browser, uncover its hidden power, and see if once and for all it was really written by a man named Professor Faulken (this is precisely why they shouldn't let me write these chapter intros after 1:00 a.m.).

Saving Your Digital Negatives

I know you want to get right to organizing and editing your photos, but before we get to those "fun parts," there are a couple critically important things you'll need to do first—before you even actually open Photoshop Elements 3. They'll take a minute or two, but if you don't do them, you'll be sorry down the road.

Step One:

Plug your card reader (CompactFlash card, Smartcard, etc.) into your computer and the Adobe Photo Downloader will appear. By default, all of your photos are marked to be imported into your computer (that's why you'll see a little checkbox marked beneath each photo). If there are photos you don't want imported, just uncheck the little box beneath the photos you don't want. If you want to choose a location (folder) on your hard disk in which to save these photos, click the Browse button, choose the location where you'd like these photos saved, and then click the Get Photos button at the bottom-right corner of the Adobe Photo Downloader. When you click that button, a progress dialog will appear showing that the photos are being copied to your hard disk.

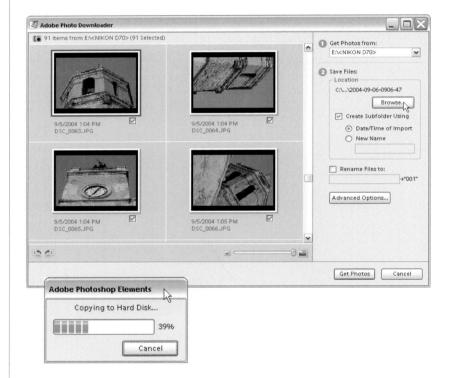

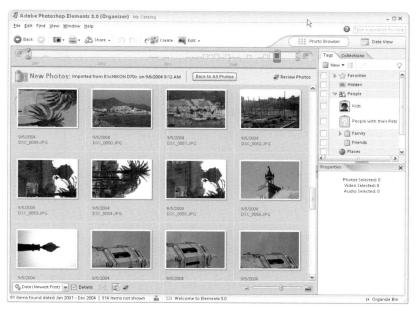

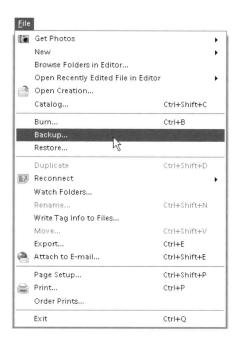

Step Two:

Once your photos are imported, they're automatically loaded into the Photoshop Elements Organizer as their own separate collection. Before you start sorting and editing these photos, you need to burn these photos to a CD. Don't open the photos, adjust them, choose your favorites, and then burn them to a CD-burn them now-right off the bat. The reason this is so important is that these are your negatives—your digital negatives, which are no different than the negatives you'd get from a film lab after it's processed your film. By burning a CD now, before you start editing, you're creating a set of digital negatives that can never be accidentally erased or discarded—you'll always have these digital negatives.

Step Three:

Now, what if you don't have a CD burner? That's easy—buy one. It's that critical, and such a key part of your digital setup. Luckily, burning CDs has become so fast, so inexpensive (you can buy blank writable CDs for less than 50¢ each), and so easy to do that you can't afford to skip this step. To burn the photos you just imported onto a CD, go under the Organizer's File menu and choose Backup.

Step Four:

Choosing Backup brings up the Burn/Backup dialog. Click the Backup the Catalog radio button to copy all the images in your current catalog (the ones you just imported) onto a CD. Press the Next button to move to the next step. (You may get a warning dialog asking if you want to "reconnect" your images. This dialog just verifies that the files imported properly. It's up to you to click Continue or Reconnect, but reconnecting couldn't hurt.)

Step Five:

On the next screen of the dialog, click the Full Backup radio button, since this is the first time you're backing up this particular set of photos. Then click the Next button again.

Step Six:

In the Destination Settings section of the dialog, click on your CD burner's drive in the list at the top of the dialog. When prompted, insert a blank CD in your CD burner, and then give your CD a name in the Name field. Now, click the Done button at the bottom of the dialog to begin the backup process.

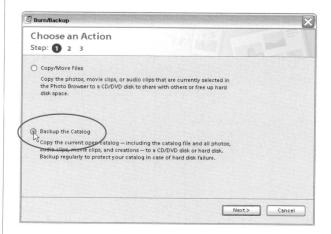

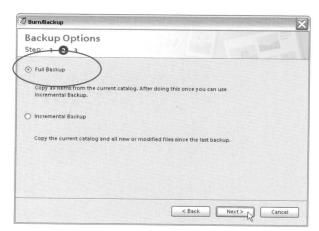

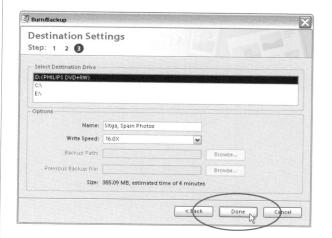

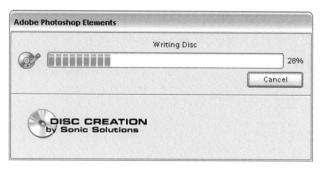

Step Seven:

A status dialog will appear while your backup disc is being burned.

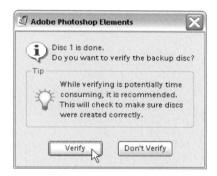

Step Eight:

When it's done writing, another dialog will appear asking if you want to verify that the disc was written correctly. Since this disc contains something very important and is virtually irreplaceable, I would suggest that you absolutely click the Verify button. That way, you're ensured that the backup worked flawlessly.

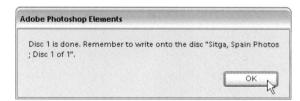

Step Nine:

When the verification process is done, you'll be greeted with a somewhat insulting dialog that reminds you to take a marker and write the name of what's on your backup disc on the backup disc itself. Think of it as the "Duh!" screen. By the way, if you're the extra careful type (read as "paranoid"), you can burn yourself another copy to keep as a second backup. There's no loss of quality, so burn as many copies as you need to feel secure (remember, just because you're paranoid, doesn't mean they're not out to get you).

Creating a Contact Sheet for Your CD

All right, your CD of "digital negatives" is burned and it's time to get to work, but before you go any further, you can save yourself a lot of time and frustration down the road if you create a CD-jewel-box-sized contact sheet now. That way, when you pick up the CD, you'll see exactly what's on the disc before you even insert it into your computer. Luckily, the process of creating this contact sheet is automated, and after you make a few decisions on how you want your contact sheet to look, Photoshop Elements 3 takes it from there.

Step One:

First open the photos you want to appear on your contact sheet in the Elements Editor, then go under the File menu and choose Print Multiple Photos (or press the keyboard shortcut Alt-Control-P). (*Note:* If you're already working in the Organizer, you can create a contact sheet from the currently open collection by going under the Organizer's File menu and choosing Print.)

Step Two:

Choosing Print Multiple Photos first brings up the Elements Organizer, and immediately after, the Print Photos dialog will appear. There are three categories on the right side of the dialog. Under the Select Type of Print category, choose Contact Sheet from the pop-up menu.

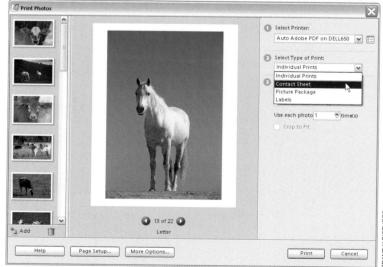

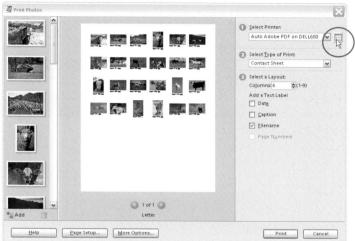

Step Three:

Now that you've told Elements that you want to print a contact sheet (and the preview window shows how your selected photos would look as a contact sheet on a letter-sized page, which is its default size), your next step should be to specify the size you need your contact sheet to be (in this case, one that will fit in the front of a CD jewel case). To do that, start by choosing Adobe PDF in the Select Printer pop-up menu. Then, click on the blue-and-white icon that appears to the immediate right of the Select Printer pop-up menu at the top right of the dialog.

Step Four:

This brings up a dialog with options for your printer (since we're printing to an Adobe PDF driver rather than printing the file out to a regular printer, you'll see the options for a PDF). Since Adobe didn't include a standard size for CD jewel cases, you're going to create one by clicking on the Add Custom Page button in the top right of the dialog.

Step Five:

Clicking the Add Custom Page button brings up the dialog shown here. First, give your new paper size a name (something like "CD Jewel Case") in the Paper Name field. Then in the Paper Size section, enter "4.5" for Width and "4.5" for Height, click the Inch radio button in the Unit section, and then click the Add/Modify button to save your custom size in the Adobe PDF Page Size pop-up menu's list of presets.

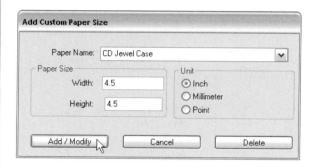

Step Six:

When you click Add/Modify, it returns you to the Adobe PDF Document Properties dialog. Click on the Adobe PDF Page Size pop-up menu and when the menu appears, you'll see that your new custom size (CD Jewel Case) now appears in the list. Click on it to select it as your contact sheet size.

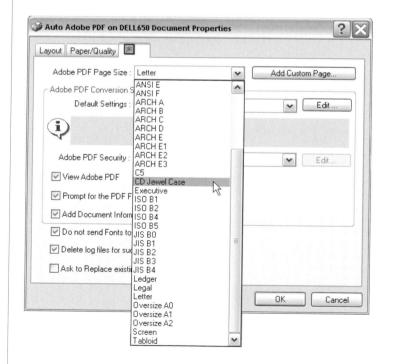

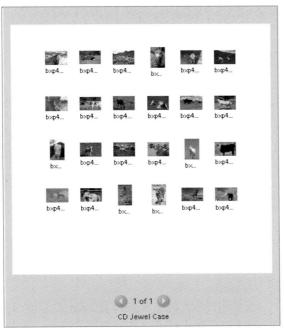

Step Seven:

When you click OK, the contact sheet preview (which appears in the center of the dialog) will now display how your contact sheet thumbnail photos will appear on your CD jewel case. (*Note:* The name CD Jewel Case will appear below the preview.) If you had more than one page's worth of photos open, you'll have more than one page of thumbnails (instead of saying page 1 of 1, it'll say something like 1 of 2, or 1 of 3, and so on). To see any additional pages, click on the right-facing arrow button below the preview.

Step Eight:

On the right side of the dialog, you can decide if you want to have Elements 3 print the file's name below each thumbnail on your contact sheet. I strongly recommend turning this feature on because one day you may have to go back to this CD looking for a photo. The thumbnail will let you see if the photo you're looking for is on this CD (so you've narrowed your search a bit), but if there's no name below the image, you'll have to manually search through every photo on the CD to locate the exact one you saw on the cover. However, if you spot the photo on the cover, and you can see its name, then you just open Elements 3, then open that file. Believe me, it's one of those things that will keep you from ripping your hair out by the roots, one by one. Now you can click Print and your contact sheet is created in PDF format and opened in Elements. Now just go the File menu, select Print, and print your contact sheet to your printer.

Continued

Step Nine (or so you think...):

This is more like a tip than a step, but a number of photographers add a second contact sheet to make it even easier to track down the exact image they're looking for. It's based on the premise that in every roll (digital or otherwise) there's usually one or two key shots—two really good "keepers"—that will normally be the ones you'll go searching for on this disc (after all, it's pretty rare to shoot 30 or 40 shots and each one of them is just fantastic. Usually, there are a couple of great ones, 15 or so that are "okay," and the rest shall never see the light of day, so to speak). So what they do is make an additional contact sheet that either becomes the front cover of the jewel case (with the regular contact sheet behind it in the cover of the case) or vice versa (the regular contact sheet is visible on the outside of the jewel case, and this additional contact sheet is behind it). This additional contact sheet only includes the one or two key photos from that roll, along with a description of the shots, to make finding the right image even easier.

Step Ten:

Here's the final result with a two-photo contact sheet for the cover of the CD jewel case, after a regular contact sheet with multiple images was printed and slid into the CD jewel case behind it. To create this contact sheet, open one or two images in the Editor and just repeat Steps One through Eight. When you get to Step Eight, just press the letter T to switch to the Type tool and enter descriptive text next to your contact sheet thumbnail(s). Now print your new contact sheet.

This one, which we used for the Farm ad, is also on here. It's name is bxp41370s.jpg

This CD has

this shot of the horse in the mist.

The file's name is bxp49391s.jpg

I know, the name "Dealing with the Welcome Screen" makes the Welcome Screen sound like something obtrusive, but really it's not. At least, not at first. In fact, at first it's welcome (like the way I worked that in there?), but after you've seen it a few hundred times, if you're like most folks you'll probably want it to go away. But before you make it go away for good, there's a few things you might want to decide first. And they are...

Dealing with the Welcome Screen

The First Time:

The Welcome Screen that appears when you launch the program is designed to help first-time users figure out what they want. If you're holding this book, my guess is you already know what you want, so click the Edit and Enhance Photos button near the top center of the Welcome Screen, which takes you right into the Elements Editor (which, if you've used previous versions of Elements, you know simply as Photoshop Elements).

Future Uses:

You can use this Welcome Screen to decide what happens when you launch Elements 3 in the future. For example, by default it wants to show you this Welcome Screen each time you launch Elements. You may want that the first few times, but once the novelty wears off, you'll want to go straight to the Editor when you launch Elements. Then, you just need to change one thing: At the bottom left-hand corner of the Welcome Screen, where it says "Start Up In" you'll see the words "Welcome Screen." Click on Welcome Screen and choose Editor from the pop-up menu that appears. Now when you start up Elements, you'll get the Editor.

Start with Sorting:

If you'd prefer to skip the Welcome Screen and instead go right into sorting your images rather than editing them, you can go to the built-in Organizer (which used to be the standalone product Photoshop Album) by choosing Organizer from the Start Up In pop-up menu.

Welcome Back Welcome Screen:

Okay, what if you've chosen to start up in the Editor or Organizer, and then at some later date you think you'd like to get that Welcome Screen back again? It's easy—just go under the Window menu (in either the Editor or Organizer) and choose Welcome, and the screen will reappear. However, once you close it, it won't reappear at startup unless you change the Start Up In pop-up menu in the bottom-left corner to Welcome Screen.

Other Options:

One last thing—just to save you some time: If you have the Welcome Screen open, there are three buttons that actually take you to the Editor—they just take you to different parts. Quickly Fix Photos opens the Editor in the Quick Fix mode; the Edit and Enhance button just launches regular ol' Elements 3 (the Editor); and Start From Scratch opens the Editor too, but it thoughtfully opens the New (document) dialog for you.

How to Make Elements 3 Look and Act Like Elements 2

By now you've already noticed that Elements 3 has a new interface (new Toolbox, new way it displays your photos, new palette scheme—new everything). Now, although I think the new interface is a huge step in the right direction, we both know there are people out there who don't like change (not you and me, of course—other people. Freaks mostly). Anyway, if you run into those "no-change people," you can show them how to quickly change the Elements 3 interface to look and act just like previous versions of Elements using the technique below.

Step One:

The most obvious difference between versions is that the Elements 2 floating Toolbox has been replaced by a single-row Toolbox that is attached to the left side of your screen in Elements 3. To make it look like the old floating Toolbox again, just click on the tiny tab that appears at the top of the Toolbox and drag it out into your work area. The old two-row floating Toolbox is back. To return to the single-row look, just drag the top of the Toolbox back to the top-left corner where the single row had been.

Step Two:

The next major thing you'll notice is that by default photos no longer appear in their own separate windows. They now appear centered onscreen with a gray work area around them. Adobe calls this Maximize Mode. This mode is really great for two reasons: (1) It gives you the maximum working area possible by centering your photo onscreen; and (2) it puts a neutral gray color around your working photo, which pros prefer while color correcting images so background colors don't interfere with the perception of color. But if you'd like the ol' "separate-floating-window-for-every-photo" scheme of Elements 2 back (without having your photos centered with the gray area surrounding your images), just go under the Window menu, under Images, and choose Cascade. Voilá—the individual windows are back. (To return to the new view, just go to Window, under Images, and choose Maximize Mode.)

Step Three:

The third thing that's changed is the introduction of the Palette Bin that appears along the right side of your screen, which replaces the free-floating palettes of Elements 1 and 2. If you want those floating palettes back (and do away with the new Palette Bin altogether), just click on the tab of one of the "nested" palettes in the bin, drag it out into your work area (as I did here with the Layers palette), and it becomes a regular floating palette again. Just like in previous versions of Elements, you can nest your most-used palettes together by dragging-and-dropping their tabs onto any open floating palette.

Continued

Step Four:

Once you've emptied out the Palette Bin (you've taken out, nested, or closed all the palettes that Adobe puts there by default), you can close the Palette Bin by either clicking on the little tab in the center of the vertical divider bar or clicking the arrow to the left of the words "Palette Bin" in the lower-right corner of your screen. (To return to the new layout, click on the arrow next to the words "Palette Bin" again to open it, and dragand-drop your palettes' tabs to "re-nest" them in the Bin.)

Step Five:

Elements 3 also introduced the Photo Bin. It appears along the bottom of your screen and shows a small thumbnail of each of your open documents. So even though the Maximize Mode only shows one photo at a time, you can use the Photo Bin to bring the photo of your choice to the front with just one click on a thumbnail. There are also two tiny arrow buttons along the bottom-left corner of the Photo Bin that work much like forward and reverse buttons. Click on the right-facing arrow to move to the next photo in the Bin, or click on the left-facing arrow to move to the previous photo. To close it so Elements 3 looks more like Elements 2, click on the downfacing arrow to the right of the words "Photo Bin" in the bottom-left corner of your screen. (To go back to the Photo Bin, click on the arrow again.)

Standard Elements 3 window

Elements 3 window lookin' "old school"

It's Decision Time: File Browser or Organizer?

Back in Photoshop Elements 2 (and in the Macintosh version of Elements 3), your only method of importing and organizing photos was the File Browser. A new-and-improved File Browser exists in Elements 3, but there's actually something better—the Organizer. It's an updated version of what previously was a standalone product that Adobe sold separately as Photoshop Album 2. Since they're both built in, which should you use—the updated File Browser or the new Organizer? Here's how to determine which one's right for you.

The Organizer:

The Organizer does double duty—it works wonderfully well with photos you've just taken with your digital camera, but its forte is cataloging all your digital camera photos and keeping them one or two clicks away at any time. It was designed for creating a giant (yet very fast) database of all your photos taken through the years; it excels at tracking and organizing your photos; and (perhaps most importantly) it's designed to help you find the photos you're looking for fast.

Another great thing about the Organizer is its ability to output (share) your photos in a wide variety of formats, including full-featured slide shows, DVDs, websites, online printing services, and HTML-based email.

So who should use the Organizer? (1) Anyone new to Elements should definitely use the Organizer because it's the future of Elements digital photo management. (It's not the File Browser or Adobe would have just kept on improving it. I predict the File Browser will probably go away completely in a future version of Elements.) (2) People who want instant access to all their photos without having to search through CDs of photos.

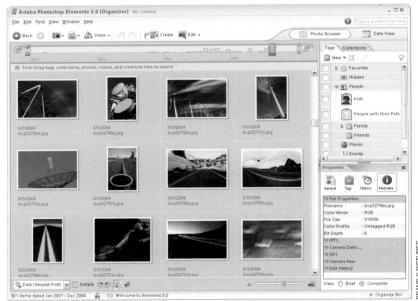

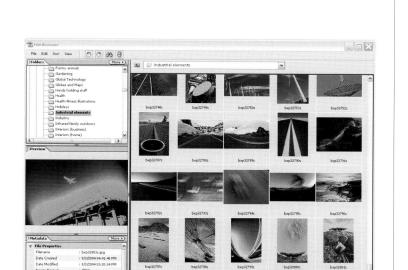

(3) Anyone who wants to do other things than just print photos out of a desktop printer (you want slide shows, DVDs, websites, etc.). (4) Anyone who is using Photoshop Album 1 or 2 and is already familiar with it. (5) Anyone who wants something better, more full-featured, more powerful than the File Browser. In short, my recommendation to almost everyone is "use the Organizer."

The File Browser:

The File Browser is essentially used for managing your current photos. In other words, it works best when importing and sorting photos you just shot from your digital camera. It's great for separating the good shots from the bad shots before you actually open them in Elements 3 for editing. That's its forte.

Here's the bad part: It's not very good at working with a big collection of all your photos (like a catalog of your past two years of photos). It's too slow, too clunky, and although you could conceivably manage thousands of photos using the File Browser, that's not really what it was designed for, so it will be a bit laborious and slow using it in that role.

So who should use the File Browser?

(1) People who are used to the File Browser from Elements 2 and don't feel like learning how to use the Organizer;

(2) people who think they'll soon be moving to the full-blown Photoshop CS, which uses a similar File Browser, and who want to familiarize themselves with it before they upgrade; (3) people who don't care about keeping their entire collection of photos accessible right from their hard drive; and (4) Mac users, whose version of Elements has no Organizer.

Accessing the File Browser

The File Browser (which has been greatly enhanced since version 2) is ideal for working with a folder full of images or images you just saved from your camera. Think of the File Browser as a tool for working with images you just shot today, rather than the new Photo Browser, which is part of the Organizer that's used for working with a catalog of all of your photos you've taken over the years.

One Way:

You can access the File Browser by going under the File menu and choosing Browse Folders. An even quicker way is to use the keyboard shortcut Shift-Control-O.

Another Way:

Or, you can even open it directly from the Window menu by choosing File Browser.

The File Browser is divided into four main palettes, if you will: one for navigating to your photos; one that displays thumbnail versions of your photos (once you find them); one that shows a larger preview of your currently selected thumbnail; and one that lets you see information about the currently selected photo. We'll start with the navigation window (after all, if you can't find your photos, the rest of the File Browser will look pretty, um...blank).

Navigating to Your Photos Using the File Browser

Accessing Your Photos:

The left side of the File Browser is the palette area (although they're palettes, they're not "floating palettes" like most of the palettes in Elements, because they have to stay within the File Browser). The top-left palette (called Folders) is designed to give you direct access to photos on your digital camera's memory card, photos on your hard drive, a CD of images, a network drive—you name it. The idea behind this is simple: It gives you access to your digital camera images without leaving Elements. To navigate to the photos inside a folder from the palette, just click once on the folder's icon.

Saving Your Favorite Folders:

If you find yourself going to a particular folder fairly often, you can save that folder as a "favorite." Just go under the File Browser's mini-menu, under File, and choose Add Folder to Favorites. That folder will now appear under the heading Favorite Folders in the pop-down navigation menu that appears directly above the main thumbnail window. To delete a folder from your Favorite Folders list, select the folder in the Folders palette, go under that File menu again, and choose Remove Folder from Favorites.

Continued

Moving Photos from Folder to Folder:

Another nice navigation feature of the File Browser is that you can use it to move photos from one folder to another. You do this by dragging the thumbnail of the photo you want to move, then dropping that photo into any folder that appears in the Folders palette (when you move the dragged photo over a folder, a rectangular highlight appears letting you know that you've targeted that folder). That photo will now be removed from the currently selected folder and placed into the folder you dragged-and-dropped it into.

TIP: If you hold the Control key as you drag, instead of moving your photo, it will place a duplicate of your photo into that folder, rather than the original.

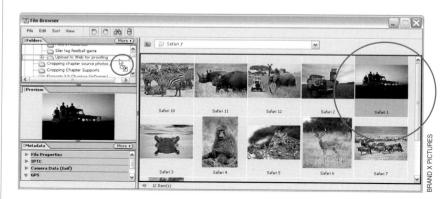

The second palette down on the left side of the File Browser is designed to give you a larger preview of the thumbnail images you click on in the main thumbnail window. Although the Preview palette looks like a one-trick pony, here are a few hidden little features that can make it a much more useful tool.

Previewing Your Images

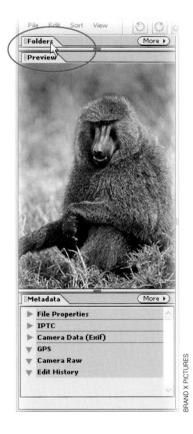

Bigger Previews are Just a Double-Click Away:

The default size for the Preview palette's thumbnail is fairly small, but you can make it much bigger by double-clicking—not on the tab that says "Preview," but instead on the little tab that says "Folders." This will collapse (hide) the Folders palette to where just its tab is visible, which expands the viewing area of the Preview palette automatically.

Continued

Portrait Previews:

If you need the preview even bigger, double-click on the Metadata tab at the bottom left of the File Browser and it will collapse, expanding the Preview palette even more. This works particularly well when you're viewing a photo that was shot in portrait orientation (tall rather than wide).

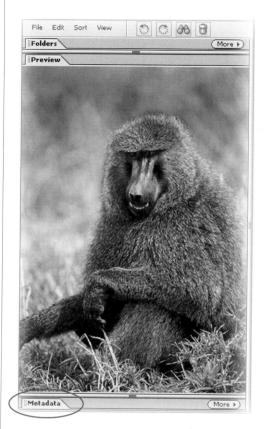

Landscape Previews:

However, when you have a photo in landscape orientation, to get the preview much bigger you'll also have to drag the Preview palette out wider by clicking anywhere along the divider bar between the Preview palette and the main thumbnail window and dragging to the right to expand the width of the Preview palette. *Note:* To make any collapsed palette visible again, just doubleclick directly on its tab name.

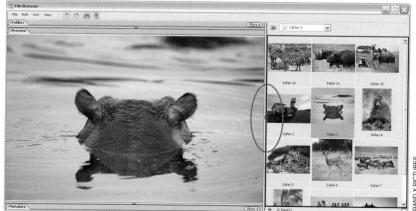

24

The third palette down in the palette area is the Metadata palette. It gives you access to information that's embedded into your photo by your digital camera at the moment you took the shot. (If you're on a Mac, there's a Keywords palette nested with the Metadata palette as well, which enables you to search for specific images by assigning keywords.) We'll start here with a simple look at how to access the embedded background information on your photo by using the Metadata palette.

Getting Info (Called Metadata) on Your Photos

Background Info on Your Photo: When you shoot a photo with today's digital cameras, at the moment you take the shot, the camera automatically embeds loads of information about what just took place: things like the make and model of the camera, the time the photo was taken, the exposure setting, the f-stop, shutter speed, etc. Then, once you bring the digital photo into Elements, the application then embeds more information into the photo (stuff like the file name, when it was last edited, which format the file was saved in, its physical dimensions, color mode, etc.). All this embedded info comes under the heading Metadata, and that's why it appears in the Metadata palette. At the top of the palette, under the heading File Properties, is the info Elements embeds into your file. The next field down is IPTC metadata, which is where you'll see any extra data added to the file (Adobe Photoshop CS users can embed their own personal data into files). The next field down, Camera Data (Exif), displays the background info embedded by your camera. You may never use this, but it's nice to know it's

there in case of a pop quiz.

Setting Up How You'll View Your Photos

Before you start sorting your photos, it helps to get a handle on how to view your images in the File Browser. In Elements 3 you have a decent amount of control over how this is done, so here I'm basically going to show you what your options are, then show you how to set up the File Browser to display photos in a way that's most comfortable for you.

Working in the Main Thumbnail Window:

The main window displays the thumbnail views of your photos. If you click on a thumbnail within this window, the photo highlights to let you know it's selected, and a preview of the photo is displayed in the Preview palette to its left. If you want to open the full-size image in Elements, just double-click on the thumbnail in the main window. (*Note:* You can also double-click on the Preview palette's thumbnail to open the photo.)

You can select multiple photos to open at the same time by clicking on the first photo you want to open, holding the Control key, clicking on any other photos, and then double-clicking on any one of the selected thumbnails. Also, you can select entire contiguous rows by clicking on the first thumbnail in a row, holding the Shift key, clicking on the last photo in that row, and double-clicking any selected photo.

TIP: You can navigate from thumbnail to thumbnail by using the Arrow keys on your keyboard.

The default setup for your File Browser has the palette area on the left and the main thumbnail window on the right. However, once you've located the folder with the image you'll be working with, you might want to do what many pros do at this point and choose the Expanded View (which hides the palette area, enabling you to see significantly more thumbnails at once). You do that by clicking on the two-headed arrow icon at the very bottom of the File Browser, to the immediate right of the divider

bar that separates the palette area from the main thumbnail window. If you want to get back to the standard view, click the same arrow icon again.

Viewing Things Your Way:

Changing the View Size of Your Thumbnails:

In Elements 3 there are four different thumbnail view sizes to choose from: Small, Medium, Large, and Custom. Choose which view you'd like from the File Browser's View menu. Here's my handy tip on how to determine which view is right for you: Small is way too small; ants use small and they complain. Medium is still too small to see what's going on. Large should probably be called "Small," but it's the first thumbnail view that's big enough in which you can actually tell what's going on in the photo, so I used Large almost exclusively back in Elements 2. But in Elements 3, something wonderful happened....

Continued

The Wonderful World of Custom Views:

In Elements 3, Adobe added the view of your dreams—a custom view where you decide how big you want your thumbnails to be. To access this view, just go under the View menu and choose Custom Thumbnail Size. Your thumbnails adjust to a size that's perhaps even larger than the preview of the image in the Preview palette. This is one sweet view! Oh, but it gets better, because you're not stuck at this size—remember this is called "Custom Thumbnail Size," so you can customize it.

Customizing the Custom Size: To create your own custom-sized thumbnails, go to the File Browser's mini-menu, under Edit, and choose Preferences. This is basically just a shortcut to the main Elements Preferences dialog, so you can also reach this dialog by going under the Elements Editor's Edit menu, under Preferences, and choosing File Browser. It brings up the same dialog and does the same thing, but since you're already in the File Browser, why not use the shortcut, eh?

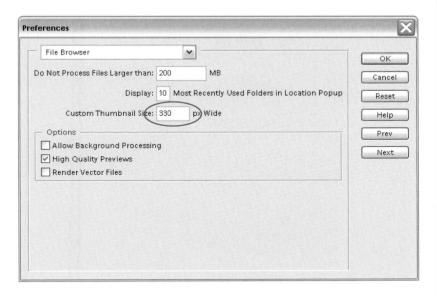

Changing the Default Size:

When the Preferences dialog appears, there's a field called Custom Thumbnail Size and by default the size is 256 pixels wide. Highlight that 256 and type in your own preferred size (I changed my view to 330 pixels), and then click OK to set this size as your new Custom Thumbnail Size. (*Note:* For a more impressive thumbnail view, click on the Expanded View icon [it's the two-sided arrow along the bottom of the Browser window] to hide the palette area on the left so you can see your large thumbnails side by side.)

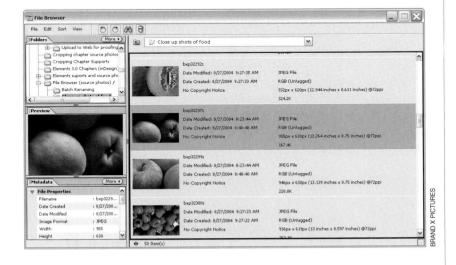

Getting the Details:

There's another layout view for your File Browser window called Details. This particular viewing option is very popular with professional photographers because not only does it display the thumbnail at a decent size, but it also displays some of the File Properties information about the photo to the right of the thumbnail. The Details view is found under the View menu, listed right below Custom Thumbnail Size.

Renaming Individual Photos

If you want to rename an individual photo, it's fairly straightforward. Now, there is a way to instantly rename every photo at once with names that make sense (to you anyway), but that, my friends, is in the next tutorial. For now, here's how to rename one thumbnail image at a time (this is a great technique to employ if you charge by the hour).

Step One:

It's hard to imagine why someone wouldn't like such a descriptive file name like "DSC_0029.jpg," but if you're one of those people who enjoys names that actually describe what's in the photos, here's how it's done: When you move your cursor over the file name of a thumbnail, you'll notice that your cursor changes into a text cursor (an "I-beam"), so all you have to do is click that I-beam cursor once on that text and a text entry field appears, highlighting the old name.

bxp28134s bxp28135s bxp28139s bxp28140s.jpg bxp28141s bxp28144s bxp28144s bxp28154s bxp28155s bxp28156s ✓ 50 Item(s)

Step Two:

Now just type in a new name, press the Enter key, and the thumbnail will have your new-and-improved name. *Note:* There's yet another way to rename a photo from within the File Browser; you can Right-click on a thumbnail and a pop-up menu will appear. Choose Rename and it will highlight the naming field for you. Isn't that more complicated than just clicking on the name field? Yep.

The File Browser will actually let you change the name of an entire folder (or disc) full of images so your digital camera photo names are no longer the cryptic DSC01181,JPG, DSC01182,JPG, DSC01183,JPG variety, but names you choose that will be more recognizable, such as Concert Shot 1, Concert Shot 2, Concert Shot 3, etc., and best of all, the whole process is automated. (Incidentally, this is particularly helpful when you're working off your CD, because you can have Elements create a duplicate folder of these photos on your hard drive with the new names.) Here's how:

Batch Renaming Your Files

Step One:

You can hold the Control key and click on only the photos you want to rename, but a more likely scenario is that you'll want to rename all the photos displayed in your File Browser, so go under the File Browser's Edit menu and choose Select All.

Step Two:

Once you have selected all the photos that you want to rename, go under the File Browser's File menu and choose Rename Multiple Files.

Step Three:

When the Batch Rename dialog appears, you first need to choose a destination for these renamed photos. Your choices in the Destination Folder category are limited to either renaming the photos in the same folder where they reside (if you're working off a CD of saved originals, this really isn't a choice) or moving them to a new folder (which is what you'll probably choose). If you choose Move to New Folder, you'll need to click the Browse button, and in the resulting dialog, navigate to the folder you want your photos moved into once they're renamed. One limitation of batch renaming is that after it renames your originals it either keeps them in the same folder or moves them to a new folder. I wish there were an option where Elements would make copies (leaving the originals untouched) and rename only the copies; but at this point, there's not.

Step Four:

Under the File Naming section of the dialog, the first pop-up menu on the top left is where you can type in the name you've chosen. Just click your cursor in this field, and type in a name.

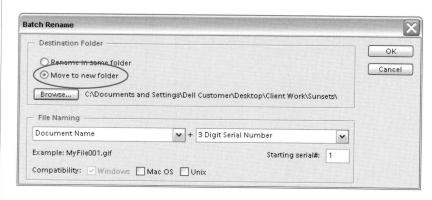

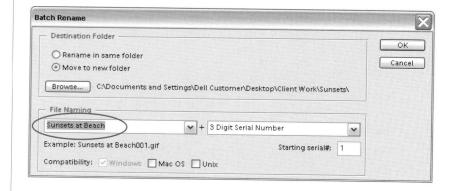

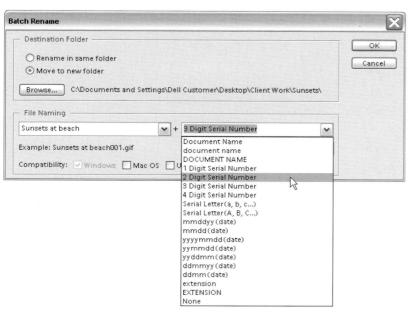

atch Rename			>
— Destination Folder ————			ОК
Rename in same folder			Cancel
Move to new folder			Carreer
Browse C:\Documents a	nd Settings\Dell Customer\Desktop\Client Work\Su	insets\	
- File Naming			
File NamingSunsets at Beach	+ 3 Digit Serial Number	~	

Step Five:

The next field to the right is where you tell Elements the numbering scheme you'd like to use after the name you've assigned. (After all, you can't have more than one file in the same folder with the same name. Instead, you need them named with numerals, as in Trip 01, Trip 02, etc.) To use Elements' built-in autonumbering, click on the arrow to the immediate right of the field and a pop-up menu will appear. Here you can choose to number your photos with a 1- to 4digit serial number, letters, or by date. For example, choosing 2 Digit Serial Number will automatically add a sequential number after the name, starting with "01." You can also choose the starting serial number by entering a number in the field at the bottom-right corner of the dialog.

TIP: If you're concerned about making a mistake when you rename your files, don't be, because directly below the File Naming category is a live example of what your file name will look like. Freak Out Warning: Don't let it freak you out that it always shows .gif as the file extension even though your file is a JPEG-Elements is just using .gif to let you know that an extension will be added. The real extension it adds will be based on the file format of the files you chose to rename. So if your files are in JPEG format, Elements will add the .jpg extension, not .gif as the live example shows. This FOW (Freak Out Warning) is based on actual real-world testing and evaluation (meaning the first time it happened to me, I freaked out).

Continued

Step Six:

When you click OK, Elements does its thing, and in just a few seconds, your photos will appear (in a new folder, if you chose that option) sporting their brandnew names. Now when you view those images in the File Browser, they'll have more meaningful names.

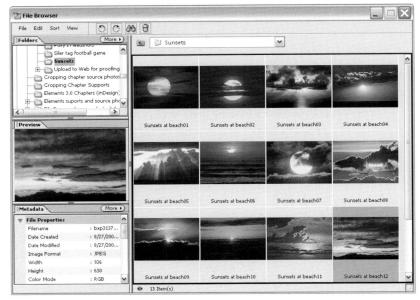

View from the File Browser

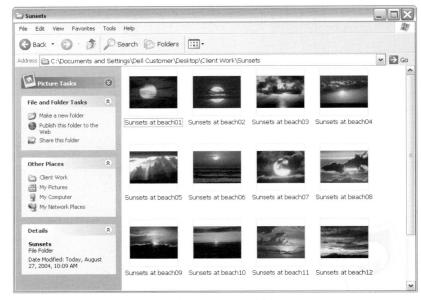

View from your new folder

Rotating photos within the File Browser is as easy as clicking one button. However, when you rotate photos within the File Browser itself, it's only really rotating the thumbnail. This is handy, because when you're sorting photos and you have some photos that have portrait orientation (they're tall rather than wide), you want to be able to see them upright to make a sorting judgment call, but you have a separate decision to make if you want the actual photo rotated—not just the thumbnail. Here's how to do both.

Rotating Photos

Rotating Thumbnails:

Rotating a thumbnail is a total no-brainer: just click on the photo you want to rotate, then click on the circular rotation icons in the File Browser's Options Bar. The left icon rotates counterclockwise; the right icon rotates clockwise. You can also use the shortcut Control-[(Left Bracket key) to rotate counterclockwise, and Control-] (Right Bracket key) to rotate clockwise. When you rotate a thumbnail, a warning dialog will appear saying you're not rotating the actual image—just click OK. A little rotate icon will appear in the lower right-hand corner of the thumbnail.

Rotating the Actual Photo:

When you rotate a thumbnail, the photo doesn't really get rotated until you actually open it in the Elements Editor (look in the image's folder on your hard drive, and you'll see—the photo isn't rotated). However, you can apply the same rotation to the photo by going under the File Browser's Edit menu and choosing Apply Rotation (or simply Right-click the thumbnail and choose Apply Rotation) when you have the thumbnail selected. You'll get a warning dialog telling you this will degrade the image a bit (rotating does that, ya know). Click OK to apply the rotation.

Sorting and Arranging Your Photos

Ah, finally we get to the fun part—actually sorting and arranging photos. Back in Elements 2, there really wasn't much sorting—you just kind of looked at the photos and you left it at that. Luckily, that's all changed in Elements 3, and now the File Browser is more like your own personal light table. And if moving your photos around manually sounds like too much work, the File Browser can even do some sorting for you—automatically.

Drag-and-drop:

In Elements 3, if you want a particular photo in a particular spot in your main thumbnail window, you just click on that photo and drag it there. For example, if you want an image to appear in a different row, just click on its thumbnail and drag it in that row. A thick, black vertical bar lets you know where the dragged thumbnail will land. You can treat the main thumbnail window like your own personal light box, dragging photos into the exact order you want them. Besides this manual way of sorting photo by photo, you can have Elements 3 do some basic sorting for you (as you'll see in the next step).

AND X PICTURES

Automated Sorting:

You have a number of choices when it comes to having Elements sort your photos, and you make your choices from the Sort menu on the File Brower's mini-menu. Just click on Sort and choose how you want your photos sorted in the thumbnail window. At the bottom of the menu, you can decide if you want your sorted photos to appear in Ascending Order (the default menu choice) or descending order (which you get by choosing Ascending Order when it's checked. Choosing it when it's already checked, unchecks it, giving you descending order. Check it out).

When and Why You Need to Refresh: Let's say you chose to sort by Filename (which sorts your file names alphabetically) from the Sort menu, and then you changed a photo named "Hawaii" to "A Big Volcano." You'd expect that since this new name starts with an "a" it would jump to the top of the thumbnail window, right? Nope. That would be way too easy. Once you've sorted your photos, they stay right in the same order they were in until you "refresh" the File Browser. This "refreshing" is basically telling the Browser to update itself. You can refresh by clicking on the More button to the right of the Folders palette and choosing Refresh (it's the only choice in the menu) or by pressing F5 on your keyboard (which is faster and easier). You can also choose Filename again from the Sort menu, which will Refresh, too.

Searching for Photos

Elements 3 gives you a hand when you're trying to find a particular photo by including a search function that lets you search by a host of different criteria. Here's how to use it to find the photo you're looking for:

Step One:

To bring up the Search dialog, click on the little binoculars (Search) icon in the File Browser's Option Bar.

Step Two:

When the Search dialog appears, first choose where you want to search (in a particular folder, on your card reader, your entire hard disk, etc.) by selecting the folder in the Look In pop-up menu, or click the Browse button to find a folder.

Step Three:

In the Criteria section of the Search dialog, choose how you want to search. You can even search by EXIF Metadata, so if you know you shot a group of photos using a particular camera, you would choose EXIF Metadata from the first Criteria pop-up menu. Set the second pop-up menu to "contains," then in the third pop-up menu enter your camera model, and then click Search. The results of your search (all the photos you took with your specified camera model) will appear in the main thumbnail window.

If a file is so vile that it doesn't even deserve to be sorted, you may want to delete it altogether just to cut down on clutter (and save drive space). There are a number of different ways to delete files—all of them simple.

Deleting Files from within the File Browser

Deleting Photos:

If you burned a CD when you first inserted your memory card (and I know you did, because you know how important it is to keep your digital negatives safely stored), you can safely delete any photo you don't want. You can do this as easily as clicking on the offending thumbnail and pressing the Delete key. You'll get a warning dialog basically telling you that if you continue this madness (by clicking Yes), Elements will actually move this file from the folder where it resides and put it into the Recycle Bin until you choose to empty the Recycle Bin.

Another way to delete a file is to click on it and then click on the Trash icon in the File Browser's Options Bar. Or better yet, Right-click the thumbnail and choose Delete in the contextual menu.

And of course, there is (as always) the slow way—go under the File Browser's File menu and choose Delete.

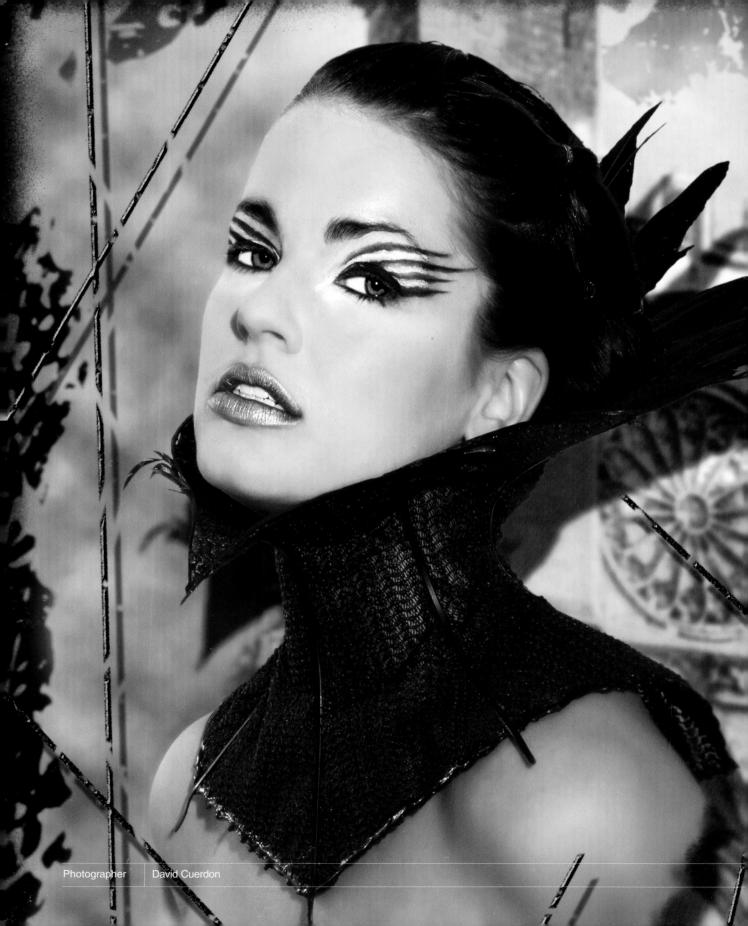

Organized Chaos is the perfect name for this chapter because not only is it a song title (by the band Benediction), it's also apparently a marketing directive put forth by a super-secret department at Adobe who,

Organized Chaos managing photos using the organizer

from what I gather, is charged with making simple things more complex. For example, let's take a look at the File Browser (for sorting images). Of course, in Elements there is no menu item for File Browser: instead it says "Browse for Files." By changing both the order of the words, and the spelling, they secured a hefty annual bonus, and because they were able to add an additional word ("for") they get an extra commission on the back end. Now, when they introduced the Organizer (also for sorting images), the supersecret department members all got brand new company cars, because having two completely separate tools that do seemingly the same thing is a home run. But where they really cashed in was with their addition of a button called the "Photo Browser." It's the perfect scam, because there actually is no Photo Browser. When you click it—believe it or not—it brings up the Organizer. That should be worth some extra stock options.

Importing Photos from Your Scanner

Because this is a book for digital photographers, I imagine most of your photos will come from a digital camera (if so, see "Saving Your Digital Negatives" in Chapter 1), but if you've been a photographer for a while now, you probably have some traditional prints lying around that you'd like to scan in, so here we'll look at importing scanned images into the Organizer.

Step One:

To scan images and have them appear in your Organizer, click the Photo Browser button in the Elements Editor's Options Bar to launch the Organizer. Then go under the Organizer's File menu, under Get Photos, and choose From Scanner. By the way, once the Organizer is open, you can use the shortcut Control-U to import photos from your scanner.

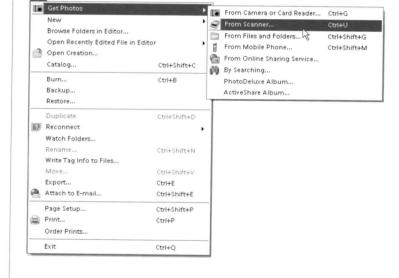

Step Two:

Once the Get Photos from Scanner dialog is open, choose your scanner from the Scanner pop-up menu. Choose a high Quality setting (I generally choose the highest quality unless the photo is for an email to my insurance company for a claim—then I'm not as concerned). Then click OK to bring in the scanned photo. See, pretty straightforward stuff.

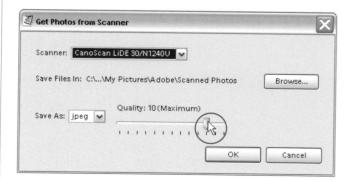

This new feature added in Elements 3 is a huge timesaver because it lets you choose a folder that is "watched" by the Organizer. When you drag photos into this folder, they will automatically be added to your Organizer.

Here's how to set it up:

Automating the Importing of Photos by Using Watched Folders

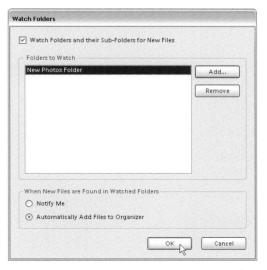

Step One:

Go under the Organizer's File menu and choose Watch Folders.

Step Two:

When the Watch Folders dialog appears, make sure the Watch Folders and their Sub-Folders for New Files checkbox is turned on. In the Folders to Watch section, click the Add button, and then in the resulting dialog, navigate to any folders you want the Organizer to "watch" for the addition of new photos. Select the folder you want to watch, and then click OK. Continue to click the Add button and select more folders to watch. When you've selected all your folders, they will appear in the Folders to Watch section of the Watch Folders dialog, where you have the choice of having the Organizer alert you when new photos are found in the watched folders (meaning you can choose to add them) or you can have them added automatically, which is what this feature is really all about. But if you're fussy about what gets added when (i.e., you're a control freak), at least you get an option.

Changing the Size of Your Photo Thumbnails

Thumbnails of your photos are displayed in the Organizer's Photo Browser, and luckily you have great control over what size they're displayed at.

Step One:

The size of your thumbnails is controlled by a slider at the bottom-right corner of the Photo Browser window. Drag the slider to the right to make them bigger—to the left to make them smaller. To jump to the largest possible view, just click on the Single Photo View button to the right of the slider. To jump to the smallest size, click on the Small Thumbnail Size button to the left of the slider. To jump up one size at a time, hold the Control key and press the Plus (+) sign. To jump down press Control-Minus (–) sign.

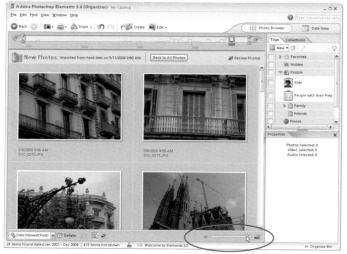

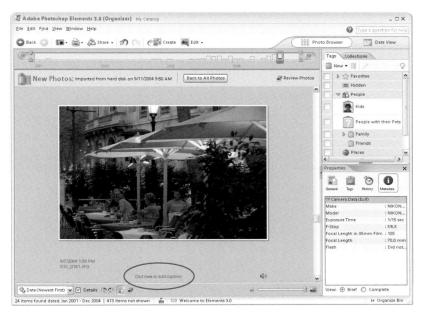

Step Two:

Another shortcut to jump to the largest view is to just double-click on your thumbnail. At this large view, you can enter a caption directly below the photo by clicking on the placeholder text (which reads "Click here to add caption") and typing in your caption.

Seeing Full-Screen Previews

How about this for a view? Elements 3 lets you see a full-screen preview of a selected thumbnail—all without leaving the Organizer. It's like an onscreen slide show of your thumbnails. Here's how it works:

Step One:

To see a full-screen preview of your currently selected photo, click on the Photo Review button (it looks like a stack of tiny slides) in the bottom left-hand corner of the window (or just press F11).

Step Two:

This brings up the Photo Review dialog with a number of presentation options, which look like the options for a slide show. Basically, that's usually what you'll use this Photo Review feature for, but if you just select one photo, it shows just that one photo at full screen. So when this dialog appears, click OK and your photo will be displayed full screen. If you want to return to the Photo Browser. press the Escape key on your keyboard. By the way, once your photo appears full screen, you'll see thumbnails of other photos along the right side of the screen. If you want to see any of those full screen, just click on them. There's also a floating palette at the top of the screen in case you want to see a slide show of those photos on the right—press the green Play button to start it, and click the X button to stop it and return to the Photo Browser

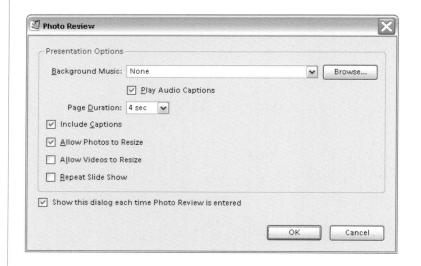

When photos are imported into the Organizer, the Organizer automatically sorts them by date. How does it know on which dates the photos were taken? The time and date are embedded into the photo by your digital camera at the moment the photo was taken (this info is called EXIF data). The Organizer reads this info and then sorts your photos automatically by date, but finding the photos by dates takes a little doing on your part.

Sorting Photos by Date

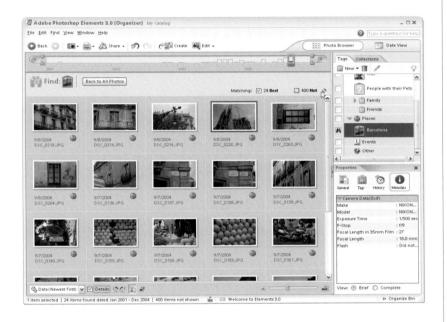

Step One:

By default, the newest photos are displayed first, so basically, the last photo you shot will be the first photo in the Organizer. Also, by default, the exact date each photograph was taken is shown directly below each thumbnail photo. (*Note:* If you don't want this extra detail about each photo to be visible, just uncheck the Details checkbox at the bottom-left side of the Browser window.)

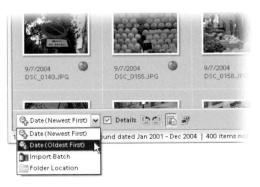

Step Two:

If you'd prefer to see your photos in reverse order (the oldest photos up top), then choose Date (Oldest First) from the pop-up menu in the bottom-left corner of the Browser window. There you have it!

Adding Scanned Photos? Enter the Right Time and Date

I know, I know—this is a book for "digital" photographers, but you know, and I know, that you've got a scanner. At some point you're going to scan some photos (then they'll become "digital images"), and then you'll want these images to be automatically organized in your catalog. All the scanned photos will have their "creation" date as the day you scanned them, unless you add your own date. This way, you can set the approximate date to when they were shot so they'll appear in your catalog when they were taken, rather than when they were imported.

Step One:

First, get the photos from your scanner (see the "Importing Photos from Your Scanner" tutorial earlier in this chapter). Select all the photos you want to set the date for by Control-clicking each image (or Shift-clicking the first and last image if the images are contiguous) in the Photo Browser window. Then, go under the Organizer's Edit menu and choose Adjust Date and Time of Selected Items (or press Control-J).

Step Two:

This brings up a dialog asking how you want to handle the date and time for these photos. For this example, select Change to a Specified Date and Time, and click OK.

Step Three:

This brings up the Set Date and Time dialog, where you can use the pop-up menus to set your selected photos' date and time. Now these photos will appear sorted by the date you entered, rather than the date you imported them.

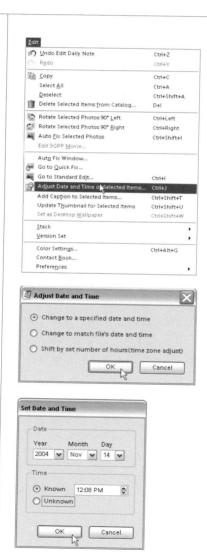

The method that the Organizer uses to help you find the photos you're looking for is month and year. It figures you might not know exactly when you took a group of photos, but let's say, for example, you're trying to find the photos from last year's vacation. If you know you went sometime last summer—even if you can't remember whether it was June, July, or August—you can get mighty close mighty fast using the Month/Year Timeline. Here's how it works:

Finding Photos Fast by Their Month and Year

Step One:

We're going to assume you're trying to find last year's vacation photos (as outlined above). You see those little bars along the Timeline that look like the little bar charts from Microsoft Excel? Well, the higher the bar, the more photos that appear in that month. So click on any month in 2004 and only the photos taken in that month will appear in the Browser window. As you slide your cursor to the left (or right), you'll see each month's name appear. When you get to July, only photos taken in July 2004 will appear. Take a quick look and see if any of those photos are your vacation photos. If they're not in July, scroll over on the Timeline to August, and only those photos will be visible.

Tagging Your Photos (Tags are Keywords)

Although finding your photos by month and year is fairly handy, the real power of the Organizer appears when you assign tags (keywords) to your photos. This simple step makes finding the exact photos you want very fast and very easy. The first step is to decide whether you can use the pre-made tags that Adobe puts there for you or whether you need to create your own. In this situation you're going to create your own custom tags.

Step One:

Start by clicking on the Tags tab on the right side of the Organizer. Adobe's default set of tags will appear in a vertical list. (By the way, if you don't see the Tags and Collections tabs on the right side of the Organizer, click on the words "Organize Bin" at the bottom-right corner of the Organizer window.)

Step Two:

You'll start by creating your own custom category (in this case, we're going to create a category of all of wedding shots taken for your clients). Click on the New pop-up menu that appears just below the Tags tab itself, and from the drop-down menu that appears, choose New Category. This brings up the Create Category dialog. Type in "Weddings." Now choose an icon from the Category lcon list and then click OK. (The icon choices are all pretty lame, so I chose the Heart icon because it was the least offensive for weddings.)

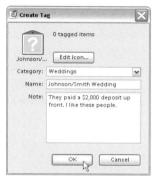

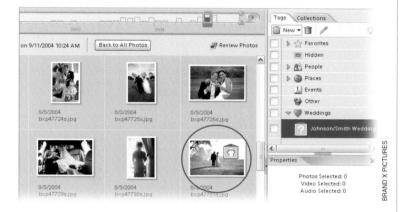

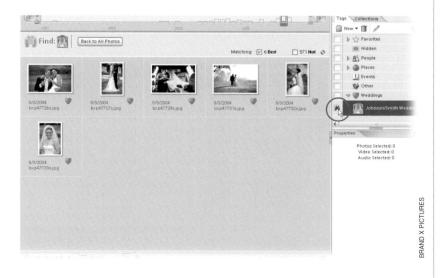

Step Three:

To create your own custom tag, click on the New pop-up menu again and choose New Tag. This brings up the Create Tag dialog. Choose Weddings from the Category pop-up menu (if it's not already chosen), then in the Name field, type in "Johnson/Smith Wedding." If you want to add additional notes about their wedding, you can add it in the Note field (or you can choose a photo as an icon by clicking the Edit Icon button). Now click OK to create your tag.

Step Four:

Now you'll assign this tag to all the photos from the Johnson/Smith wedding. In the Photo Browser window, scroll to the photos from that wedding. We'll start by tagging just one photo, so click on the Johnson/Smith tag that appears at the bottom of your Tags list and drag-and-drop that tag on any one of the photos. That photo is now "tagged." If you have the photo's Details visible (if not, turn on the Details checkbox at the bottom-left corner of the Browser window), you'll see a small tag icon appear below the photo's thumbnail (in this case, the Heart icon).

Step Five:

So at this point, we've only tagged one photo from the wedding. Drag-and-drop that same tag onto five more photos from the wedding so a total of six photos are tagged. Now, in the list of Tags on the right side of the Organizer, click in the small box in the column to the left of your Johnson/Smith tag (a tiny binoculars icon will appear in that box), and instantly, only the photos with that tag will appear in the Photo Browser window. To see all your photos again, click on the Back to All Photos button that appears at the top left of the Browser window.

Tagging Multiple Photos

Okay, you've learned how to create your own custom category (Weddings), then a custom tag so you can sort one wedding from the other (Johnson/Smith), but you're dragging-and-dropping that tag onto one photo at a time (which takes too much time for an entire wedding). There are faster ways than this one-tag-at-a-time method. For example...

Step One:

To tag all the photos from the wedding at the same time, try this: First, click on any untagged photo from the wedding. Then hold the Control key and click on other photos from that particular wedding. As you click on them, they'll become selected (you'll see a thin blue line around all the selected photos). Or, if all the photos are contiguous, click the first image in the wedding series, pressand-hold the Shift key, then click on the last image in the series to select them all.

Step Two:

Now drag-and-drop your Johnson/Smith tag on any one of those selected photos, and all of the selected photos will have that tag. Now if you want to see just the photos from that wedding, you can click in the left column beside the Johnson/Smith tag and only photos with that tag will appear. By the way, if you decide you want to remove a tag from a photo, just Right-click on the photo and from the contextual menu that appears, choose Remove Tag. If you have more than one tag applied, you can choose which tag you want removed.

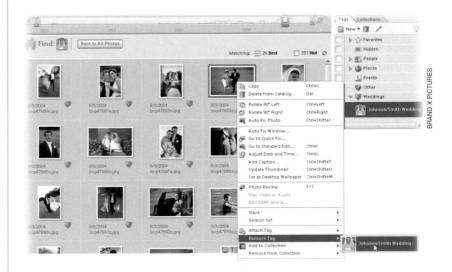

Okay, what if you want to assign the Johnson/Smith tag to a photo, but you also want to assign other tags (perhaps a "Client Work" tag and a "Make Prints" tag), as well? Here's how:

Assigning Multiple Tags to One Photo

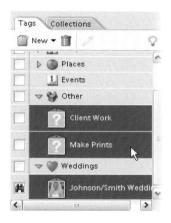

Step One:

To assign multiple tags at once, first, of course, you have to create the tags you need, so go ahead and create two new tags by clicking on the New pop-up menu just below the Tags tab—naming one "Client Work" and another "Make Prints." Now you have three tags you can assign. To assign all three tags at once, just hold the Control key, then in the Tags list, click on each tag you want to assign (Johnson/Smith, Client Work, and Make Prints).

Step Two:

Now click-and-drag those selected tags, and as you drag, you'll see you're dragging three tag icons as one group. Drop them onto a photo, and all three tags will be applied at once. If you want to apply the tags to more than one photo at a time, first hold the Control key and click on all the photos you want to have all three tags. Then, go to the Tags list, hold the Control key again, and click on all the tags you want to apply. Drag those tags onto any one of the selected photos, and all the tags will be applied at once. Cool.

Combining (Merging) Tags

It's easy to go "tag crazy," and if that happens (and you've got dozens of different tags applied to your photos), you may want to simplify by merging some of your tags together. For example, if you shot the 2004 Olympics, and you have tags for 100-meter dash, 400-meter dash, 600-meter dash, and a half dozen more dashes, you may want to combine all those separate tags into just one tag. Here's how:

Step One:

To combine (merge) multiple tags into just one convenient tag, start by holding the Control key and clicking on all the tags that you want to combine in the Tags list on the right side of the Organizer. Then Right-click on any of your selected tags, and from the contextual menu that appears, choose Merge Tags.

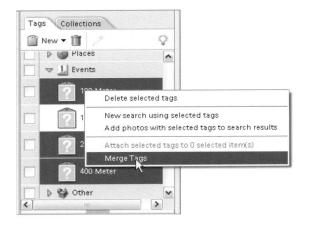

Step Two:

This brings up a dialog that asks you which of the selected tags will be the surviving tag (in other words, which tag will remain after the rest are merged into this one). Choose the tag that will remain from the list of tags, then click OK. The tags will be merged into that one. Every photo that had any one of those selected tags will now have the combined tag.

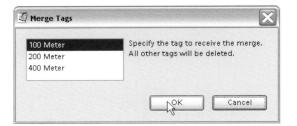

Let's say you went to the Olympics with a group of photographers, and they're using Elements 3, too. If you've created a nice set of tags for identifying images, you can now export these tags and share them with the other photographers from that trip. That way, they can import them and start assigning tags to their Olympics photos without having to create tags of their own.

Sharing Your Tags (or Collections) with Others

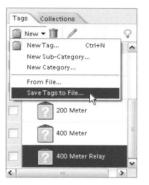

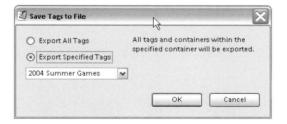

Step One:

To export your tags to share with others, start by going to the Tags tab (on the right side of the Organizer), then click on the New pop-up menu and choose Save Tags to File.

Step Two:

When the dialog appears, you can choose to Export All Tags, or better yet, click on the Export Specified Tags radio button, and then you can choose which tags you want to export from the pop-up menu. Choose the tags you want to export, and click OK. A standard Windows Save dialog will appear, so you can choose where you want your file saved. Name your file, click Save, and now you can email your exported tags to a friend.

Step Three:

Once your friends receive your tags, tell them they can import your tags by going to the Tags tab, clicking on the New popup menu, and choosing From File. Now they just locate the file on their hard drive and click Open. The new tags will appear in the Tags tab.

Collections: It's How You Put Photos in Order One by One

Once you've tagged all your photos from the Johnson/Smith wedding, you may want to create a collection of just the best photos (the ones you'll show to your clients: the bride and groom). You do that by creating a "collection." An advantage of collections is that once photos are in a collection, you can put the photos in the order you want them to appear (you can't do that with tags). This is especially important when you start creating your own slide shows and albums.

Step One:

To create a collection, click on the Collections tab on the top-right side of the Organizer (it's just to the right of the Tags tab when you have the Organize Bin open). You create a new collection by clicking on the New pop-up menu, then choosing New Collection. When the Create Collection dialog appears, enter a name for your collection, and then click OK.

Step Two:

Now that your collection has been created, you can either (a) drag the Collection icon onto the photos you want in your collection, or (b) Control-click photos to select them and then drag-and-drop them onto your Collection icon in the Collections list. Either way, the photos will be added to your collection. To see just the photos in your collection, click on the box in the column to the left of your collection and tiny binoculars will appear. Now, to put the photos in the order you want, just click on any photo and drag it into position. The Organizer automatically numbers the photos for you, so it's easy to see what's going on as you drag photos into order. To return to all of your images, click the Back to All Photos button in the top-left corner of the Browser window.

By default, a tag or collection uses the first photo you add to that tag or collection as its icon. Unfortunately, these icons are so small that you probably can't tell what the icon represents. That's why you'll probably want to choose your own photo icons instead.

Choosing Your Own Icons for Tags and Collections

Step One:

It's easier to choose icons once you've created a tag or collection, meaning you've tagged a few photos or added some photos to a collection. Once you've done that, click on your tag or collection, then click on the Pencil icon (it's right under the tab name). This brings up the Edit Tag (or Collection) dialog. In this dialog, click on the Edit Icon button to launch the dialog you see here.

Step Two:

You'll see the first photo in your collection in the preview window (this is why it's best to edit the icon after you've added photos to the collection). If you don't want to use this first photo, click the arrow buttons under the bottomright corner of the preview window to scroll through your photos. Once you find the photo you want to use, click on the little cropping border (in the preview window) to isolate part of the photo. This gives you a better close-up photo that's easier to see as an icon. Then click OK in the dialogs and that cropped area becomes your icon.

Deleting Tags (or Collections)

If you've created a tag or a collection, and then later decide that you don't want that tag or collection, you can delete it in just three clicks.

Step One:

To delete a tag or collection, start by clicking on the tag or collection you want to delete in the list of tags or collections on the right side of the Organizer.

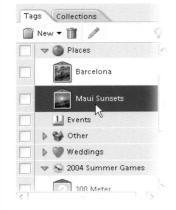

Step Two:

Once you've selected the tag or collection you want to delete, just click the Trash icon at the top of the Tags (or Collections) tab (it's found to the immediate right of the New pop-up menu). If you're deleting a tag, when you click on the Trash icon, it brings up a warning dialog letting you know that deleting the tag will remove it from all your photos. If you want to remove that tag, click OK. If you've got a collection selected when you click the Trash icon, it asks if you want to delete the collection. Click OK and it's gone. However, it does not delete these photos from your main library—it just deletes that collection.

When you take a photo with a digital camera, a host of information about that photo is embedded into the photo by the camera itself. It contains just about everything, including the make and model of the camera that took the photo, the exact time the photo was taken, what the f-stop setting was, what the focal length of the lens was, and whether or not the flash fired when you took the shot. You can view all this info (called Exchangeable Image File [EXIF] data—also known as metadata) from right within the Organizer. Here's how:

Seeing Your Photo's Metadata (EXIF Info)

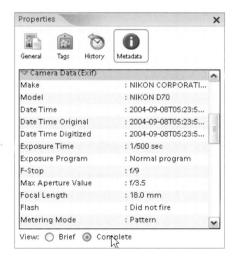

Step One:

To view a photo's EXIF data, first click on the photo in the Photo Browser, and then click the Show or Hide Properties button at the bottom-left side of the Photo Browser window to show the Properties palette.

Step Two:

When the Properties palette appears in the bottom-right corner of the window, click the Metadata button at the top of the palette (it's the fourth button from the left). This shows an abbreviated version of the photo's EXIF data (basically, the make, model, ISO, exposure, f-stop, focal length of the lens, and the status of the flash). Of course, the camera embeds much more info than this. To see the full EXIF data, under the View section at the bottom of the palette, just select Complete and you'll get more information on this file than you'd probably ever want to know. One thing that isn't displayed in the Brief section that you probably might want to know is the date and time the photo was taken, and to see that you will have to open the Complete view.

Adding Your Own Info to Photos

Although your digital camera automatically embeds information into your photos, you can also add your own info from right within the Organizer. This includes simple things like a photo caption (that can appear onscreen when you display your photos in a slide show) or you can add notes to your photos for your personal use, either of which can be used to help you search for photos later.

Step One:

First, click on the photo in the Photo Browser window you want to add your own info to and click the Show or Hide Properties button at the bottom left of the Organizer, or you can also use the keyboard shortcut by pressing Alt-Enter.

Step Two:

This brings up the Properties palette along the bottom-right corner of the Organizer. At the top of the palette are four buttons for the four different sections of your photo's properties. By default, the General section is selected. In the General section, the first field is for adding captions (I know, that's pretty self-explanatory), and then the photo's file name appears below that. It's the third field down—Notes—where you add your own personal notes about the photo.

Step Three:

If you want to see other info about your photo (for example, which tags have been added to your photos; the date when you imported the photo or when you last printed, emailed or posted the photo on the Web; or the info embedded into the photo by your digital camera), just click on the various buttons at the top of the palette.

(none>

Finding a group of photos is fairly easy using the Organizer, especially if you've tagged your images, but finding an individual photo takes a bit of work. It's not hard; it just takes some effort because you essentially have to narrow the amount of photos down to a small group (like the month or day you shot the photos). Then you scroll through the photos in that group until you find the individual photo you want. It sounds complicated, but it's really quite easy. Here are the most popular searching methods:

Finding Photos

From the Timeline:

The Timeline, which is a horizontal bar across the top of the Photo Browser, shows you all the photos in your catalog. Months and years are represented along the Timeline. The years are visible below the Timeline; the small light blue bars above the Timeline are individual months. If there is no bar visible, there are no photos stored in that month. A short blue bar means just a few photos were taken that month—a tall bar means lots of photos. If you hover your cursor over a blue bar, the month it represents will appear. To see the photos taken in that month, click on the bar and only those photos will be displayed in the Photo Browser window. Once you've clicked on a month, you can click-and-drag the locator bar to the right or left to display different months.

Using Tags:

If there's a particular shot of a bride and groom you're looking for, and you've tagged all your bride and groom shots with a tag named "Brides and grooms," then just click on the Tags tab and click on the empty box in the column to the left of that tag. Now only shots of brides and grooms will appear in the Photo Browser window.

Continued

By Date Ranges:

Let's say you're looking to find a particular photo you shot on last year's vacation. If you can remember approximately when you went on vacation, you can display photos taken within a certain date range (for example, all the photos taken between June 1 and June 30, 2004). Here's how: Go under the Organizer's Find menu and choose Set Date Range. This brings up a dialog where you can enter start and end dates. Click OK and only photos taken within that timeframe will be visible. Scroll through those images and see if you can find your photo.

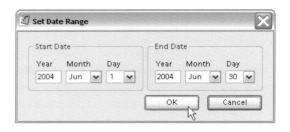

By Caption or Note:

If you've added personal notes within tags or you've added captions to individual photos, you can search those fields to help you narrow your search. Just go under the Organizer's Find menu and choose By Caption or Note. Then in the resulting dialog, enter the word that you think may appear in the photo's caption or note, and click OK. Only photos that have that word in a caption or note will appear in the Photo Browser window.

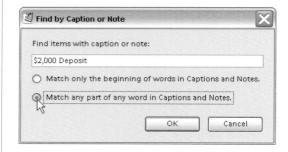

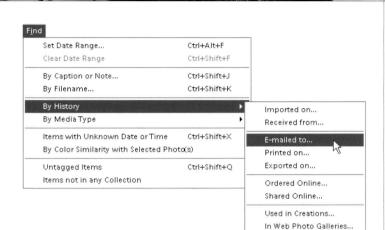

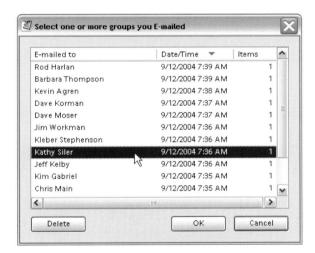

By History:

The Organizer keeps track of when you imported each photo and when you last shared it (via email, print, webpage, etc.); so if you can remember any of those dates, you're in luck. Just go under the Organizer's Find menu, under By History, and choose which attribute you want to search under in the submenu. A dialog with a list of names and dates will appear. Click on a date and name, click OK, and only photos that fit that criterion will appear in the Photo Browser window.

Finding Photos Using the Date View

Okay, I have to admit, this particular feature is probably going to be your least-used Organizer feature because it seems so...I dunno...cheesy (for lack of a better word). When you use it, you see a huge calendar, and if photos were created on a particular day in the currently visible month, you'll see a small version of one of those images on that date. Personally, when I see this view, I feel like I've just left a professional-looking application and entered a "consumer" application, so I avoid it like the plague, but just in case you dig it (hey, it's possible), here's how it works:

Step One:

To enter the Date View in the Organizer, click the Date View button at the topright side of the Organizer window.

Step Two:

This brings up the Date View calendar window with the Month view showing by default (if you're not in Month view, click the Month button along the bottom center of the window). If you see a photo on a date, it means there are photos that were taken on that day (or there are photos that you scanned and imported on that day). To see a photo, click on it within the calendar and a larger version will appear in the window at the top right of the Date View window. To see the rest of the photos on this day, press the Next Item on Selected Day button found directly under this preview window. Each time you click this button, the window displays a preview of the next photo taken on that day.

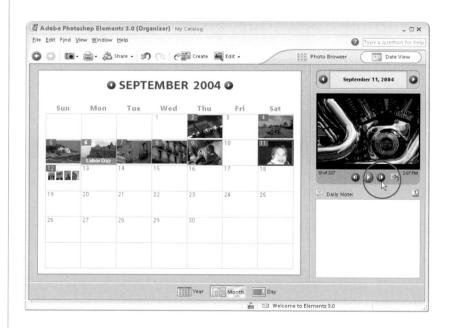

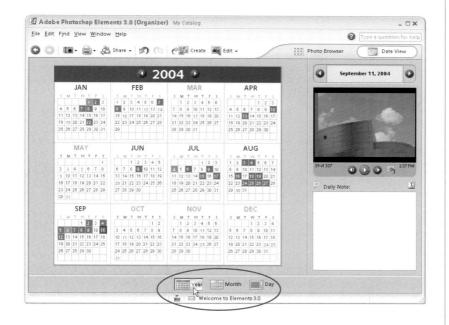

If you find the photo you're looking for (I'm assuming that if you're searching around in the Date View, you're looking for a particular photo), press the little square icon to the immediate right of the Next Item on Selected Day button. This takes you out of Date View, opens the Organizer's Photo Browser window, and jumps right to where your photo is and highlights it. Now if you want to edit that photo in Photoshop Elements 3, just press the Standard Edit button in the Organizer's Options Bar.

Step Four:

Return to the Organizer and press the Date View button again to show the Date View. While we're here, I want to show you a couple of the other features. Although the Month view is shown by default, there are buttons at the bottom of the Date View window for viewing the entire year (where days that have photos appear as solid-color blocks) or an individual day (where all the photos from that day appear in a slide-show-like window).

Step Five:

While in the Date View, you can add a Daily Note, which is a note that doesn't apply to the current photo—it applies to every photo taken on that calendar day. If you change to the Day view (by clicking the Day button at the bottom of the Date View window), fields for adding a Caption and a Daily Note to the currently displayed photo will appear along the right side of the window. Now when you're in Day view, you can not only see your caption for your photo, but you can also see the Daily Note for each photo taken on that calendar day.

Seeing an Instant Slide Show

If you want to see a quick slide show of a collection or currently selected photos in the Organizer, it's pretty much just a two-click process. Later in this book I'll show you how to create rich, full-featured slide shows using an entirely different feature of Elements 3, but for now we'll just look at how to create a quickie slide show with minimum time and effort.

Step One:

Open the Organizer and make sure the Photo Browser window is active by clicking the Photo Browser button in the top right of the Organizer. Now hold the Control key and click on each photo you want to appear in your slide show (if the photos are contiguous, you can click on the first photo, hold the Shift key, click on the last photo, and all the photos in between will be selected). Once the photos you want are selected, click on the Photo Review button (it looks like little slides) at the bottom left of the Organizer window.

Step Two:

This brings up the Photo Review dialog, which contains presentation options for your slide show. You can choose music that will play during your slide show from the Background Music pop-up menu. You can also choose how long each photo will appear onscreen. By default, it assumes you want any captions included, but you can turn that off by clicking the Include Captions checkbox, and you can also have your slide show loop when it reaches the end by clicking on the Repeat Slide Show checkbox. Now click OK to begin your slide show.

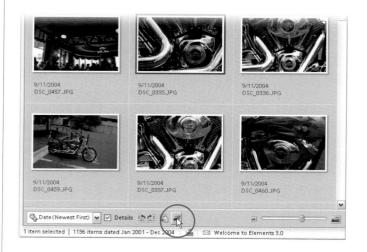

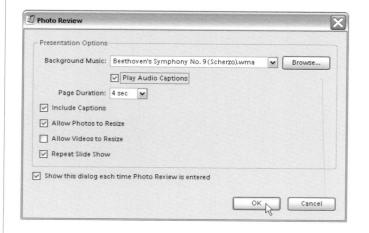

Once you click OK, you'll enter Photo Review mode, where you'll see a floating slide show Control Bar on the top-left side of your screen. Your slide show won't actually start advancing until you click the green Play button (or press the shortcut F5). To stop your slide show from advancing (to pause it), press the Play button again in the Control Bar (to resume the slide show, just press Play one more time).

Step Four:

Besides the standard Previous, Play, Next, and Stop buttons that appear in the Photo Review Control Bar, you'll also see other controls on the right. These extra controls are for comparing still images and are not for use during your slide show. To hide these other controls, click on the tiny left-facing arrow on the far-right side of the Control Bar and it will collapse down to just display the slide show controls.

Step Five:

To quit your slide show and return to the Photo Browser, press the Escape key on your keyboard or click the Stop (X) button on the Control Bar.

Comparing Photos

Let's say you've just shot a bike show, and now you're looking at 14 close-up shots of the prize-winning Harley-Davidson. The Organizer has a great feature that lets you compare two images onscreen (either side by side or one above the other) to help you narrow down your choice to the best possible photo.

Step One:

Open the Organizer and make sure the Photo Browser window is active by clicking the Photo Browser button in the top right of the Organizer. To compare (or review) photos side by side, first hold the Control key and click on all the photos you want to compare. Then press the Photo Review button at the bottom left of the Photo Browser window (or just press the F11 key on your keyboard). This brings up the Photo Review dialog, which presents options for a slide show. You can ignore those slide show options and just click OK to enter Photo Review mode, which is really a full-screen mode that can be used to compare images.

Step Two:

The photo you selected first will appear in Full Screen mode, and you'll see a floating Control Bar at the top-left side of your screen. Click on the Photo Compare button (it looks like two boxes), which puts the first and second photos you selected side by side onscreen. The first photo (on the left) has the number 1 in its upper-left-hand corner, and the second photo (the one being compared) is noted as number 2.

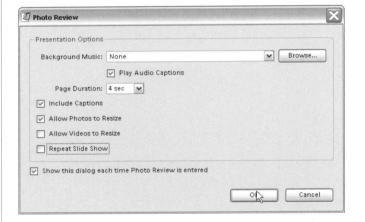

Now visually compare these two photos. You'll want the one that looks best to remain onscreen so you can compare other selected photos against it, right? To do that, click on the "bad" photo, and a blue highlight will appear around that photo, indicating that this is the one that will change. In this example, I thought the first photo looked better, so I clicked on photo number 2 (the one on the right).

Step Four:

Now go to the Control Bar, click on the Next Photo button, and the second photo will be replaced with your next photo in that series. Again, review which of these two looks the best, then click on the photo that looks worst (that way, you can replace it with another photo you want to compare). Click the Next Photo button to compare the next photo (and so on). To back up and review a previous photo, click the Previous Photo button in the Control Bar.

Step Five:

Besides this side-by-side mode, there's also an option that lets you see your photos stacked one on top of the other (which you might like for comparing photos in landscape orientation). To change to that mode, click on the down-facing arrow to the immediate right of the Photo Compare button, and from the drop-down menu that appears, choose Above and Below. Cycle through the images as you did before—just repeat Steps Three and Four until you find the photo you like best. When you're finished, press the Escape key on your keyboard or click the Stop (X) button in the Control Bar. The photo you selected will appear highlighted in the Photo Browser window.

Comparing Photos by Zooming and Panning

This isn't exactly an Organizer technique, but there's also a new way to compare photos in the Elements Editor. This is a cool feature that Elements 3 borrows from Photoshop CS—the ability to view multiple images at once (for comparison purposes)—but more importantly, to be able to view each one at the same magnification (even when changing zoom magnifications). You can scroll around (pan) to inspect images and have all the images pan at the same location and rate. This is one you need to try to really appreciate.

Step One:

Open the multiple photos you want to compare in the Editor. (In this instance, we'll compare four photos, so open four photos, which will appear in the Photo Bin at the bottom of the Elements window. The power of this feature will be more apparent if you open four similar images, like four portraits of the same person at one sitting, etc.)

Step Two:

Go under the Window menu, under Images, and choose Tile. This will put all your photos in their own separate windows, and then it will tile these four open windows across your screen so you can see all four photos at once.

Now that your photos are tiled, return to the Window menu, under Images, and choose Match Zoom. Now, press-and-hold the Shift key, press Z to switch to the Magnifying Glass tool (okay, it's called the Zoom tool, but its icon looks like a magnifying glass), and click-and-drag a selection around the eyes of the person in one of the active image windows. You'll notice that all four photos jump to the same zoom.

Step Four:

Now go under the Window menu, under Images, and choose Match Location. Press H to switch to the Hand tool (it's right under the Zoom tool in the Toolbox), press-and-hold the Shift key, then click within your image and drag to pan around your photo. If you don't hold the Shift key first, it will just pan around the front-most active window. By holding Shift, all the windows pan at the same time and speed, enabling you to compare particular areas of your photos at the same time.

Reducing Clutter by Stacking **Your Photos**

This is one of my favorite new features added in version 3, because it lets you reduce "photo clutter" and makes things more organized when working in the Photo Browser. It's called "stacking," and it lets you stack similar photos together, leaving just one photo to represent a stack of photos. So, if you took 120 shots at the rehearsal dinner, and you've already sorted the best of the bunch into a collection, you don't have to have 120 shots cluttering up your catalog. Instead, you can have just one representative photo, and underneath it are the 120 others.

Step One:

With the Photo Browser open in the Organizer, hold the Control key on your keyboard and click on all the photos you want to add to your stack (or if the images are contiguous, simply click the first image in the series, press-and-hold the Shift key, and click on the last image in the series). Once they're all selected, go under the Organizer's Edit menu, under Stack, and choose Stack Selected Photos in the submenu.

ndo Attach Tag(s) To Item(s) Redo Сору Select All Ctrl+Shift+A Deselect m Delete Selected Items from Catalog. Rotate Selected Photos 90" Left Ctrl+Left Rotate Selected Photos 90° Right Ctrl+Right Ctrl+Shift+l Auto Fix Selected Photos Edit 3GPP Movie. Auto Fix Window... Go to Quick Fix... Go to Standard Edit... Ctrl+l Adjust Date and Time of Selected Items... Ctrl+J Add Caption to Selected Items.. Ctrl+Shift+T Update Thumbnail for Selected Items Ctrl+Shift+U Set as Desktop Wallpaper Ctrl+Shift+W Stack Selected Photos Version Set Color Settings.. Contact Book... Flatten Stack Preferences Set as Top Photo

Ctrl+Z

Step Two:

No dialog appears, it just happens your 120 photos now are stacked behind the first photo you selected (think of it as 120 layers, and on each layer is a photo, stacked one on top of another). You'll know a thumbnail photo contains a stack because a Stack icon (which looks like a little blue stack of paper) will appear in the upper-righthand corner of your photo.

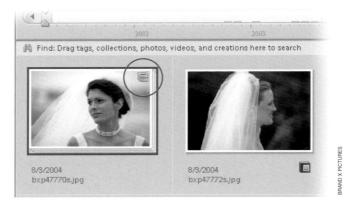

Once your photos are stacked, you can view these photos anytime by clicking the photo with the Stack icon, and then going under the Edit menu, under Stack, and choosing Reveal Photos in Stack. This is like doing a "Find," whereas all the photos in your stack will appear in a "find results" window (called the Photos in Stack window) so you can see them without unstacking them. Then return to the Photo Browser window by clicking on the Back to All Photos button in the top-left corner of the window.

Step Four:

If you do want to unstack the photos, select the photo with the Stack icon in the Photo Browser window, then go under the Edit menu, under Stack, and choose Unstack Photos. If you decide you don't want to keep any of the photos in your stack, select the photo with the Stack icon in the Photo Browser window, go back under the Edit menu, under Stack, and choose Flatten Stack. It's like flattening your layers—all that's left is that first photo. However, when you choose Flatten, you will have the choice of deleting the photos from your hard disk or not.

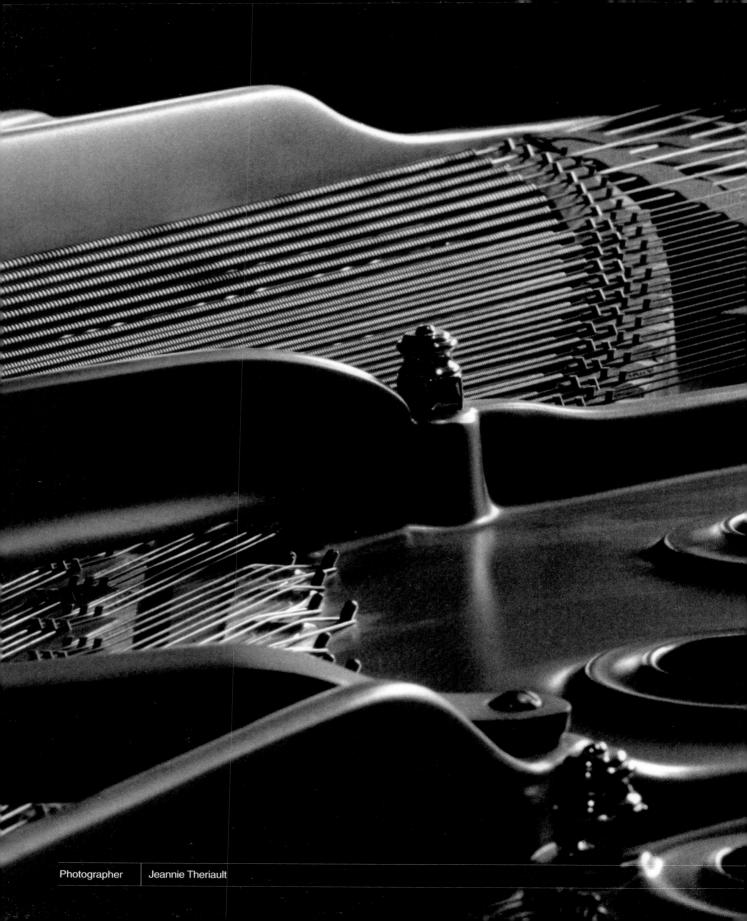

If a chapter on cropping and resizing doesn't sound exciting, really, what does? It's sad, but a good portion of our lives is spent doing just that—cropping and resizing. Why is that? It's because nothing, and

Cream of the Crop cropping and resizing

I mean nothing, is ever the right size. Think about it. If everything were already the right size, there'd be no opportunity to "Super Size it." You'd go to McDonald's, order a Value Meal, and instead of hearing, "Would you care to Super Size your order?" there would just be a long uncomfortable pause. And frankly, I'm uncomfortable enough at the McDonald's drive-thru, what with all the cropping and resizing I'm constantly doing. Anyway, although having a chapter on cropping and resizing isn't the kind of thing that sells books (though I hear books on crop circles do fairly well), both are important and necessary, especially if you ever plan on cropping or resizing things in Elements. Actually, you'll be happy to learn that there's more than just cropping and resizing in this chapter. That's right—I supersized the chapter with other cool techniques that honestly are probably a bit too cool to wind up in a chapter called "Cropping and Resizing," but it's the only place they'd fit. But don't let the extra techniques throw you; if this chapter seems too long to you, flip to the end of the chapter, rip out a few pages, and you have effectively cropped the chapter down to size. (And by ripping the pages out yourself, you have transformed what was originally a mere book into an "interactive experience," which thereby enhances the value of the book, making you feel like a pretty darn smart shopper.) See, it almost makes you want to read it now, doesn't it?

Cropping Photos

After you've sorted your images in the Organizer or File Browser, one of the first editing tasks you'll probably undertake is cropping a photo. There are a number of different ways to crop a photo in Elements. We'll start with the basic garden-variety options, and then we'll look at some ways to make the task faster and easier.

Step One:

Open the image you want to crop, and press the letter C to get the Crop tool (you could always select it directly from the Toolbox, but I only recommend doing so if you're charging by the hour).

Click within your photo and drag out a cropping border. The area to be cropped away will appear dimmed (shaded). You don't have to worry about getting your cropping border right when you first drag it out, because you can edit it by dragging the control handles that appear in each corner and at the center of each side.

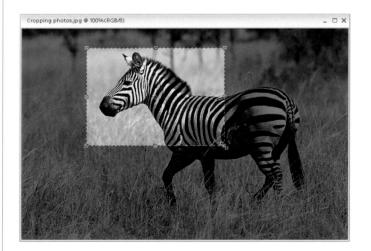

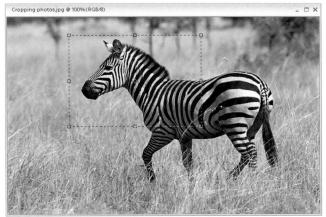

TIP: If you don't like seeing your photo with the cropped-away areas appearing shaded (as in the previous step), you can toggle this shading feature off/on by pressing the Forward Slash key (/) on your keyboard. When you press the Forward Slash key, the border remains in place but the shading is turned off.

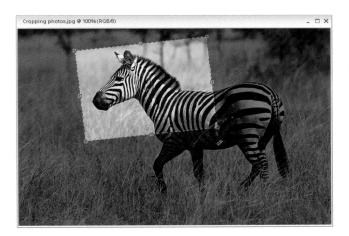

While you have the crop border in place, you can rotate the entire border. Just move your cursor outside the border, and your cursor changes into a double-headed arrow. Just click-and-drag, and the cropping border will rotate in the direction that you drag. (This is a great way to save time if you have a crooked image, because it lets you crop and rotate at the same time.)

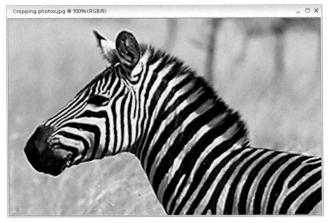

Step Four:

Once you have the cropping border where you want it, you can choose any one of the following to actually crop the image to size:

- (1) Press the Enter key
- (2) Click any other tool in the Toolbox
- (3) Click the Checkmark icon in the topright side of the Options Bar.

Continued

TIP: Changing Your Mind

If you've dragged out a cropping border and then decide you don't want to crop the image, there are two ways to cancel your crop:

- (1) Press the Escape key on your keyboard and the crop will be canceled; the photo will remain untouched.
- (2) Look in the Options Bar, and you'll see the international symbol for "No way." Click the circle with the diagonal line through it to cancel your crop.

Before

After

If you're outputting photos for clients, chances are they're going to want them in standard sizes so they can easily find frames to fit. If that's the case, here's how to crop your photos to a predetermined size (like a 5x7", 8x10", etc.).

Auto-Cropping to Standard

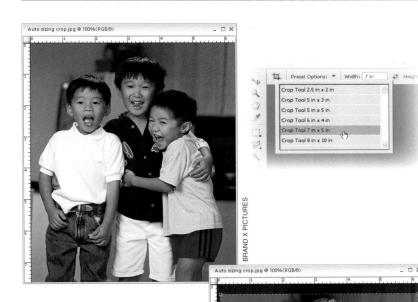

Step One:

Open an image that you want to crop to be a perfect 7x5". Press C to get the Crop tool, then go in the Options Bar and click on the arrow to the right of the words "Preset Options" and a list of preset crop sizes will appear. Click on "Crop Tool 7 in x 5 in."

Step Two:

Now click-and-drag the Crop tool over the portion of the photo that you want to be 7x5". While dragging, you can press the Spacebar to adjust the position of your border. Press the Enter key, and the area inside your cropping border will become 7x5".

Continued

Now, what if you want a 7x5" photo, but at 150 ppi or 72 ppi? Get the Crop tool, and in the Options Bar in the Resolution field, enter your desired resolution. Now crop.

Before

After

Okay, now you know how to crop to Element's built-in preset sizes, but how do you crop to a nonstandard size—a custom size that you determine? Here's how.

Cropping to an Exact Custom Size

Step One:

Open the photo that you want to crop. (I want to crop this image to 6x4" at a resolution of 150 ppi.) First, press C to get the Crop tool. In the Options Bar, you'll see fields for Width and Height. Enter the size you want for width, followed by the unit of measure you want to use (e.g., enter "in" for inches, "px" for pixels, "cm" for centimeters, "mm" for millimeters, etc.). Next, press the Tab key to jump over to the Height field and enter your desired height, again followed by the unit of measure.

lions:

Width: 6 in
| Width: 4 in | Resolution: 150 | pixel:

TIP: You can swap the figures in the Height and Width fields by clicking on the Swaps icon between the fields in the Options Bar.

Continued

Step Two:

Once you've entered these figures in the Options Bar, click within your photo with the Crop tool and drag out a cropping border. You'll notice that as you drag, the border is constrained to a 6x4" aspect ratio; no matter how large of an area you select within your image, the area within that border will become your specified size. When you release your mouse button, no side handles are visible along the border—only corner handles.

Once your cropping border is onscreen, you can resize it using the corner handles or you can reposition it by moving your cursor inside the border. Your cursor will change to a Move arrow, and you can now click-and-drag the border into place. You can also use the arrow keys on your keyboard for more precise control. When it looks right to you, press Enter to finalize your crop. (I made the rulers visible [Control-R] so you could see that the image measures exactly 6x4".)

TIP: Once you've entered a width and height in the Options Bar, those dimensions will remain there. To clear the fields, just choose the Crop tool, and up in the Options Bar, click on the Clear button. This will clear the Width and Height fields, and now you can use the Crop tool for freeform cropping (you can drag it in any direction—it's no longer constrained to your specified size).

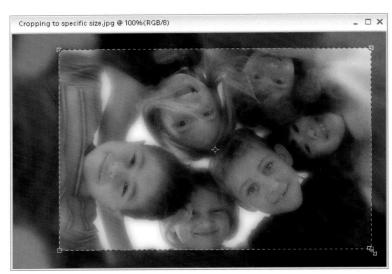

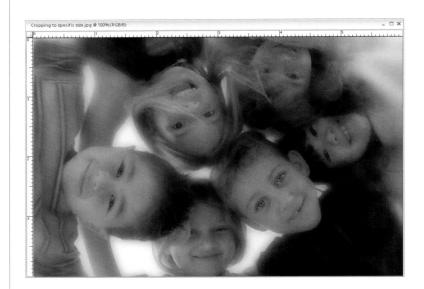

COOLER TIP: If you already have one photo that's the exact size and resolution you want, you can use its dimensions for cropping another photo. First, open the photo you'd like to resize, then open your "ideal-size-and-resolution" photo. Get the Crop tool, then in the Options Bar click on the Front Image button. Photoshop will automatically input that photo's specifications in the Width, Height, and Resolution fields—all you have to do is switch to the image you want to resize, click-and-drag with the Crop tool, press Enter, and this image will share the exact same specs as the other image.

After

Cropping into a Shape

Elements version 3.0 added a cool new feature that lets you crop your photo into a pre-designed shape. Technically, you could do this back in version 2.0, but it was a bit tedious; you had to draw the shape, and it didn't give you the ease and flexibility that this new "cookie cutter" method does.

Step One:

In Elements, open the photo you want to crop into a pre-designed shape, and press the letter Q to get the Cookie Cutter tool.

Step Two:

Now, go up to the Options Bar and click on the down-facing arrow to the right of the word "Shape." This brings up the Custom Shape Picker, which contains the default set of 30 shapes. To load more shapes, click on the right-facing arrow at the top right of the Picker and a list of built-in shape sets will appear. Click on any one to load them, or load them all by choosing All Elements Shapes in the menu.

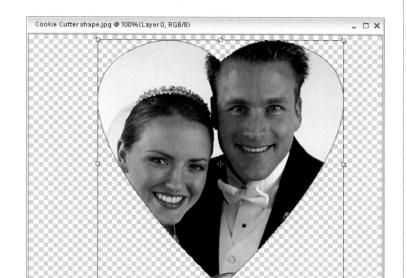

Once you find the custom shape you want to use, just click-and-drag it over your image to the size you want it. When you release the mouse button, your photo is cropped to fit within the shape.

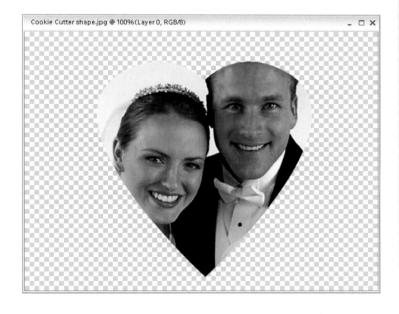

Step Four:

You'll see a bounding box around the shape, which you can use to resize, rotate, or otherwise mess with your shape. To resize your shape, hold the Shift key to keep it proportional while you drag a corner point. To rotate the shape, move your cursor outside the bounding box until your cursor becomes a double-sided arrow, and then click-and-drag. As long as you see that bounding box, you can still edit the shape. When it looks good to you, press Enter and the parts of your photo outside that shape will be permanently cropped away.

TIP: If you want your image area cropped down tight, so it's the exact size of your shape, just turn on the Cookie Cutter's Crop checkbox (up in the Options Bars) before you drag out your shape. Then when you press Enter to lock in your final shape, size, and location, Elements will tightly crop the image area to the shape.

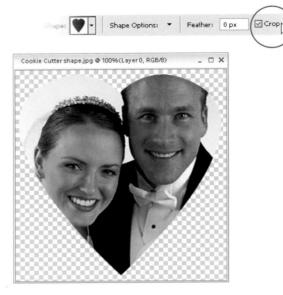

After

A lot of photographers scan photos using a technique called "gang scanning." That's a fancy name for scanning more than one picture at a time. Scanning three or four photos at once with your scanner saves time, but then you eventually have to separate these photos into individual documents. Here's how to have Elements 3 do that for you automatically.

Auto-Cropping Gang-Scanned Photos

Step One:

Place the photos you want to "gang scan" on the bed of your flatbed scanner, and scan the images into Elements using the Organizer (they'll appear in one Elements document). You can access the scanned images by clicking on the Get Photos button in the Organizer's Options Bar. Choose From Scanner in the submenu, and in the dialog that appears, select where and at what quality you want to save your scanned image.

Step Two:

Go under the Image menu and choose Divide Scanned Photos. It will immediately find the edges of the scanned photos, straighten them if necessary, and then put each photo into its own separate document. Once it has "done its thing," you can close the original gang-scanned document, and you'll be left with just the individual documents.

Cropping without the Crop Tool

Sometimes it's quicker to crop your photo using some of Elements' other tools and features than it is to reach for the Crop tool every time you need a simple crop. This is the method I probably use the most for cropping images of all kinds (primarily when I'm not trying to make a perfect 5x7", 8x10", etc.—I'm basically just "eyeing" it).

Step One:

Start by opening a photo you need to crop and press M to get the Rectangular Marquee tool from the Toolbox. (I use this tool so much that I usually don't have to switch to it—maybe that's why I use this method all the time.) Drag out a selection around the area you want to keep (leaving all the other areas outside the selection that you want cropped away).

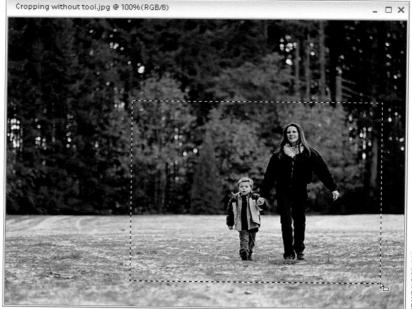

HAND A PICTURE

Step Two:

Choose Crop from the Image menu.

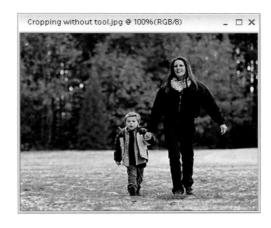

Step Three:

When you choose Crop, the image is immediately cropped. There are no crop handles, no dialogs—bang—it just gets cropped—down and dirty, and that's why I like it. Just press Control-D to deselect.

TIP: One instance of where you'll often use the Crop command from the Image menu is when you're creating collages. When you drag photos from other documents onto your main document and position them within your collage, any parts of the images that extend beyond the document borders are actually still there. So to keep your file size manageable, choose All from the Select menu or press Control-A, then choose Crop from the Image menu. This deletes all the excess layer data that extends beyond the image border and brings your file size back in line. To deselect, press Control-D.

Continued

After

Before

I know the heading for this technique doesn't make much sense—"Using the Crop Tool to Add More Canvas Area." How can the Crop tool (which is designed to crop photos to smaller sizes) actually make the canvas area (white space) around your photo larger? That's what I'm going to show you.

Using the Crop Tool to Add More Canvas Area

Step One:

Open the image to which you want to add additional blank canvas area. Press the letter D to set your Background color to its default white.

Step Two:

If you're in Maximize Mode, press Control-Minus to zoom out a bit (so your image doesn't take up your whole screen). If you're not in Maximize Mode, click-and-drag out the bottom corner of the document window to see the gray desktop area around your image. (To enter Maximize Mode, click the Maximize button in the top-right corner of the image window, which automatically changes the viewing mode to Maximize Mode.)

Continued

Press the letter C to switch to the Crop tool and drag out a cropping border to any random size (it doesn't matter how big or little it is at this point).

Step Four:

Now, grab any one of the side or corner points and drag outside the image area, out into the gray area that surrounds your image. The cropping border extending outside the image is the area that will be added as white canvas space, so position it where you want to add the blank canvas space.

Step Five:

Now, just press the Enter key to finalize your crop, and when you do, the area outside your image will become white canvas area.

If you hold your digital camera by hand for most of your shots rather than using a tripod, you can be sure that some of your photos are going to come out a bit crooked. Well, I have good news and bad news. First, the good news: Elements has a built-in function for straightening crooked images. Now, the bad news: It doesn't always work. That's why I included a pretty slick workaround for when the auto-straighten function doesn't work.

Straightening Crooked Photos

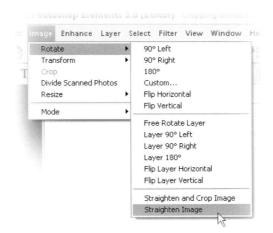

Automated Straightening Step One (The Only One):

Open the photo that needs straightening. To use Elements' automated straightening (which works fairly well in many cases), simply go under the Image menu, under Rotate, and choose Straighten Image. If it can find a straight edge, it'll straighten your image (well, most of the time). *Note:* Oftentimes when the image is rotated, you'll see white canvas area around the image, so if you want to straighten and crop at the same time, choose (do I even have to say it?) Rotate and select Straighten and Crop Image from the Image menu. That does it (there is no Step Two).

Manual Straightening

Step One:

Open the photo that needs straightening. Go under the Window menu and choose Info to bring up the Info palette.

Continued

Step Two:

Next choose the Line tool from Element's Toolbox. (It's in the Custom Shape tool's flyout menu just below the Gradient tool. You can press Shift-U to cycle through the Custom Shape tools until you get the Line tool.)

Step Three:

Find a straight edge in your photo that is supposed to be horizontal (such as the horizon, a table, a window, etc.—anything that you think should be horizontal). Click-and-drag the Line tool along this straight edge in your photo, starting from the left and extending right, but don't let go of the mouse button (that's important).

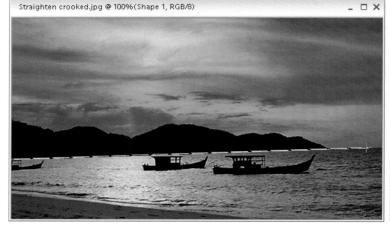

Step Four:

While you're still holding down the mouse button, look over on the right side of the Info palette, and third from the top is the letter "A" representing "Angle." Look at the amount and remember that number. Now you can release the mouse button.

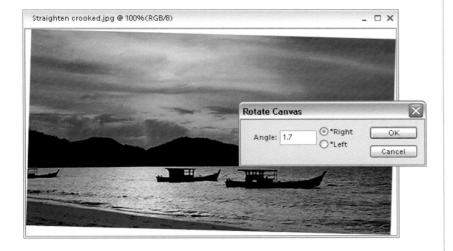

Step Five:

Using the Line tool in this fashion creates a Shape Layer, so press Control-Z to undo this layer (it's no longer needed). Next, go under the Image menu, under Rotate, and choose Custom to bring up the Rotate Canvas dialog. Remember that angle you were supposed to remember? That goes in the Angle field in this dialog. You also have to click on the radio button for whether it should rotate to the Right or Left, then click OK and whammo! (whammo! being a technical term); your image is straightened. Note: If the rotation leaves white space near the image's corners, you can crop your image with the Crop tool (C). Click-and-drag the tool avoiding the white space and press Enter to finalize the crop.

Using a Visible Grid for Straightening Photos

Here's another popular technique for straightening photos that works particularly well when you're having trouble finding a straight edge within your image.

Step One:

Open a photo that needs straightening. Go under the View menu and choose Grid. Elements will put a non-printing grid over your entire photo. Go under the Window menu, under Images, and choose Maximize Mode. Then make sure you're zoomed out enough (press Control-Minus a couple of times) so that the gray canvas area around your photo is visible.

Step Two:

Press Control-A to select the entire photo, and then press Control-T to bring up the Free Transform bounding box around your photo. Move your cursor outside the bounding box and click-and-drag upward or downward to rotate your image (using the onscreen grid as a guide to align your image). If one of the horizontal grid lines isn't close enough to a part of your image that's supposed to be horizontal, just move your cursor inside the bounding box and use the Up or Down Arrow key on your keyboard to nudge your photo up or down until that part reaches a grid line.

TIP: If you want more control of your rotation (and this is particularly helpful when you're trying to align to a grid, rather than just "eyeing it"), try this: While you have Free Transform in place, go to the Options Bar and click once inside the Rotate field. Then use either the Up or Down Arrow key on your keyboard, which will rotate your photo in 1/10° increments, giving you maximum control.

Step Three:

When you've finished straightening your photo, press Enter to lock in your transformation. Then, go back under the View menu and choose Grid to remove the grid. Once you remove the grid, you'll notice that there are white canvas areas visible in the corners of your image, so you'll have to crop the image to hide these from view.

Step Four:

Press the letter C to switch to the Crop tool, then drag out a cropping border that will crop your image so that none of the white corners are showing. When your cropping border is in place, press Enter.

Resizing Digital Camera Photos

If you're more familiar with resizing scanned images, you'll find that resizing images from digital cameras is a bit different, primarily because scanners create high-resolution scans (usually 300 ppi or more), but the default setting for most digital cameras usually produces an image that is large in physical dimension, but lower in ppi (usually 72 ppi). The trick is to decrease the physical size of your digital camera image (and increase its resolution) without losing any quality in your photo. Here's the trick:

Step One:

Open the digital camera image that you want to resize. Press Control-R to make Elements' rulers visible. Check out the rulers to see the approximate dimensions of your image. As you can see from the rulers in the example here, this photo is around 13x9".

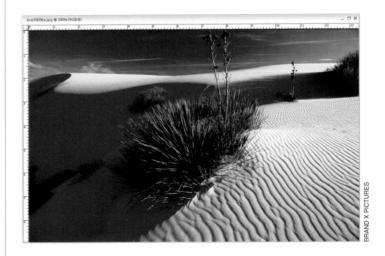

Step Two:

Go under the Image menu, under Resize, and choose Image Size to bring up the Image Size dialog. Under the Document Size section, the Resolution setting is 72 pixels/inch (ppi). A resolution of 72 ppi is considered "low resolution" and is ideal for photos that will only be viewed onscreen (such as Web graphics, slide shows, etc.). This res is too low to get high-quality results from a color inkjet printer, color laser printer, or for use on a printing press.

If we plan to output this photo to any printing device, it's pretty clear that we'll need to increase the resolution to get good results. I wish we could just type in the resolution we'd like it to be in the Resolution field (such as 200 or 300 ppi), but unfortunately, this "resampling" makes our low-res photo appear soft (blurry) and pixelated. That's why we need to turn off the Resample Image checkbox (it's on by default). That way, when we type in the setting that we need in the Resolution field, Elements automatically adjusts the Width and Height of the image in the exact same proportion. As your Width and Height decrease (with Resample Image turned off), your resolution increases. Best of all, there's absolutely no loss of quality. Pretty cool!

Step Four:

Here I've turned off Resample Image, then I typed 150 in the Resolution field (for output to a color inkjet printer—I know, you probably think you need a lot more resolution, but you usually don't). At a resolution of only 150 ppi, I can actually print a photo that is 6 inches wide by almost 4 inches high.

Step Five:

Here's the Image Size dialog for my source photo, and this time I've increased the Resolution setting to 212 dpi (for output to a printing press. Again, you don't need nearly as much resolution as you'd think). As you can see, the Width and Height fields for my image have changed.

Step Six:

When you click OK, you won't see the image window change at all—it will appear at the exact same size onscreen. But now look at the rulers—you can see that your image's dimensions have changed.

Resizing using this technique does three big things: (1) It gets your physical dimensions down to size (the photo now fits on an 8x10" sheet); (2) it increases the resolution enough so you can even output this image on a printing press; and (3) you haven't softened or pixelated the image in any way—the quality remains the same—all because you turned off Resample Image. Note: Do not turn off Resample Image for images that you scan on a scanner—they start as high-res images in the first place. Turning off Resample Image is only for photos taken with a digital camera.

What happens if you drag a large photo onto a smaller photo in Elements? (This happens all the time, especially if you're collaging or combining two or more photos.) You have to resize the photo using Free Transform, right? Right.

But here's the catch—when you bring up Free Transform, at least two (or more likely all four) of the handles that you need to resize the image are out of reach. You see the center point, but not the handles you need to reach to resize. Here's how to get around that hurdle quickly and easily.

Resizing and How to Reach Those Hidden Free Transform Handles

Open two photos. Use the Move tool (V) to drag-and-drop one photo on top of the other (if you're in Maximize Mode, drag one image onto the other image's thumbnail in the Photo Bin). To resize a photo on a layer, press Control-T to bring up the Free Transform command. Next, hold the Shift key (to constrain your proportions), grab one of the Free Transform corner points, and (a) drag inward to shrink the photo, or (b) drag outward to increase its size (not more than 20%, to keep from making the photo look soft and pixelated). But wait, there's a problem. The problem is—you can't even see the Free Transform handles in this image.

Step Two:

To instantly have full access to all of Free Transform's handles, just press Control-0 (zero) and Elements will instantly zoom out of your document window and surround your photo with gray desktop, making every handle well within reach. Try it once, and you'll use this trick again and again. *Note:* You must choose Free Transform first for this trick to work.

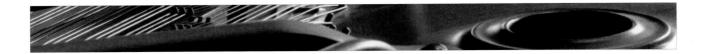

The Cool Trick for Turning Small Photos into Poster-Sized Prints

Generally speaking, shrinking the physical dimensions of a photo does not create a quality problem—you can make an 8x10" into a 4x5" with little visible loss of quality. It's increasing the size of an image where you run into problems (the photo often gets visibly blurry, softer, and even pixelated). However, digital photography guru (and *Photoshop User* columnist) Jim DiVitale showed me a trick he swears by that lets you increase your digital camera images up to full poster size, with hardly any visible loss of quality to the naked eye, and I tell ya, it'll make a believer out of you.

Step One:

Open the digital camera image you want to increase to poster size, even if its resolution is set at 72 ppi.

AND X PICTURES

Step Two:

Go under the Image menu, under Resize, and choose Image Size. When the Image Size dialog appears, make sure Resample Image is turned on. Switch the unit of measure pop-up menus in the dialog from Inches to Percent and type in 110 in both the Width and Height fields, which will increase your image by 10%. Believe it or not, when you increase in 10% increments, for some reason it doesn't seem to soften (blur) the image. It's freaky, I know, but to believe it, you just have to try it yourself.

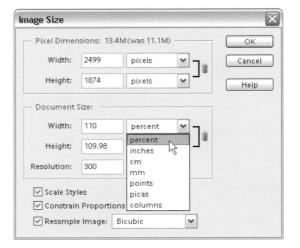

To get this image up to poster size, it's going to take quite a few passes with this "increase-by-10%" technique, so make sure you've got a comfy chair before you start. But if you need to make your prints big, and keep as much clarity and definition as possible, it's worth the extra effort.

Look at the final image onscreen and show the rulers by pressing Control-R. The loss of quality is almost negligible, yet the image is almost the size of a standard, full-size poster. I had to increase the size by 10% about 12 times to get it up in size. Thanks to Jimmy D for sharing this amazing, yet deceptively simple technique with us. Jim rocks!

Okay, did you catch that reference to the band The Fixx in the title? You did? Great. That means that you're at least in your mid-thirties to early forties. (I myself am only in my mid- to early twenties, but I listen to

The Big Fixx digital camera image problems

oldies stations just to keep in touch with baby boomers and other people who at one time or another tried to break-dance.) Well, the Fixx had a big hit in the early '80s (around the time I was born) called "One Thing Leads to Another" and that's a totally appropriate title for this chapter because one thing (using a digital camera) leads to another (having to deal with things like digital noise, color aliasing, and other nasties that pop up when you've finally kicked the film habit and gone totally digital). Admittedly, some of the problems we bring upon ourselves (like leaving the lens cap on; or forgetting to bring our camera to the shoot, where the shoot is, who hired us, or what day it is; or we immersed our flash into a tub of Jell-O, you know—the standard stuff). And other things are problems caused by the hardware itself (the slave won't fire when it's submerged in Jell-O, you got some Camembert on the lens, etc.). Whatever the problem, and regardless of whose fault it is, problems are going to happen, and you're going to need to fix them in Elements. Some of the fixes are easy, like running the "Remove Camembert" filter, and then changing the blend mode to Fromage. Others will have you jumping through some major Elements hoops, but fear not, the problems you'll most likely run into are all covered here in a step-by-step format that will have you wiping cold congealed gelatin off your flash unit faster than you can say, "How can Scott possibly be in his mid-twenties?"

Compensating for "Too Much Flash" or Overexposure

Don't ya hate it when you open a photo and realize that either (a) the flash fired when it shouldn't have; (b) you were too close to the subject to use the flash and they're totally "blown out"; or (c) you're simply not qualified to use a flash at all, and your flash unit should be forcibly taken from you, even if that means ripping it from the camera body? Here's a quick fix to get your photo back from the "flash graveyard" while keeping your reputation, and camera parts, intact.

Step One:

Open the photo that is suffering from "flashaphobia," meaning the entire subject is washed out. Make a copy of the photo by dragging-and-dropping your Background layer on the Create a New Layer icon at the top of the Layers palette. This will create a layer titled "Background copy."

Step Two:

Next, change the layer blend mode of the Background copy from Normal to Multiply from the pop-up menu at the top of the Layers palette. This blend mode has a "multiplier" effect and brings back a lot of the original detail the flash "blew out."

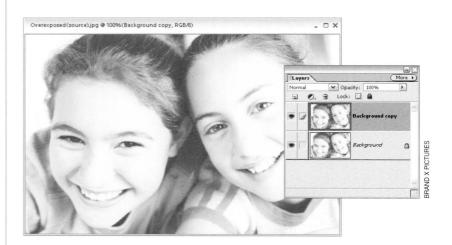

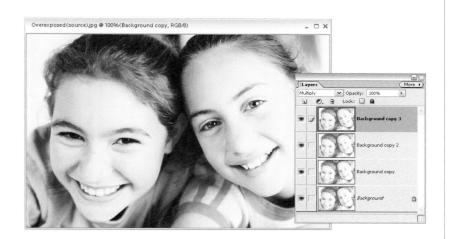

If the photo still looks washed out, you may need to make a duplicate of the Background copy layer a few times. Just drag-and-drop it to the Create a New Layer icon at the top of the Layers palette. These additional copies of the Background layer copy will already be in Multiply mode.

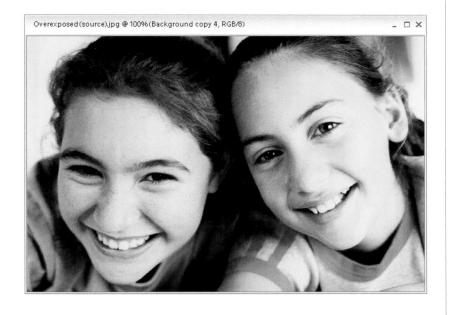

TIP: Incidentally, because of the immutable laws of life, chances are that creating one layer with its blend mode set to Multiply won't be enough, but adding another layer (in Multiply mode) will be "too much." If that's the case, just go to the Layers palette and lower the Opacity setting of the top layer to 50% or less—this way, you can "dial in" just the right amount of flash.

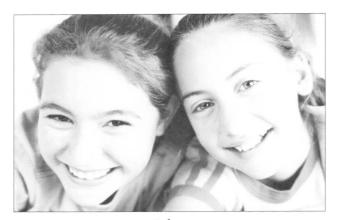

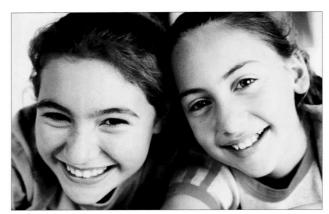

Before

After

If you're shooting in a low-lighting situation or shooting with a high ISO, chances are you're going to get some amount of "digital noise" (also referred to as "color aliasing"). You generally can't remove all this noise, but you usually can reduce it—and Elements 3 has a new feature to help you do just that. However, remember this is one of those "the-cheaper-the-digital-camera-the-more-noise-it-creates" situations, so if you're shooting with an "el cheapo" digital camera, this is a technique you'll be using a lot.

Removing Digital Noise (Method #1)

Step One:

Open the photo that was taken in low lighting or using a high ISO setting and that has visible digital noise. This noise will be most obvious when viewed at a magnification of 100% or higher. *Note:* If you view your photos at smaller sizes, you may not notice the noise until you make your prints.

Step Two:

Go under the Filter menu, under Noise, and choose Reduce Noise. The default settings really aren't too bad, but if you're having a lot of color aliasing (dots or splotchy areas of red, green, and blue), drag the Reduce Color Noise slider to the right (try 25% and see how that works).

Continued

One thing to watch out for when using this filter is that although it can reduce noise, it can also make your photo a bit blurry, and the higher the Strength setting and the higher the amount of Color Noise Reduction, the blurrier your photo will become. If the noise is really bad, you may prefer a bit of blur to an incredibly noisy photo, so you'll have to make the call as to how much blurring is acceptable, but to soften the noise a bit, drag the Preserve Details slider to the right.

TIP: To see an instant before/after of the Reduce Noise filter's effect on your photo without clicking the OK button, click your cursor within the Reduce Noise's preview window. When you click-and-hold within that window, you'll see the before version without the filter. When you release the mouse, you'll see how the photo will look if you click the OK button.

Before

After

Removing Digital Noise (Method #2)

If Elements 3's built-in noise reduction feature doesn't give you the results you're looking for, you can try this quick trick I learned from Jim DiVitale and Kevin Ames. It does a good job of reducing noise, in particular those nasty red, green, and blue little dots that often appear in digital photos shot in low-lighting situations. This technique won't remove all the noise, but it will remove the red, green, and blue color from the noise so it will appear much less prevalent in the photo.

Step One:

Open the photo that has visible digital noise. Make a copy of the Background layer by dragging it to the Create a New Layer icon at the top of the Layers palette. This will create a layer titled "Background copy."

Step Two:

Go under the Filter menu, under Blur, and choose Gaussian Blur. Drag the Radius slider all the way to the left, then start dragging to the right until the digital noise is blurred enough that you can't see it (of course, the rest of the photo will look mighty blurry too, but don't sweat that, just blur it until the digital noise goes away, even if the photo gets very blurry). Click OK to apply the blur.

Go to the Layers palette and change the blend mode of this layer from Normal to Color.

Step Four:

Changing the layer blend mode to Color removes the visible blurring, but at the same time, it removes the red, green, and blue color from the noise, leaving you with a much cleaner-looking photo. Remember, this technique does not remove all the noise that your camera introduced. Instead, it removes the color from the noise, which makes the overall amount of noise less visible to the eye.

Before

After

If you have a problem with your photo, there's a pretty good chance it's in the shadow areas. Either you shot the photo with the light source behind the subject, or the lighting in the room put part of the subject in the shadows, or...well...you just messed up (hey, it happens). Luckily, you can open up just the shadows by moving one simple slider. Of course, you have to know where to look.

Opening Up Shadow Areas That Are Too Dark

Step One:

Open the photo that needs to have its shadow areas opened up to reveal detail that was "lost in the shadows."

Step Two:

Go under the Enhance menu, under Adjust Lighting, and choose Shadows/ Highlights. When the dialog appears, it already assumes you have a shadow problem (sadly, most people do but never admit it), so it automatically opens up the shadow areas in your document by 50% (you'll see that the Lighten Shadows slider is at 50% by default [0% is no lightening of the shadows]). If you want to open the shadow areas even more, drag the Lighten Shadows slider to the right. If the shadows appear to be opened too much with the default 50% increase, drag the slider to the left to a setting below 50%. When the shadows look right, click OK. Your repair is complete.

After

116

Although most of the lighting problems you'll encounter are in the shadow areas of your photo, you'll be surprised how many times there's an area that is too bright (perhaps an area that's lit with harsh, direct sunlight, or you exposed for the foreground but the background is now overexposed). Luckily, this is now an easy fix, too!

Fixing Areas That Are Too Bright

Step One:

Open the photo that has highlights that you want to tone down a bit. *Note*: If it's an individual area (like the sun shining directly on your subject's hair), you'll want to press the L key to switch to the Lasso tool and put a loose selection around that area. Then go under the Select menu and choose Feather. For low-res, 72-ppi images, enter 2 pixels and click OK. For high-res, 300-ppi images, try 8 pixels.

Step Two:

Now go under the Enhance menu, under Adjust Lighting, and choose Shadows/ Highlights. When the dialog appears, drag the Lighten Shadows slider to 0% and drag the Darken Highlights slider to the right, and as you do, the highlights will decrease, bringing back detail and balancing the overall tone of your selected highlights with the rest of your photo. Sometimes when you make adjustments to the highlights (or shadows), you can lose some of the contrast in the midtone areas (they can become muddy or flat looking, or they can become oversaturated). If that happens, drag the Midtone Contrast slider (at the bottom of the dialog) to the right to increase the amount of midtone contrast, or drag to the left to reduce it. Then click OK. Note: you'll need to press Control-D to deselect when you're finished.

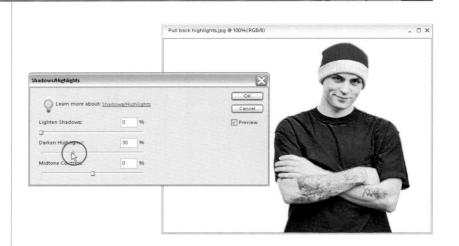

After

There's a natural tendency for some photographers to react to their immediate surroundings, rather than what they see through the lens. For example, at an indoor concert, there are often hundreds of lights illuminating the stage. However, some photographers think it's one light short—their flash—because where they're sitting, it's dark. When they look at their photos later, they see that the flash lit everyone in front of them (which wasn't the way it really looked—the crowd is usually in the dark), ruining an otherwise great shot. Here's a quick fix to make it look as if the flash never fired at all.

Fixing Photos Where You Wish You Hadn't Used the Flash

Step One:

Open a photo where shooting with the flash has ruined part of the image.

Step Two:

Press the letter L to get the Lasso tool, and draw a loose selection around the area where the flash affected the shot.

Step Three:

In the next step, we're going to adjust the tonal range of this selected area, but we don't want that adjustment to appear obvious. We'll need to soften the edges of our selection quite a bit so our adjustment blends in smoothly with the rest of the photo. To do this, go under the Select menu and choose Feather. When the Feather Selection dialog appears, enter 25 pixels to soften the selection edge. (By the way, 25 pixels is just my guess for how much the selection might need. The rule of thumb is the higher the resolution of the image, the more feathering you'll need, so don't be afraid to use more than 25 if your edge is visible when you finish.) Click OK.

Step Four:

It will help you make a better adjustment if you hide the selection border (I call it "the marching ants") from view. We don't want to deselect—we want our selection to remain intact—but we don't want to see the annoying border, so press Control-H to hide the selection border. Now, press Control-L to bring up the Levels dialog. At the bottom of the dialog, drag the right Output Levels slider to the left to darken your selected area. Because you've hidden the selection border, it should be very easy to match the selected area to its surroundings when you drag this slider to the left.

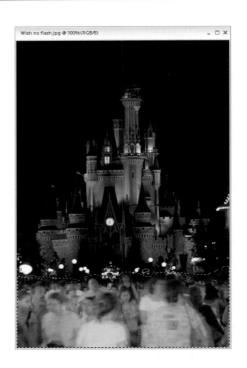

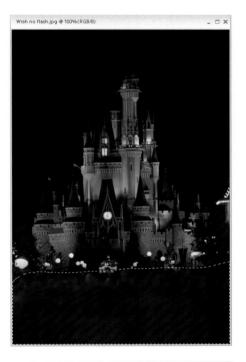

Step Five:

When the photo looks about right, click OK to apply your Levels adjustment. Then, press Control-H to make your selection visible again (this trips up a lot of people who, since they don't see the selection anymore, forget it's there, and then nothing reacts as it should from that point on).

Step Six:

Press Control-D to deselect and view your repaired "flash-free" photo.

Before

After

This is a tonal correction for people who don't like making tonal corrections (more than 60 million Americans suffer from the paralyzing fear of MTC [Making Tonal Corrections]). Since this technique requires no knowledge of tonal corrections (like using Levels), it's very popular; and even though it's incredibly simple to perform, it does a pretty incredible job of fixing underexposed photos.

Fixing Underexposed Photos

Step One:

Open an underexposed photo that could've used either a fill flash or a better exposure setting.

Step Two:

Make a copy of the Background layer by dragging it to the Create a New Layer icon at the top of the Layers palette. This will create a layer titled "Background copy." In the Layers palette, change the blend mode of this new layer from Normal to Screen to lighten the entire photo.

Continued

If the photo still isn't properly exposed, drag this Screen layer to the Create a New Layer icon at the top of the Layers palette to duplicate it, and keep duplicating it until the exposure looks about right (this may take a few layers, but don't be shy about it—keep going until it looks good).

Step Four:

There's a good chance that at some point you'll duplicate the Screen layer again and the image will look overexposed. What you need is "half a layer." Half as much lightening. Here's what to do: Lower the Opacity of your top layer to "dial in" the perfect amount of light, giving you something between the full intensity of the layer (at 100%) and no layer at all (at 0%). For half the intensity, try 50% (did I really even have to say that last line? Didn't think so). Once the photo looks properly exposed, click the "More" arrow at the top right of the Layers palette to access the palette's flyout menu, and choose Flatten Image.

After

When You Forget to Use Fill Flash

Wouldn't it be great if Elements had a "Fill Flash" brush, so when you forgot to use your fill flash, you could just paint it in? Well, although it's not technically called the Fill Flash brush, you can use a brush to achieve the same effect. I predict you'll like this technique. Hey, it's just a prediction.

Step One:

Open a photo where the subject of the image appears too dark. Make a copy of the Background layer by dragging it to the Create a New Layer icon at the top of the Layers palette. This will create a layer titled "Background copy."

Step Two:

Go under the Enhance menu, under Adjust Lighting, and choose Levels. Drag the middle Input Levels slider (the gray one) to the left until your subject looks properly exposed. (*Note*: Don't worry about how the background looks—it will probably become completely "blown out" but you'll fix that later; for now, just focus on making your subject look right.) If the midtones slider doesn't bring out the subject enough, you may have to increase the highlights as well, so drag the far-right Input Levels slider to the left to increase the highlights. When your subject looks properly exposed, click OK.

Step Three:

Hold the Control key and click on the Create a New Layer icon at the top of the Layers palette. This creates a new blank layer beneath your duplicate layer. In the Layers palette, click on the top layer (your duplicate of the Background layer), then press Control-G to group this photo layer with the blank layer beneath it. This removes the brightening of the photo from Step Two.

Step Four:

In the Layers palette, click on the blank layer beneath your grouped, top layer. Press B to switch to the Brush tool and click the Brush Preset icon in the Options Bar to open the Brush Picker, where you'll choose a soft-edged brush. Press D to set black as your Foreground color, and then begin to paint (on this blank layer) over the areas of the image that need a fill flash with your newly created "Fill Flash" brush. The areas you paint over will appear lighter, because you're "painting in" the lighter version of your image on this layer.

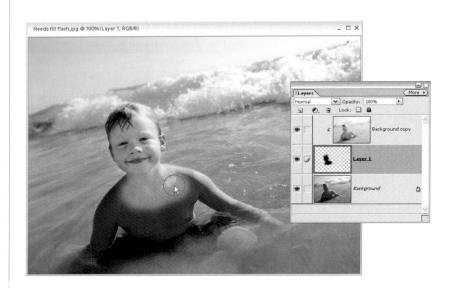

Step Five:

Continue painting until it looks as if you had used a fill flash. If the effect appears too intense, just lower the Opacity of the layer you're painting on by dragging the Opacity slider to the left in the Layers palette.

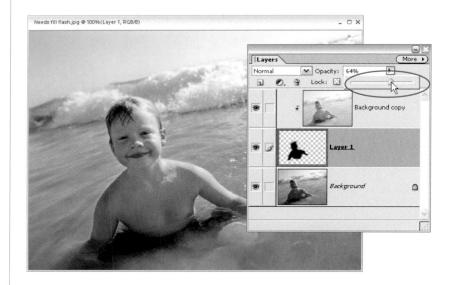

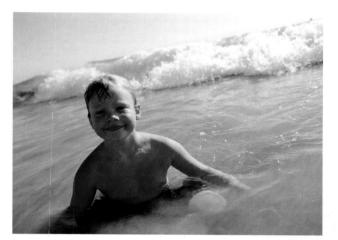

Before After

Instant Red-Eye Removal

When I see a digital camera with the flash mounted directly above the lens, I think, "Hey, there's an automated red-eye machine." In studio situations, you don't have to deal with this as much, because your flash probably wouldn't be mounted directly above your lens—you're using bounce flash, holding the flash separately, you've got studio strobes, or are employing one of a dozen other techniques. Elements has had instant red-eye removal for a while now, but the red-eye removal in version 3.0 gives significantly better results.

Step One:

Open a photo where the subject has red eye. Press Z to switch to the Zoom tool (it looks like a magnifying glass in the Toolbox) and drag out a selection around the eyes (this zooms you in on the eyes).

Step Two:

Now, press the letter Y to switch to the Red Eye Removal tool (its Toolbox icon looks like an eye with a tiny crosshair cursor in the left corner). There are two different ways to use this tool: click or click-and-drag. We'll start with the most precise: which is click. Take the Red Eye Removal tool and click it once directly on the red area of the pupil. It will isolate the red in the pupil and replace it with a neutral color. Instead, now you have "gray" eye, which doesn't look spectacular, but it's a heck of a lot better than red eye.

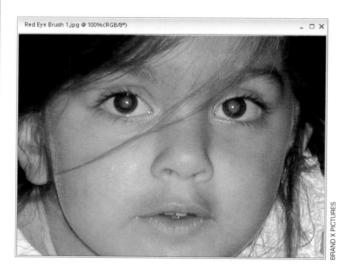

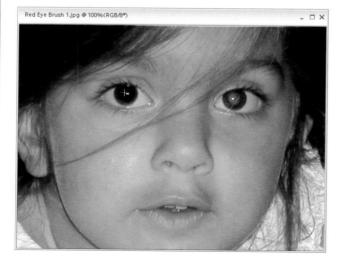

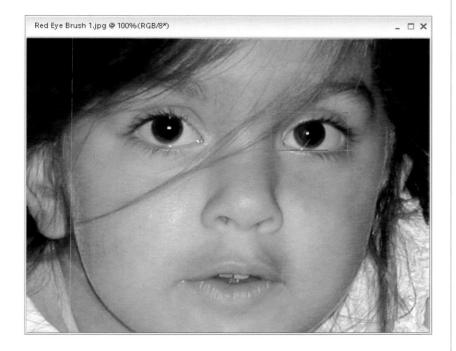

Step Three:

If the gray color that replaces the red seems too "gray," you can adjust the darkness of the replacement color by going to the Options Bar and increasing the Darken Amount.

Step Four:

To get better results, you may have to adjust the Pupil Size setting so that the area affected by the tool matches the size of the pupil. This is also done in the Options Bar when you have the Red Eye Removal tool selected. Now, on to the other way to use this tool (for really quick red-eye fixes).

Step Five:

If you have a lot of photos to fix, you may opt for this quicker red-eye fix—just click-and-drag the Red Eye Removal tool over the eye area (putting a square selection around the entire eye). The tool will determine where the red eye is within your selected area, and it removes it. Use this "drag" method on one eye at a time for the best results.

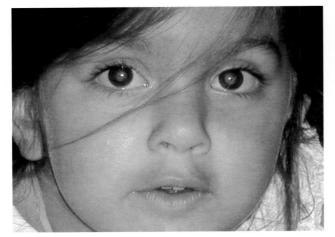

Before

After

This technique is a little more complicated (not hard, it just has a few more steps) but the result is more professional. After you remove the red eye and replace it with the more pleasing "gray eye" (like in the previous "Instant Red-Eye Removal" trick), you're going to restore the eye to its original color.

Removing Red Eye and Recoloring the Eye

Red eye recolor(source),jpg @ 300%(RGB/9*)

Step One:Open a photo where the subject has red eye.

Step Two:

Zoom in close on one of the eyes using the Zoom tool (the magnifying glass, which you access by pressing the Z key). Use the technique shown on the previous pages, which removes the red eye and replaces it with "gray eye." *Note*: You might not want to do this late at night if you're home alone, because seeing a huge, scary eye on your screen can really give you the willies.

Continued

Step Three:

Press the L key to switch to the Lasso tool, and draw a very loose selection around one entire eye. The key word here is loose—stay well outside the iris itself, and don't try to make a precise selection. Selecting the eyelids, eyelashes, etc., will not create a problem. Once one eye is selected, hold the Shift key, and then use the Lasso tool to select the other eye in the same fashion (giving you both eyes as selections).

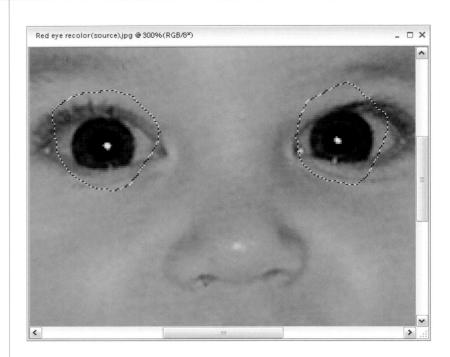

Step Four:

Once you have loose selections around both eyes, press Control-J to instantly copy and paste them onto a new layer in the Layers palette. This does two things: (1) It pastes the copied eyes on this layer in the exact same position as they are on the Background layer, and (2) it automatically deselects for you. Now you have just a pair of eyes on this layer.

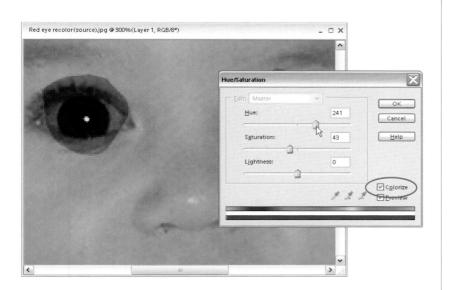

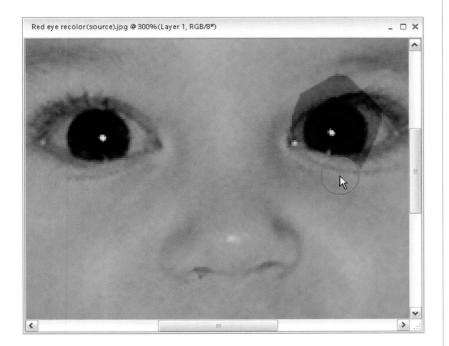

Step Five:

While you're on this "eyes" layer, go under the Enhance menu, under Adjust Color, and choose Adjust Hue/ Saturation. In the dialog, click on the Colorize checkbox (in the bottom righthand corner). Now you can choose the color you'd like for the eyes by moving the Hue slider. Don't worry about the color being too intense at this point, you can totally adjust that later, so if you want blue eyes, choose a deep blue and you'll "dial in" the exact shade later. Click OK to apply the color to the irises and the area around them as well. (Don't let this freak you out that other areas around the iris appear blue. We'll fix that in the next step.)

Step Six:

Press the E key to switch to the Eraser tool. Press D to make sure your Background color is white. Choose a small, hard-edged brush (from the Brush Picker up in the Options Bar), and then simply erase the extra areas around the iris. This sounds much harder than it is—it's actually very easy—just erase everything but the colored iris. Don't forget to erase over the whites of the person's eyes. Remember, the eyes are on their own layer, so you can't accidentally damage any other parts of the photo.

Step Seven:

If the eye color seems too intense (and chances are, it will), you can lower the intensity of the color by simply lowering the Opacity of this layer (using the Opacity slider in the upper right-hand corner of the Layers palette) until the eyes look natural.

Step Eight:

To finish the red-eye correction and recoloring, press Control-E to merge the colored eye layer with the Background layer, completing the repair.

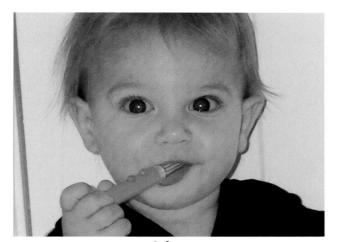

Before After

Repairing Keystoning

Keystoning is often found in photos with tall objects such as buildings, where the objects appear as if they're falling away from the viewer (giving the impression that the tops of these tall objects are narrower than their bases). Here's how to use Elements' Free Transform function, and one simple filter, to fix the problem fast.

Step One:

Open an image that has a keystoning problem, where a tall object seems to be leaning away from the viewer.

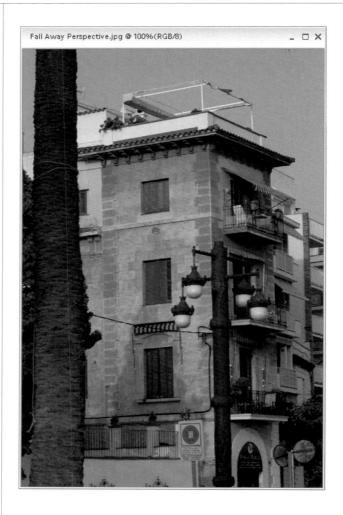

Step Two:

Make sure you're in Maximize Mode by going under the Window menu, under Images, and choosing Maximize Mode. Click on the Foreground color swatch (at the bottom of the Toolbox) to bring up the Color Picker. In the R (red) field enter 74, for G (green) enter 132, and in the B (blue) field enter 255, then click OK to set your Foreground color to a light blue.

Step Three:

Switch to the Line tool (press Shift-U to cycle through the Shape tools until you get the Line tool). Go up in the Options Bar and set the Weight to 2 pixels. Then, hold the Shift key and draw a vertical, blue, 2-pixel line from the top of your image down to a corner at the base of your tall object. This will add a Shape layer in your Layers palette. (Note: If it's not positioned where you want it, then you can drag it with the Move tool [V]. If this layer is locked, click on the Lock icon near the top center of the Layers palette to unlock it.) This blue line will act as your visual guide. Now, in the Layers palette, click back on the Background layer. Press Control-A to put a selection around your entire photo, then press Control-Shift-J to cut your image from the Background layer and put it on its own separate layer.

Continued

Step Four:

With your image's layer active, press Control-T to bring up the Free Transform bounding box.

Step Five:

Go to the Options Bar and you'll see a grid that represents the bounding box around the photo. Click the bottom-center box so any transformation you apply will have the bottom center locked in place.

Step Six:

Hold Shift-Alt-Control and drag either the top-left and/or top-right corner points of the bounding box around the image outward until the top corner of the object aligns with your guide.

Step Seven:

Making this correction can sometimes make your object look a bit "smushed" and "squatty" (my official technical terms), so release the Shift-Alt-Control keys, grab the top center point, and drag upward to stretch the photo back out and fix the "squattyness" (another technical term).

Continued

Step Eight:

When your object looks right, press Enter to lock in your transformation. Now you can go to the Layers palette, click on your blue-line Shape layer, and drag it onto the Trash icon at the top of the Layers palette to delete it. Then click on your image's layer and press Control-E to merge your image layer with the Background layer. There's still one more thing you'll probably have to do to complete this repair job.

If after making this adjustment the object looks "round" and "bloated," you can repair that problem by going under the Filter menu, under Distort, and choosing Pinch. Drag the Amount slider to 0%, and then slowly drag it to the right (increasing the amount of Pinch), while looking at the preview in the Pinch dialog, until you see the roundness and bloating go away. When it looks right, click OK to complete your keystoning repair.

Before In the original photo, the building appears to be "falling away."

The same photo after repairing the keystoning and bloating.

Opening and Processing RAW Images

The RAW format is about the hottest thing happening in digital photography. There are two reasons why: (1) unmatched quality, and (2) you become the processing lab, creating your own custom originals from your digital negative (the RAW file itself, which remains unchanged). Think of it this way: With traditional film, you take the film to the lab, and someone processes your prints from a negative. Well, with RAW, you get to be the person processing the photo—with control over white balance, exposure, and more—all before your file opens in Elements 3.

Step One:

If you have a digital camera that is capable of shooting in RAW format, you can open these RAW files for processing by going under Element's File menu and choosing Open. Navigate your way to the file, click the Open button, and your file will open in the Camera Raw processing window (you'll know you're there because the basic EXIF data, including the make and model of the camera that took the photo, will appear in the window's title bar). (Note: You can import RAW photos into the Organizer once your camera is connected to your computer by going to File, choosing Get Photos, and navigating to your files. With your files open in the Photo Browser window, click on a cataloged RAW photo, then click on the Standard Edit button in the top-right corner of the Organizer window and the photo will open in the Camera Raw processing window.)

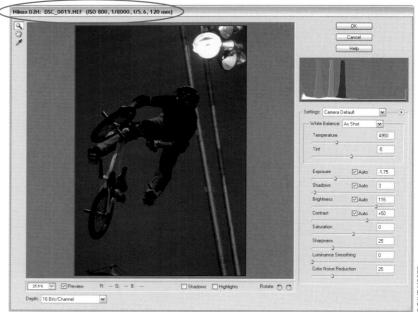

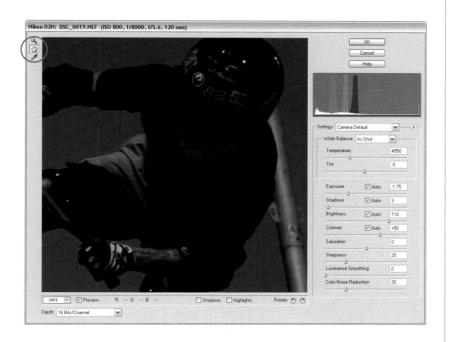

Step Two:

Your RAW photo is displayed in the large preview window on the left of the dialog. There are only three tools: the Zoom tool (for zooming in/out of the preview), the Hand tool (for panning around when you're zoomed in), and the White Balance tool (which looks like an eyedropper used for sampling colors or reading tones). Click the Zoom tool once or twice on your photo until your image fills the full preview area.

Step Three:

Although there are a number of different settings in the RAW processing window, most users wind up using just a few. The most popular is the White Balance control. You can drag the Temperature slider yourself, or just choose one of the preset settings in the White Balance pop-up menu to correct for different lighting situations.

Step Four:

The next most-useful (and popular) adjustment is the Exposure setting, which lets you adjust the exposure up to 2 full f-stops. There are Auto checkboxes for Exposure, Shadows, Brightness, and Contrast to help you if you're not comfortable making these choices yourself. There are also sliders for controlling Saturation, Sharpness, Luminance Smoothing, and a slider to help reduce digital noise from photos shot in low-lighting situations or shot with high ISO settings.

Step Five:

You'll need to decide what the bit depth of your photo will be: Will it be 16-bit (for the highest image quality), or will it be a regular 8-bit image? (You'll learn more about which mode to choose in the next tutorial.) Choose your setting from the Depth pop-up menu at the bottom-left corner of the dialog. Click OK and your new original is processed, but your original RAW file (your digital negative) remains untouched, so you can go back and make as many custom originals as you'd like. That's the power of RAW.

Many high-end pro photographers want to work in 16-bit depth as much as possible because it maintains more tonal quality than 8-bit. Although Elements 3 now supports opening RAW images and working in 16-bit depth, what you can do is very limited. In fact, you're basically limited to tonal adjustments because features such as layers, most filters, and a host of other cool features are not available at all when working in 16-bit—you have to convert down to 8-bit to get Elements' full feature set back. Is 16-bit really that much better? It's a matter of constant debate among photographers.

Working with 16-bit Images

Step One:

You have to start by opening an image in a "high-bit" format (like RAW) to be able to create a real 16-bit image (go to File, choose Open, and navigate to your RAW file). Opening a regular 8-bit JPEG image and then converting it to 16-bit depth won't add quality that wasn't there in the first place. You have to start with a RAW image, then you can decide whether you want to continue working in 16-bit or process the file as a regular 8-bit image. Choose your setting from the Depth popup menu in the bottom-left corner of the Camera Raw processing window.

Step Two:

If you choose to process the image as a 16-bit image and click OK in the Camera Raw processing window, take a quick look under Elements' Filter menu and you'll see how few filters are available to you. Pretty much all of Elements will feel this same way—almost everything's grayed out (you can't access it). However, after you've made your tonal adjustments in 16-bit mode, you can convert to 8-bit mode by going under the Image menu, under Mode, and choosing Convert to 8 Bits/Channel.

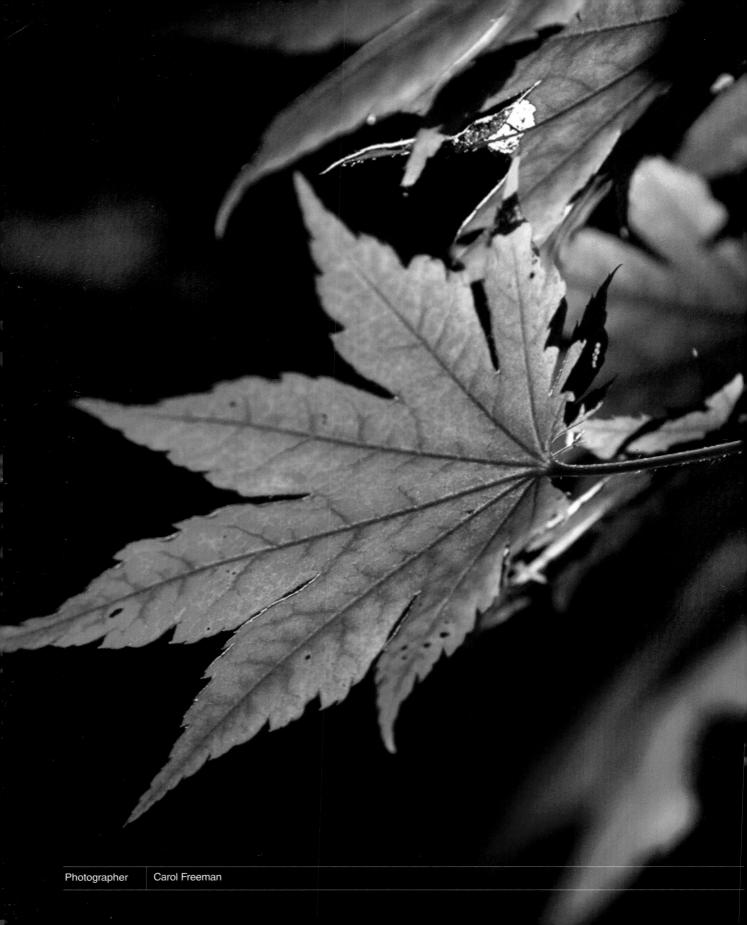

The subtitle for this chapter is "Color Correction for Photographers," which invites the question "How is color correction for photographers different from color correction for anybody else?" Actually, it's quite

Color Me Badd color correction for photographers

a bit different, because photographers generally work in RGB or black-and-white. And in reality, digital photographers mostly work in RGB because, although we can manage to build reusable spacecraft and have GPS satellites orbiting in space so golfers here on earth know how far it is from their golf cart to the green. for some reason creating a color inkjet printer that prints a decent black-and-white print is still apparently beyond our grasp. Don't get me started. Anyway, this chapter isn't about black-and-white, and now that I think about it, I'm sorry I brought it up in the first place. So forget I ever mentioned it, and let's talk about color correction. Why do we even need color correction? Honestly, it's a technology thing. Even with traditional film cameras, every photo needs some sort of color tweaking (either during processing or afterward in Elements) because if it didn't need some correction, we'd have about 20-something pages in this book that would be blank, and that would make my publisher pretty hopping mad (and if you haven't seen him hop, let me tell you, it's not pretty). So, for the sake of sheer page count, let's all be glad that we don't live in a perfect world where every photo comes out perfect and 6-megapixel cameras are only 200 bucks and come with free 1-GB memory cards.

Before you color correct even a single photo, you need to consider a couple of settings that can affect the results you'll get. It's important to note that the changes you make will remain as your defaults until you change them again, and that (particularly with Color Settings) you may change your settings from time to time based on individual projects.

Step One:

From the Edit menu, choose Color Settings (or press Shift-Control-K).

Step Two:

In the Color Settings dialog, choose from the three options: No Color Management, Limited Color Management, or Full Color Management. To a large degree, your choice will depend on your final output; but for photographers, I recommend using Full Color Management because it reproduces such a wide gamut of colors, and it's ideal if your photos will wind up in print. *Note:* Unfortunately, color management is beyond the scope of this book. In fact, entire books have been dedicated to the subject. So for now, just switch your Color Settings to Full Color Management and let's move on.

Step Three:

Now we're moving to a completely different area. Press the letter I to switch to the Eyedropper tool. In the Options Bar, the Sample Size setting for this tool (Point Sample) is fine for using the Eyedropper to steal a color from within a photo and making it your Foreground color. However, Point Sample doesn't work well when you're trying to read values in a particular area (such as flesh tones), because it gives you the reading from just one individual pixel, rather than an average reading of the surrounding area under your cursor.

Step Four:

For example, flesh tones are actually composed of dozens of different colored pixels (just zoom way in and you'll see what I mean); and if you're color correcting, you want a reading that's representative of the area under your Eyedropper, not just a single pixel within that area, which could hurt your correction decision-making. That's why you need to go to the Options Bar, under Sample Size, and choose 3 by 3 Average from the pop-up menu. This changes the Eyedropper to give you a reading that's the average of 3 pixels across and 3 pixels down in the area that you're sampling. Once you've completed the changes on these two pages, it's safe to go ahead with the rest of the chapter and start correcting your photos.

If you have a photo that has some serious problems (bad color, bad lighting, bad everything, etc.), and you have no experience with color correction or repairing other color or lighting nightmares, you'll love Elements 3's Quick Fix. It's where you go when you're not experienced at color correcting or fixing tonal problems, but you can see something's wrong with your photo and you want it fixed fast with the least amount of sweat. You'll eventually outgrow Quick Fix and want to use Levels and Unsharp Mask and all that cool stuff, but if you're new to Elements, Quick Fix can do a pretty decent job for ya.

Step One:

Open the photo that needs color correcting (in this example, our photo needs the works—color correction, more contrast, and some sharpening). Next, click on the Quick Fix button at the top-right side of the Options Bar to enter the Quick Fix mode.

Step Two:

The Quick Fix dialog shows you side-byside before-and-after versions of the photo you're about to correct (before on the left, after on the right). If you don't see this view, go to the View pop-up menu in the bottom left of the Quick Fix window and select Before and After (Portrait or Landscape). To the right of your side-byside preview is a group of nested palettes offering tonal and lighting fixes you can perform on your photo. Start with the General Fixes palette at the top. The star of this palette is Smart Fix. Click the Auto button and Smart Fix will automatically analyze the photo and try to balance the overall tone (adjusting the shadows and highlights), fixing any obvious color casts while it's at it. In most cases this feature does a surprisingly good job. There's an Amount slider under Smart Fix that you can use to increase (or decrease) the effect of the Smart Fix.

TIP: By the way, you can also access the Auto Smart Fix command without entering the Quick Fix mode by going under the Enhance menu and choosing Auto Smart Fix (or just press the keyboard shortcut Control-M). However, there are two advantages to applying the Smart Fix here in Quick Fix mode: (1) You get the Amount slider, which you don't get by just applying it from the menu or the shortcut; and (2) you get a side-by-side, before-and-after preview so you can see the results before you click OK. So if it turns out that you need additional fixes (or Smart Fix didn't work as well as you'd hoped), you're already in the right place.

Step Three:

If you apply Smart Fix and you're not happy with the results, don't try to stack more "fixes" on top of that—instead, click the Reset button that appears over the top-right corner of the After preview to reset the photo to how it looked when you first entered Quick Fix mode. If the color in your photo is OK, but it looks a little flat and needs more contrast, try the Auto button in the Levels category, found in the Lighting palette (the second palette down). I generally stay away from Auto Contrast, as Auto Levels seems to do a better job.

Step Four:

Besides Auto Contrast, there's one other very powerful tool here—the Lighten Shadows slider. Drag it to the right a bit, and watch how it opens up the dark shadow areas in the photo you just corrected. Now, on to more Quick Fixing.

Continued

Step Five:

The next palette down, Color, has an Auto button that (surprisingly enough) tries to remove color casts and improve contrast like Smart Fix and Levels do, but it goes a step further by including a midtones correction that can help reduce color casts in the midtone areas of your photo. Hit the Reset button to remove any corrections that you've made up to this point, and then try the Auto button in the Color palette. See if the grays in the photo don't look grayer and less reddish. The sliders in the palette are mostly for creating special color effects (move the Hue slider, and you'll see what I mean). You can pretty much ignore these sliders unless you want to get "freaky" with your photos.

Step Six:

After you've color corrected your photo (using the Auto buttons and the occasional slider), the final step is to sharpen your photo (by the way, to maintain the best quality, this should be the final step—the last thing you do in your correction process). Just press the Auto button in the Sharpen palette and watch the results. If the photo isn't sharp enough for you, drag the Amount slider to the right to increase the amount of sharpening, but be careful—over-sharpening can ruin the photo by becoming too obvious, and it can introduce color shifts and "halos" around objects.

Step Seven:

There are a few other things you can do while you're here (think of this as kind of a one-stop shop for quickly fixing images). In the General Fixes palette, there are icons you can click to rotate your photo (this photo doesn't need to be rotated, but hey, ya never know). Also, there are some tools in the far-left side of the dialog. You know what the Zoom and Hand tools do (they zoom you in, and then move you around once you're zoomed in), but you can also crop your photo by using the Crop tool within the After preview (it only works in the After preview), so go ahead and crop your photo down a bit. If your photo has red eye, you can remove it using the dialog's Red Eye Removal tool.

Step Eight:

Okay, you've color corrected, fixed the contrast, sharpened your image, and even cropped it down to size. So how do you leave Quick Fix mode and return to regular Elements 3? Go to the right-hand corner of the Options Bar and click on the Standard Edit button. That's basically the OK button, and it applies all the changes to your photo and returns you to the normal editing mode.

Before After

In previous versions of Elements, there were two ways to see a histogram. (A histogram is a graph showing the tonal range of your photo.) You could either view it when using Levels, or you could open a dialog that would display a histogram. But you could only view it in this dialog—it wasn't updated live as you made tonal adjustments. In Elements 3, Adobe made the histogram its own floating palette, so now you can have it open as you apply adjustments while in Standard Edit mode. Plus, it shows you before-and-after readings before you click the OK button in a tonal adjustment dialog, such as the Adjust Smart Fix dialog.

Getting a Visual Readout (Histogram) of Your Corrections

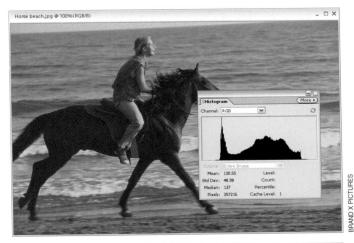

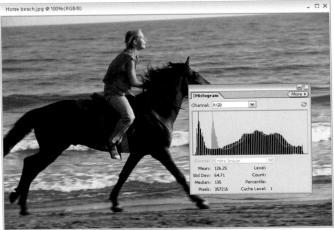

Step One:

Open the photo that needs a tonal adjustment. Now, go under the Window menu and choose Histogram to open the Histogram palette. (By the way, this palette is only available in Elements 3's Standard Edit mode—not in Quick Fix mode.)

Step Two:

Go under the Enhance menu and choose Auto Color Correction. Take a look in the floating Histogram palette and you'll see how the Auto Color Correction command affected the photo's histogram. Note: If you see a small symbol in the upper right-hand corner of the graph that looks like a tiny yellow yield sign with an exclamation point in it, that's a warning that the histogram you're seeing is not a new histogram—it's a previous histogram cached from memory. To see a fresh histogram, click directly on that warning symbol and a new reading will be generated based on your current adjustment.

Color Correcting Digital Camera Images

As far as digital technology has come, there's still one thing that digital cameras won't do—give you perfect color every time. In fact, if they gave us perfect color 50% of the time, that would be incredible, but unfortunately, every digital camera (and every scanner that captures traditional photos) sneaks some kind of color cast into your image. Generally, it's a red cast but, depending on the camera, it could be blue. Either way, you can be pretty sure—there's a cast. (Figure it this way, if there wasn't, the term "color correction" wouldn't be used.) Here's how to get your color in line.

Step One:

Open the digital camera photo you want to color correct. (The photo shown here doesn't look too bad, but as we go through the correction process, you'll see that, like most photos, it really needed a correction.)

HAND X P

Step Two:

Go under the Enhance menu, under Adjust Lighting, and choose Levels. The dialog may look intimidating at first, but the technique you're going to learn here requires no previous knowledge of Levels, and it's so easy, you'll be correcting photos using Levels immediately.

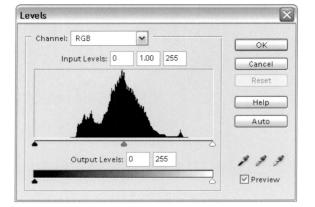

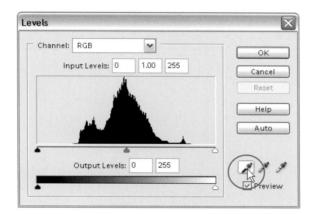

Step Three:

First, we need to set some preferences in the Levels dialog so we'll get the results we're after when we start correcting. We'll start by setting a target color for our shadow areas. To set this preference, in the Levels dialog, double-click on the black Eyedropper tool (it's on the lower right-hand side of the dialog, the first Eyedropper from the left). A Color Picker will appear asking you to "Select Target Shadow Color." This is where we'll enter values that, when applied, will help remove any color casts your camera introduced in the shadow areas of your photo.

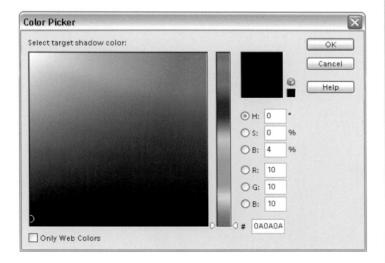

Step Four:

We're going to enter values in the R, G, and B (red, green, and blue) fields of this dialog.

For R, enter 10 For G, enter 10 For B, enter 10

TIP: To move from field to field, just press the Tab key.

Then click OK. Because these figures are evenly balanced (neutral), they help ensure that your shadow areas won't have too much of one color (which is exactly what causes a color cast—too much of one color).

Step Five:

Now we'll set a preference to make our highlight areas neutral. Double-click on the highlight Eyedropper (the third of the three Eyedroppers in the Levels dialog). The Color Picker will appear asking you to "Select Target Highlight Color." Click in the R field, and then enter these values:

For R, enter 240

For G, enter 240

For B, enter 240

Then click OK to set those values as your highlight target.

Step Six:

Finally, set your midtone preference. You know the drill—double-click on the midtone Eyedropper (the middle of the three Eyedroppers) so you can "Select Target Midtone Color." Enter these values in the R, G, and B fields (if they're not already there by default):

For R, enter 128

For G, enter 128

For B, enter 128

Then click OK to set those values as your midtone target.

Step Seven:

Okay, you've entered your preferences (target colors) in the Levels dialog, so go ahead and click OK. You'll get an alert dialog asking you if you want to "Save the new target colors as defaults." Click Yes, and from that point on, you won't have to enter these values each time you correct a photo, because they'll already be entered for you—they're now the default settings.

Step Eight:

You're going to use these Eyedropper tools that reside in the Levels dialog to do most of your correction work. Your job is to determine where the shadow, midtone, and highlight areas are, and click the right Eyedropper in the right place (you'll learn how to do that in just a moment). So remember your job—find the shadow, midtone, and highlight areas and click the right Eyedropper in the right spot. Sounds easy, right? It is.

You start by setting the shadows first, so you'll need to find an area in your photo that's supposed to be black. If you can't find something that's supposed to be the color black, then it gets a bit trickier—in the absence of something black, you have to determine which area in the image is the darkest. If you're not sure where the darkest part of the photo is, you can use the following trick to have Elements tell you exactly where it is.

Step Nine:

Go to the top of the Layers palette and click on the half black/half white circle icon to bring up the Create Adjustment Layer popup menu. When the menu appears, choose Threshold (this brings up a dialog with a histogram and a slider under it).

Continued

When the Threshold dialog appears, drag the Threshold Level slider under the histogram all the way to the left. Your photo will turn completely white. Slowly drag the Threshold slider back to the right, and as you do, you'll start to see some of your photo reappear. The first area that appears is the darkest part of your image. That's it—that's Elements telling you exactly where the darkest part of the image is.

Now that you know where your shadow area is, make a mental note of its location. Now to find a white area in your image.

Step Eleven:

If you can't find an area in your image that you know is supposed to be white, you can use the same technique to find the highlight areas that you just used to find the shadow areas. With the Threshold dialog still open, drag the slider all the way to the right. Your photo will turn black. Slowly drag the Threshold slider back toward the left, and as you do, you'll start to see some of your photo reappear. The first area that appears is the lightest part of your image. Make a mental note of this area as well (yes, you have to remember two things, but you have to admit, it's easier than remembering two PIN numbers). You're now done with Threshold so just click Cancel because you don't actually need the adjustment layer anymore.

layer anymore.

Step Twelve:

Press Control-L to bring up the Levels dialog. First, select the shadow Eyedropper (the one half filled with black) from the bottom right of the Levels dialog. Move your cursor outside the Levels dialog into your photo and click once in the area that Elements showed you was the darkest part of the photo. When you click there, you'll see the shadow areas correct. (Basically, you just reassigned the shadow areas to your new neutral shadow color—the one you entered earlier as a preference in Step Four). If you click in that spot and your photo now looks horrible, you either clicked in the wrong spot, or what you thought was the shadow point actually wasn't. Undo the setting of your shadow point by clicking the Reset button in the dialog and try again. If that doesn't work, don't sweat it; just keep clicking in areas that look like the darkest part of your photo until it looks right.

Step Thirteen:

While still in the Levels dialog, switch to the highlight Eyedropper (the one filled with white). Move your cursor over your photo and click once on the lightest part (the one you committed to memory earlier) to assign that as your highlight. You'll see the highlight colors correct.

Now that the shadows and highlights are set, you'll need to set the midtones in the photo. It may not look as if you need to set them, because the photo may look properly corrected, but chances are there's a cast in the midtone areas. You may not recognize the cast until you've corrected it and it's gone, so it's worth giving it a shot to see the effect (which will often be surprisingly dramatic).

Unfortunately, there's no Threshold adjustment layer trick that works well for finding the midtone areas, so you have to use some good old-fashioned guesswork. Ideally, there's something in the photo that's gray, but not every photo has a "gray" area, so look for a neutral area (one that's obviously not a shadow, but not a highlight either). Click the middle (gray) Eyedropper in that area. If it's not right, click the Reset button and repeat Steps 12-14.

Step Fifteen:

There's one more important adjustment to make before you click OK in the Levels dialog and apply your correction. Under the histogram (that's the black mountainrange-looking thing), click on the center slider (the Midtone slider—that's why it's gray) and drag it to the left a bit to brighten the midtones of the image. This is a visual adjustment, so it's up to you to determine how much to adjust, but it should be subtle—just enough to brighten the midtones a bit and bring out the midtone detail. When it looks right to you, click OK to apply your correction to the highlights, midtones, and shadows, removing any color casts and brightening the overall contrast.

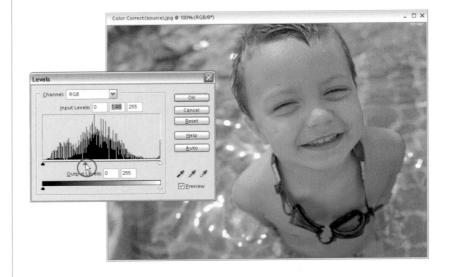

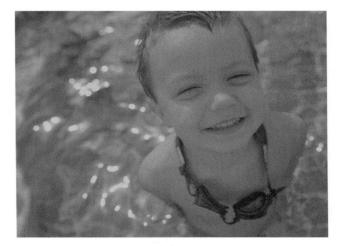

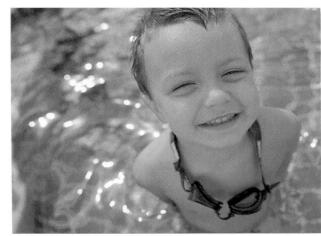

Before After

Drag-and-Drop Instant Color Correction

This is a wonderful timesaving trick for quickly correcting an entire group of photos that have similar lighting. It's ideal for shots where the lighting conditions are controlled, but works equally well for outdoor shots, or really any situation where the lighting for your group of shots is fairly consistent. Once you try this, you'll use it again and again and again.

Step One:

First, here's a tip-within-a-tip: If you're opening a group of photos, you don't have to open them one by one. Just go under the File menu and choose Open. In the Open dialog, click on the first photo you want to open, then hold the Control key and click on any other photos you want to open. Then, when you click the Open button, Elements will open all the selected photos. (If all your photos are consecutive, hold the Shift key and click on the first and last photo in the list to select them all.) So now that you know that tip, go ahead and open at least three or four images, just to get you started.

Step Two:

At the top of the Layers palette, click on the Create Adjustment Layer pop-up menu and choose Levels. *Note:* An adjustment layer is a special layer that contains the tonal adjustment of your choice (such as Levels, Brightness/Contrast, etc.). There are a number of advantages of having this correction applied as a layer, as you'll soon see, but the main advantage is that you can edit or delete this tonal adjustment at any time while you're working, plus you can save this adjustment with your file as a layer.

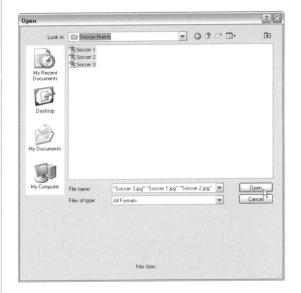

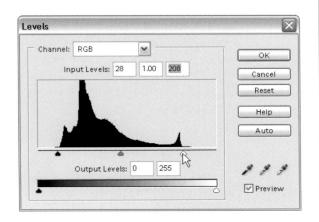

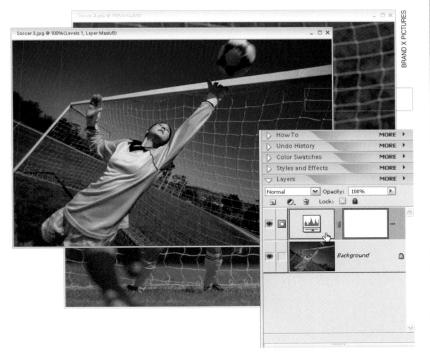

Step Three:

When you choose this adjustment layer, you'll notice that the regular Levels dialog appears, just like always. Go ahead and make your corrections as you did in the previous tutorial (setting highlights, midtones, shadows, etc., with the Eyedropper tools), and when your correction looks good, click OK. In the Layers palette, you'll see that a new Levels adjustment layer is created.

Step Four:

Because you applied this correction as an adjustment layer, you can treat this adjustment just like a regular layer, right? Right! And Elements lets you drag layers between open documents, right? Right again! So, go to the Layers palette, and simply click on the Levels adjustment layer thumbnail and drag-and-drop this layer right onto one of your other open photos. That photo will instantly have the same correction applied to it. This technique works because you're correcting photos that share similar lighting conditions. Need to correct 12 open photos? Just drag-and-drop it 12 times (making it the fastest correction in town!).

Step Five:

Okay, what if one of the "dragged corrections" doesn't look right?
That's the beauty of these adjustment layers. Just double-click directly on the adjustment layer thumbnail for that photo, and the Levels dialog will reappear with the last settings you applied still in place. You can then adjust this individual photo separately from the rest. Try this "dragging-and-dropping-adjustment-layers" trick once, and you'll use it again and again to save time when correcting a digital roll that has similar lighting conditions.

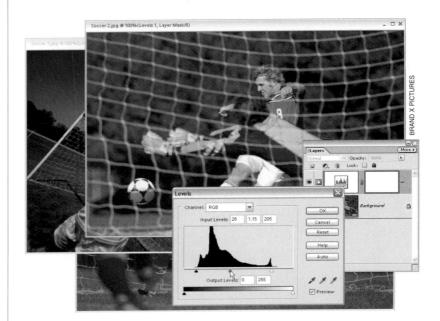

Back in the day, when we needed to adjust our camera to a particular lighting situation (let's say the image would come out too blue or too warm because of the lighting), we would use color filters that would screw onto the end of our lens. Now we "warm up" or "cool down" a photo digitally using Elements 3's

Photo Filter adjustment layer. Here's how:

Warming Up or Cooling Down a Photo

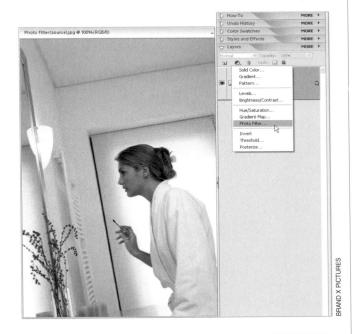

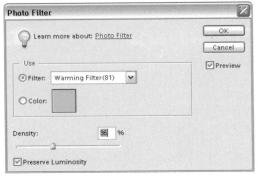

Step One:

Open the photo that needs warming up (or cooling down). In the example shown here, the photo is too cold and has a bluish tint, so we want to warm it up and make it look more natural. Go to the Layers palette and choose Photo Filter from the Create Adjustment Layer pop-up menu at the top of the palette (its icon looks like a half black/half white circle).

Step Two:

When the Photo Filter dialog appears, choose Warming Filter (81) from the Filter pop-up menu (this approximates the effect of an 81A screw-on filter). If the effect isn't warm enough, drag the Density slider to the right to warm the photo some more. Then click OK.

Continued

Step Three:

Because this Photo Filter is an adjustment layer, you can edit where the warming is applied, so press B to switch to the Brush tool, and in the Options Bar, click on the down-facing arrow next to the Brush Preset icon and choose a soft-edged brush in the Brush Picker. Then, press X until you have black as your Foreground color, and begin painting over the area that you don't want to be warm. The original color of the image will be revealed wherever you paint.

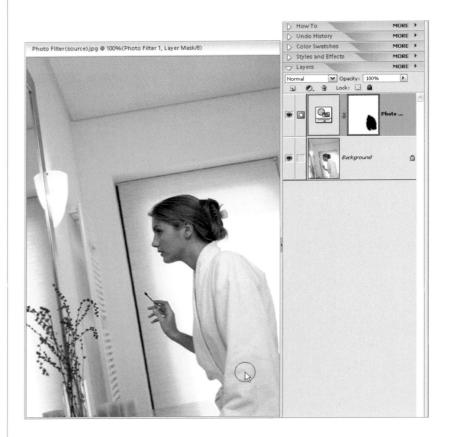

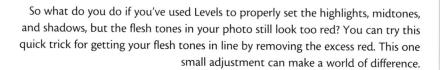

Adjusting Flesh Tones

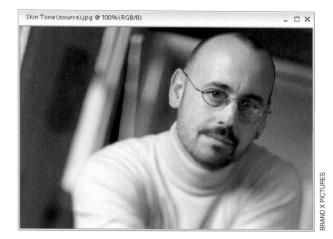

Step One:

Open a photo that needs red removed from the flesh tones. If the whole image appears too red, skip this step and move on to Step Three. However, if just the flesh-tone areas appear too red, press L to switch to the Lasso tool and make a selection around all the flesh-tone areas in your photo. (Hold the Shift key to add other flesh-tone areas to the selection, such as arms, hands, legs, etc.)

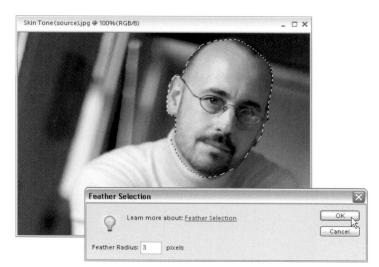

Step Two:

Next, go under the Select menu and choose Feather. Enter a Feather Radius of 3 pixels, then click OK. By adding this feather, you're softening the edges of your selection. This will prevent a hard, visible edge appearing around your adjustments.

Continued

Step Three:

Go under the Enhance menu, under Adjust Color, and choose Adjust Hue/ Saturation. When the dialog appears, click on the Edit pop-up menu and choose Reds so you're only adjusting the reds in your photo (or in your selected areas if you put a selection around the flesh tones).

Step Four:

The rest is easy—you're simply going to reduce the amount of saturation so the flesh tones appear more natural. Drag the Saturation slider to the left to reduce the amount of red. You'll be able to see the effect of removing the red as you lower the Saturation slider.

TIP: If you made a selection of the flesh-tone areas, you might find it easier to see what you're correcting if you hide the selection border from view by pressing Control-H. You can even hide the selection border while the Hue/ Saturation dialog is open. When the flesh tones look right, just click the OK button and you're set. But don't forget that your selection is still in place, so press Control-D to deselect.

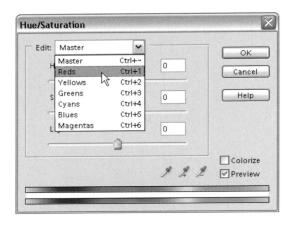

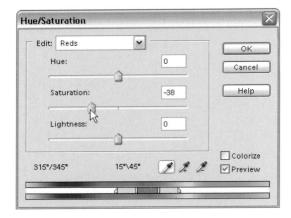

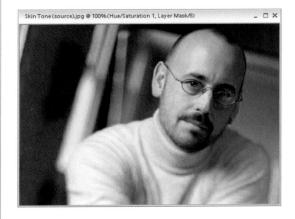

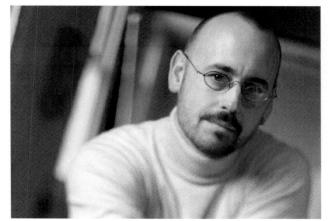

Before

After

Color Correcting One Problem Area Fast!

This technique really comes in handy when shooting outdoor scenes because it lets you enhance the color in one particular area of the photo, while leaving the rest of the photo untouched. Real estate photographers often use this trick because they want to present the house on a bright sunny day, but the weather doesn't always cooperate. With this technique, a gray cloudy sky can become a beautiful blue sky in just seconds, or a brownish yard can quickly become a lush green yard (like it really looks in summer).

Step One:

Open the image that has an area of color you would like to enhance, such as the sky.

D X PICTURE

Step Two:

Go to the Layers palette and choose Hue/Saturation from the Create Adjustment Layer pop-up menu at the top of the Layers palette (it's the half black/half white circle icon). A new layer named "Hue/Saturation 1" will be added to your Layers palette and the Hue/Saturation dialog will appear.

Step Three:

From the Edit pop-up menu at the top of the Hue/Saturation dialog, choose the color that you want to enhance (Blues, Reds, etc.), then drag the Saturation slider to the right. You might also choose Cyans, Magentas, etc., from the Edit pop-up menu and do the same thing—drag the Saturation slider to the right, adding even more color. In the example here, I increased the saturation of the Blues to 66. When your image's area looks as enhanced as you'd like it, click OK.

Step Four:

Your area is now colorized, but so is everything else. That's okay; you can fix that easily enough. Press the letter X until your Foreground color is set to black, then press Alt-Backspace to fill the Hue/Saturation layer mask with black. Doing this removes all the color that you just added, but now you can selectively add (actually paint) the color back in where you want it.

Step Five:

Press the letter B to switch to the Brush tool. In the Options Bar, click the downfacing arrow to the right of the Brush Preset icon, and in the Brush Picker choose a soft-edged brush. Press X again to toggle your Foreground color to white, and begin painting over the areas where you want the color enhanced. As you paint, the version of your enhanced photo will appear. For well-defined areas, you may have to go to the Brush Picker again in the Options Bar to switch to a smaller, hard-edged brush.

TIP: If you make a mistake and paint over an area you shouldn't have—no problem—just press X again to toggle your Foreground color to black and paint over the mistake—it will disappear. Then, switch back to white and continue painting. When you're done, the colorized areas in your photo will look brighter.

Before

After

Getting a Better Conversion from Color to Black-and-White

If you've ever converted a color photo to black-and-white, chances are you were disappointed with the results. That's because Elements simply throws away the color, leaving a fairly bland black-and-white photo in its wake. In the full version of Adobe Photoshop, there is a feature called Channel Mixer that lets you custom create a better black-and-white image. Unfortunately, that feature isn't in Elements, but I figured out a way to get similar control using a little workaround. Here's how:

Step One:

Open the color photo you want to convert to black-and-white.

Step Two:

To really appreciate this technique, it wouldn't hurt if you went ahead and did a regular conversion to black-and-white, just so you can see how lame it is. Go under the Image menu, under Mode, and choose Grayscale. When the "Discard Color Information?" dialog appears, click OK, and behold the somewhat lame conversion. Now that we agree it looks pretty bland, press Control-Z to undo the conversion, so now you can try something better.

Step Three:

Go to the top of the Layers palette and choose Levels from the Create Adjustment Layer pop-up menu (it's the half black/ half white circle). When the Levels dialog appears, don't make any changes, just click OK. This will add a layer to your Layers palette named "Levels 1."

Step Four:

At the top of the Layers palette, choose Hue/Saturation from the Create Adjustment Layer pop-up menu to bring up the Hue/Saturation dialog.

Step Five:

When the Hue/Saturation dialog appears, drag the Saturation slider all the way to the left to remove all the color from the photo, then click OK. This will add another layer to the Layers palette (above your Levels 1 layer) named "Hue/Saturation 1."

Continued

Step Six:

In the Layers palette, double-click directly on the Levels thumbnail in the Levels 1 layer to bring up the Levels dialog again. In the Channels pop-up menu at the top of the dialog, you can choose individual color channels to edit (kind of like you would with Photoshop's Channel Mixer). Choose the Red color channel.

Step Seven:

Now, you can adjust the Red channel, and you'll see the adjustments live onscreen as you tweak your black-and-white photo (it appears as a black-and-white photo because of the Hue/Saturation adjustment layer on the layer above the Levels layer. Pretty sneaky, eh?). You can drag the shadow Input Levels slider to the right a bit to increase the shadows in the Red channel.

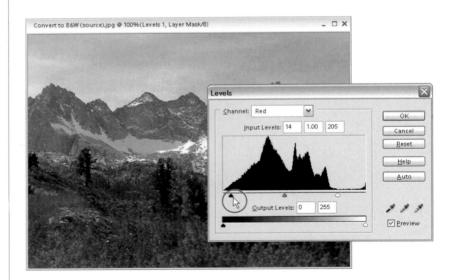

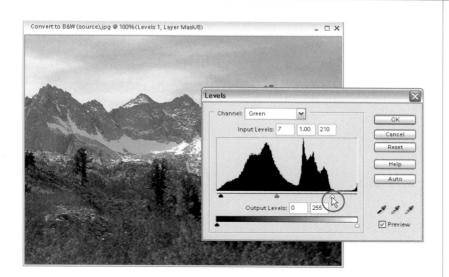

Step Eight:

Now, switch to the Green channel in the Channels pop-up menu in the Levels dialog. You can make adjustments here as well. Try increasing the highlights in the Green channel by dragging the highlight Input Levels slider to the left. Don't click OK yet.

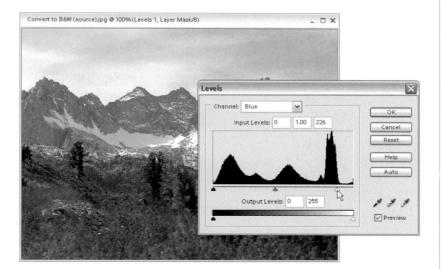

Step Nine:

Now, choose the Blue channel from the Channels pop-up menu in the Levels dialog. Try increasing the highlights quite a bit, and the shadows just a little by dragging the Input Levels sliders. These adjustments are not standards or suggested settings for every photo; I just experimented by dragging the sliders, and when the photo looked better, I stopped dragging. When the black-and-white photo looks good to you (good contrast and good shadow and highlight details), click OK in the Levels dialog.

Step Ten:

To complete your conversion, go to the Layers palette, click on the More arrow to bring up the palette's flyout menu, then choose Flatten Image to flatten the adjustment layers down to the Background layer. Although your photo looks like a black-and-white, technically, it's still in RGB Color, so if you want a grayscale file, go under the Image menu, under Mode, and choose Grayscale.

Before (lame grayscale conversion)

After (awsome adjustment layers conversion)

One of the problems with people is you can't always get them to stand in front of a white background so you can easily select them, and then place them on a different background. It's just not fair.

The Mask selection techniques

If I were elected president, one of my first priorities would be to sign an executive order requiring all registered voters to carry with them a white, seamless roll at all times. Can you imagine how much easier life would be? For example, let's say you're a sports photographer and you're shooting an NFL Monday Night Football game with one of those Canon telephoto lenses that are longer than the underground tube for a particle accelerator; and just as the quarterback steps into the pocket to complete a pass, a fullback comes up from behind, quickly unfurls a white, seamless backdrop, and lets you make the shot. Do you know how fast you'd get a job at Sports Illustrated? Do you know how long I've waited to use "unfurl" in a sentence and actually use it in the proper context? Well, let's just say at least since I was 12 (three long years ago). In this chapter, you'll learn how to treat everyone, every object, everything, as though it were shot on a white, seamless background.

Selecting Square, Rectangular, or Round Areas

Selections are an incredibly important part of working in Elements 3. That's because without them, everything you do, every filter you run, etc., would affect the entire photo. By being able to "select" a portion of your image, you can apply these effects only to the areas you want, giving you much greater control. Believe it or not, the most basic selections (squares, rectangles, circles, and ovals) are the ones you'll use the most, so we'll start with them.

Step One:

To make a rectangular selection, choose (big surprise) the Rectangular Marquee tool by pressing the M key. Adobe's word for selection is "marquee." (Why? Because calling it a marquee makes it more complicated than calling it what it really is—a selection tool, and giving tools complicated names is what Adobe does for fun.)

Step Two:

We're going to select a rectangle shape, so click your cursor in the upper left-hand corner of the shape and drag down and to the right until your selection covers the entire shape, then release the mouse button. That's it! You've got a selection, and anything you do now will affect only the area within that selected rectangle.

To add another selection to your current selection, just hold the Shift key, then draw another rectangular selection.

Step Four:

Now, apply any effect you like. (Here I chose Adjust Hue/Saturation from the Enhance menu's Adjust Color submenu.) You'll notice that the effect is applied only to your selected areas. That's why making selections is so important. To deselect (make your selection go away), just press Control-D.

Continued

Step Five:

Now, let's make a circular selection. Click-and-hold on the Rectangular Marquee tool in the Toolbox and a flyout menu will appear. Choose the Elliptical Marquee tool from the menu. We're going to make an oval selection, so start at the top left of the object and drag out a selection around it (it won't fit perfectly, of course, so just get close).

Step Six:

Re-apply the effect you used earlier to your selected object. Press Control-D to deselect. Okay, it looks pretty lame, but you get the idea. So far we've drawn freeform rectangular and oval selections (which again, you'll wind up doing a lot). So, how do you make a perfect square or a perfect circular selection?

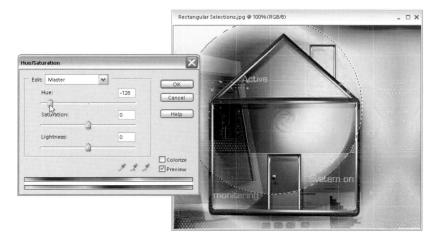

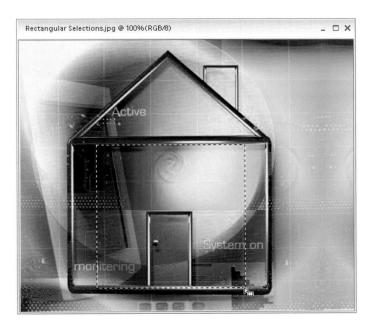

Step Seven:

To make a perfect square (or circle), just hold the Shift key as you drag out your selection, and Elements will constrain your shape into perfect square (or circular) proportions.

How to Select Things that Aren't Round, Square, or Rectangular

By now you know that selecting squares, rectangles, circles, ovals, etc., is a total no-brainer. But things get a little stickier when the area you want to select isn't square or rectangular or, well...you get the idea. Luckily, although it's not quite the no-brainer of the Marquee tools, making those selections isn't hard—if you don't mind being just a little patient. And making these "non-conformist" selections can actually be fun. Here's a quick project to get your feet wet.

Step One:

Open a photo with an odd-shaped object that's not rectangular, square, etc. This is what the Lasso tool was born for, so press the L key to access it from the Toolbox.

Step Two:

Click on the bottom-left side of your object and slowly (the key word here is *slowly*) drag the Lasso tool around the object, tracing its edges. If, after you're done, you've missed a spot, just hold the Shift key and click-and-drag around that missing area—it will be added to your selection. If you selected too much, hold the Alt key and click-and-drag around the area you shouldn't have selected.

Step Three:

When the object is fully selected, go under the Select menu and choose Feather (we're doing this to soften the edges of the selected area). Enter 2 pixels (just a slight bit of softening), then click OK. Now that our edges are softened, we can make adjustments to the object without "getting caught."

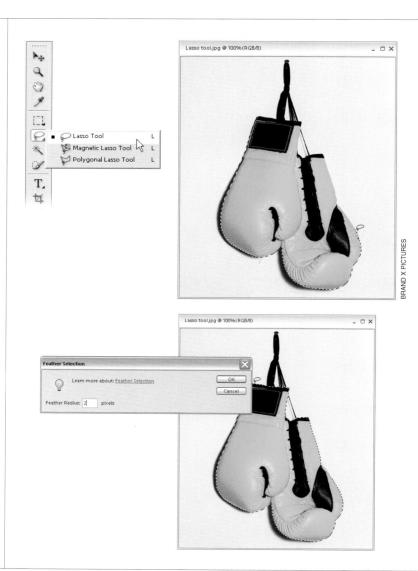

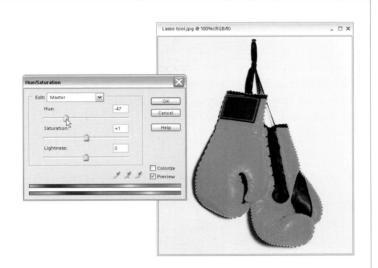

Step Four:

In the example here, we're going to change the color of the selected object, so press Control-U to bring up Hue/Saturation. Drag the Hue slider either left or right to change the color of your object. If the color looks too intense, just lower the amount of saturation by dragging the Saturation slider to the left. Remember, these adjustments affect only the object, not the whole photo, because you selected the object with the Lasso tool before you made any adjustments.

Step Five:Click OK in the dialog and press Control-D to deselect.

Softening Those Harsh Edges

When you make an adjustment to a selected area in a photo, your adjustment stays completely inside the selected area. That's great in many cases, but when you deselect, you'll see a hard edge around the area you adjusted, making the change look fairly obvious. However, softening those hard edges (thereby "hiding your tracks") is easy—here's how.

Step One:

First, drag out a selection slightly larger than you need using any tool you'd like. Now make an exaggerated adjustment (such as adjusting Shadows/Highlights, which is found under Enhance, under Adjust Lighting, and choose Shadows/Highlights). Then, deselect by pressing Control-D. Regardless of what adjustment you chose, you can clearly see the edge around the area you adjusted (as shown below).

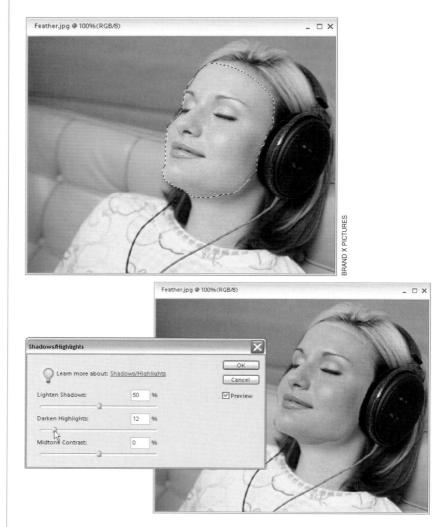

Learn more about: Feather Selection OK Cancel Idius: 10 pixels

Feather Radius: 10

So let's start over (choose Revert to Saved from the Edit menu). Make your selection again, but before you make any adjustments, go under the Select menu and choose Feather. This brings up the Feather Selection dialog, where you'll enter the desired amount of feathering. The higher the amount you enter, the softer the edges. Enter 10 pixels (just a starting point) and click OK.

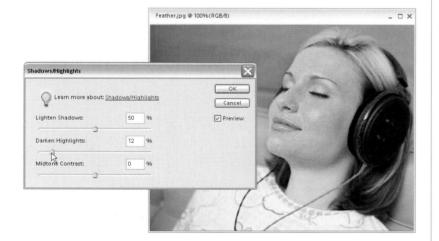

Step Three:

Now apply the adjustment you just made in Step One. Deselect (Control-D) and look at the difference. You don't see the hard edges, because the feathering you applied softened them. Cool.

Selecting Areas by Their Color

So, would you select an entire solid-blue sky using the Rectangular Marquee tool? You probably wouldn't. Oh, you might use a combination of the Lasso and Rectangular Marquee tools, but even then it could be somewhat of a nightmare (depending on the photo). That's where the Magic Wand tool comes in. It selects by ranges of color, so instead of clicking-and-dragging to make a selection, you click once, and the Magic Wand selects things in your photo that are fairly similar in color to the area you clicked on. The Magic Wand tool is pretty amazing by itself, but you can make it work even better.

Step One:

Open a photo that has a solid-color area that you want to select. Start by choosing the Magic Wand tool from the Toolbox (or press the W key). Then, click it once in the solid-color area in your photo.

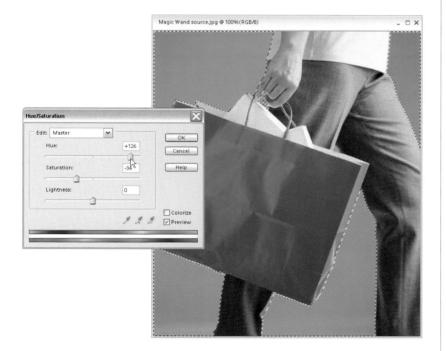

Step Two:

If your first click doesn't select the entire area, just press-and-hold the Shift key and click on another area that you want added to the selection. Keep holding the Shift key and click on all the areas that you want selected, and they'll be added to the selection. Now you can use Hue/Saturation (Control-U) to change the color of the selection, just like you did in a previous technique.

TIP: If you click in an area with the Magic Wand and not all of that area gets selected, then deselect (Control-D), go to the Options Bar, increase the Tolerance setting, and try again. The higher the setting, the wider the range of colors it will select; so as a rule of thumb: If the Magic Wand doesn't select enough, increase the Tolerance amount. If it selects too much, decrease it.

Making Selections Using a Brush

A lot of people are more comfortable using brushes than using Marquee tools. If you're one of those people (you know who you are), then you're in luck—you can make your selections by painting over the areas you want selected. Even if this sounds weird, it's worth a try—you might really like it (it's the same way with sushi). A major advantage of painting your selections is that you can choose a softedged brush (if you like) to automatically give you feathered edges. Here's how it works.

Step One:

Choose the Selection Brush tool from the Toolbox (or press the A key). Before you start, you'll want to choose your brush size, by clicking on the Brush Preset icon in the Options Bar to open the Brush Picker. If you want a soft-edged selection (roughly equivalent to a feathered selection), choose a soft-edged brush in the Picker or change your brush's Hardness setting in the Options Bar: 0% gives a very soft edge, while 100% creates a very hard edge to your selection.

Step Two:

Now you can click-and-drag to "paint" the area you want selected. When you release the mouse, the selection becomes active. *Note*: You don't have to hold down the Shift key to add to your selection when using this brush—just start painting somewhere else and it's added. However, you can press-and-hold the Alt key while painting to deselect areas.

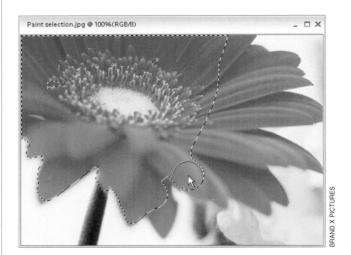

Once you have one or more objects on a layer, putting a selection around everything on that layer is a one-click affair. What's especially great about this ability is that not only does it select the hard-edged areas in a layer but it also selects the soft-edged areas, such as drop shadows.

It'll make sense in a moment.

Selecting Everything On a Layer at Once!

Step One:

Open a layered image in which one layer contains elements you want to select and alter.

Step Two:

To instantly put a selection around everything on that layer, just Controlclick on that layer in the Layers palette. For one example of why you might want to do this, go to the top of the Layers palette while your selection is still in place and click the Create a New Layer icon. Now, choose a Foreground color and press Alt-Backspace to fill your selected area with that color. Press Control-D to deselect. Next, change the blend mode of this new layer in the Layers palette to Color, so now you have colored the layer's object(s). Lower the Opacity in the Layers palette to add a slight colored cast to your layer.

Saving Your Selections

If you've spent 15 or 20 minutes (or even longer) putting together an intricate selection, once you deselect it, it's gone. (Well, you might be able to get it back by choosing Reselect from the Select menu, as long as you haven't made any other selections in the meantime, so don't count on it. Ever.) Here's how to save your finely-honed selections and bring them back into place anytime you need them.

Step One:

Open an image and then put a selection around an object in your photo using the tool of your choice.

Step Two:

To save your selection once it's in place (so you can use it again later), go under the Select menu and choose Save Selection. This brings up the Save Selection dialog. Enter a name in the Name field and click OK to save your selection.

Step Three:

Now you can get that selection back (known as "reloading" by Elements wizards) at any time by going to the Select menu and choosing Load Selection. If you've saved more than one selection, they'll be listed in the Selection dropdown menu—just choose which one you want to "load" and click OK. The saved selection will appear in your image.

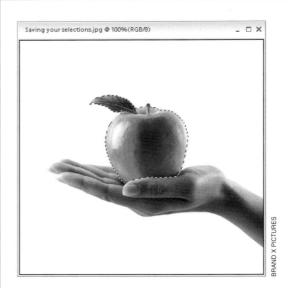

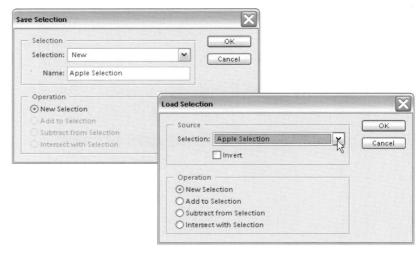

If you've tried the Lasso tool for making selections, then you know two things: (1) It's pretty useful, and (2) tracing right along the edge of the object you're trying to select can be pretty tricky. But you can get help in the form of a tool called (are you ready for this?) the Magnetic Lasso tool! If the edges of the object you're trying to select are fairly well defined, this tool will automatically snap to the edges (as if they're magnetic), saving you time and frustration (well, it can save frustration if you know these tips).

Getting Elements to Help You Make Tricky Selections

Step One:

Click-and-hold for a moment on the Lasso tool in the Toolbox, and a menu will pop out where you can choose the Magnetic Lasso tool.

Step Two:

Open an image in which you want to make a selection. Click once near the edge of an object that you want to select. Without holding the mouse button, move the Magnetic Lasso tool along the edge of the object, and the selection will snap into place. Don't move too far away from the object; stay kind of close to it for the best results.

Step Three:

As you drag, the tool lays down little points along the edge. If you're dragging the mouse and it misses an edge, just press Backspace to remove the last point and try again. If it still misses, hold the Alt key and then hold down the mouse button, which temporarily switches you to the regular Lasso tool, and drag a Lasso selection around the trouble area. Then, release the Alt key, then the mouse button, and you're back to the Magnetic Lasso tool to finish up the job. *Note*: You can also click the Magnetic Lasso tool to add selection points if needed.

This should be called "The Kevin Ames Chapter."
Actually, it really should be called the "I Hate Kevin Ames Chapter" because I already had this entire chapter written, until I stopped by Kevin's studio in

Head Games retouching portraits

Atlanta one night to show him the rough draft of the book. What should have been a 15-minute visit went on until after midnight with him showing me some amazing portrait retouching tricks for the book. So I had to go back home and basically rewrite, update, and tweak the entire chapter. Which I can tell you, is no fun once you think a chapter is done and you're about a week from deadline. But the stuff he showed me was so cool, I literally couldn't sleep that night because I knew his techniques would take this chapter to the next level. And even though Kevin was incredibly gracious to let me share his techniques with my readers (that's the kind of guy Kevin is), there was no real way I was going to name this chapter "The Kevin Ames Chapter." That's when it became clear to me-I would have to kill him. But then I remembered Kevin had mentioned that Jim DiVitale had developed some of the techniques that he had showed me, so now it was going to be a double murder. I thought, "Hey, they both live in Atlanta, how hard could this be?" but the more I thought about it, what with having to fly back up there and having to fly on Delta (stuffed in like human cattle), I figured I'd just give them the credit they deserve and go on with my life. Thus far, it's worked out okay.

Removing **Blemishes**

When it comes to removing blemishes, acne, or any other imperfections on the skin, our goal is to maintain as much of the original skin texture as possible. That way, our retouch doesn't look pasty and obvious. Here are three techniques I use that work nicely.

TECHNIQUE #1

Step One:

Open a photo containing some skin imperfections you want to remove. Press the letter Z to access the Zoom tool and zoom in if needed.

Step Two:

Choose the Clone Stamp tool from the Toolbox (or press the S key). From the Brush Picker (which you access by clicking on the Brush Preset icon in the Options Bar), choose a soft-edged brush that's slightly larger than the blemish you want to remove.

TIP: Once you're working, if you need to quickly adjust the brush size up or down, use the Bracket keys on your keyboard: the Left Bracket key ([) makes your brush smaller; the Right (]) larger.

Soft Light Hard Light Vivid Light

Linear Light
Pin Light
Hard Mix
Difference
Exclusion
Hue
Saturation
Color
Luminosity

In the Options Bar, change the Mode pop-up menu of the Clone Stamp tool to Lighten. With its Mode set to Lighten, the Clone Stamp will affect only pixels that are darker than the area you're going to sample. The lighter pixels (the regular flesh tone) will pretty much stay intact, and only the darker pixels (the blemish) will be affected.

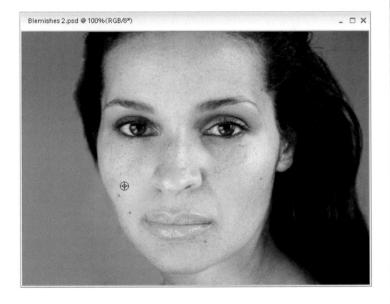

Step Four:

Find an area right near the blemish that's pretty clean (no visible spots, blemishes, etc.), hold the Alt key, and click once. The Clone Stamp will now sample the skin from that area. Try to make sure this sample area is very near the blemish so the skin tones will match. If you move too far away, you risk having your repair appear in a slightly different color, which is a dead giveaway of a repair.

Step Five:

Now, move your cursor directly over the blemish and click just once. Don't paint! Just click. The click will do it—it will remove the blemish instantly, while leaving the skin texture intact. But what if the blemish is lighter than the skin, rather than darker? Simply go to the Options Bar and change the Mode of the Clone Stamp tool to Darken instead of Lighten-it's that easy. On to Technique #2.

TECHNIQUE #2

Step One:

Press L to switch to the Lasso tool. Find a clean area (no blemishes, spots, etc.) near the blemish that you want to remove. In this clean area, use the Lasso tool to make a selection that is slightly larger than the blemish. (Note: If you make a mistake and need to add to your selection, press-and-hold the Shift key while selecting with the Lasso tool; if you need to remove parts of your selection, pressand-hold the Alt key.)

Step Two:

Once your selection is in place, go under the Select menu and choose Feather. When the Feather Selection dialog appears, enter 2 pixels as your Feather Radius and click OK. Feathering blurs the edges of our selected area, which will help hide the traces of our retouch. Feathering (softening) the edges of a selection is a very important part of facial retouching, and you'll do this quite a bit to "hide your tracks," so to speak.

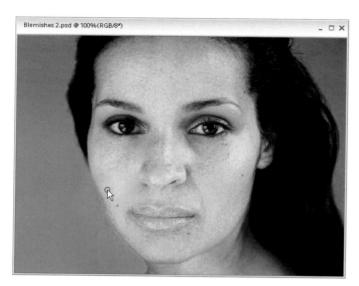

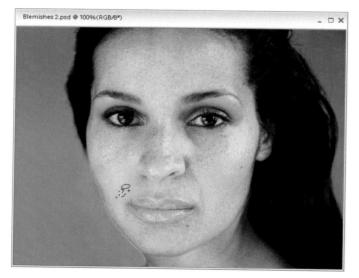

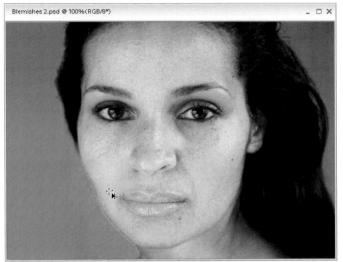

Now that you've softened the edges of the selection, hold Alt-Control, and you'll see your cursor change into two arrowheads—a white one with a black one overlapping it. This is telling you that you're about to copy the selected area. Click within your selection and drag this clean skin area right over the blemish to completely cover it.

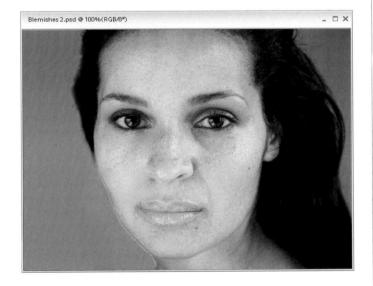

Step Four:

When the clean area covers the blemish, release the keys (and the mouse button, of course) to drop this selected area down onto your photo. Now, press Control-D to deselect. The blemish is gone. Best of all, because you dragged skin over from a nearby area, the full skin texture is perfectly intact, making your repair nearly impossible to detect.

TECHNIQUE #3

Step One:

Get the Healing Brush tool from the Toolbox (or just press the J key). We'll use it on the blemishes—and you'll see it works brilliantly.

Step Two:

Just Alt-click the tool in a clean area of skin, move over the blemish, and click once. That's it. You've got to love a technique that only has only two steps.

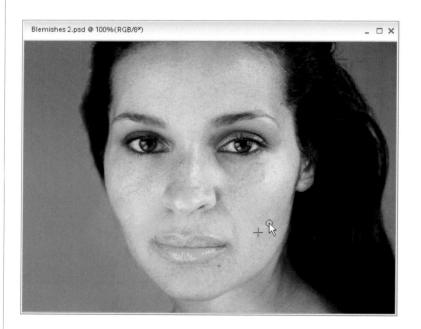

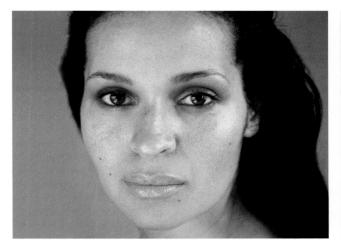

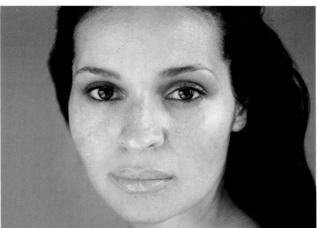

Before After

Here's a quick technique for removing the dark circles that sometimes appear under a person's eyes—especially after a hard night of drinking. At least, that's what I've been told.

Step One:

Open the photo that has the dark circles you want to lessen. Select the Clone Stamp tool in the Toolbox (or press the S key). Then, click on the Brush Preset icon in the Options Bar to open the Brush Picker and choose a softedged brush that's half as wide as the area you want to repair. Press the letter Z to switch to the Zoom tool and zoom in if needed.

Step Two:

Go to the Options Bar and lower the Opacity of the Clone Stamp tool to 50%. Then, change the Mode pop-up menu to Lighten (so you'll only affect areas that are darker than where you'll sample from).

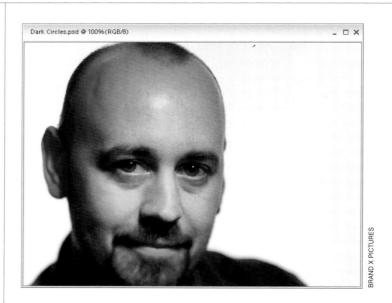

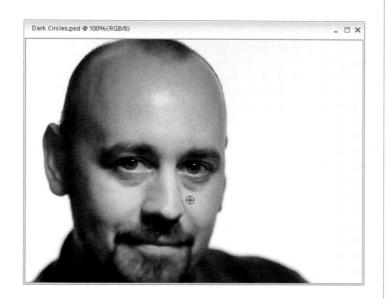

Press-and-hold the Alt key and click once in an area near the eye that isn't affected by the dark circles. If the cheeks aren't too rosy, you can click there, but more likely you'll click (sample) on an area just below the dark circles under the eyes.

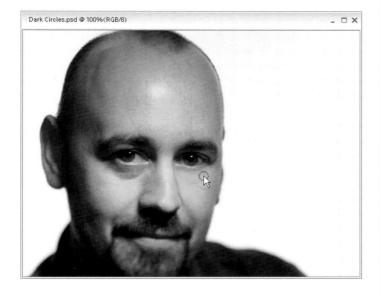

Step Four:

Now, take the Clone Stamp tool and paint over the dark circles to lessen or remove them. It may take two or more strokes for the dark circles to pretty much disappear, so don't be afraid to go back over the same spot if the first stroke didn't work. *Note*: If you want the dark circles to completely disappear, try using the Healing Brush tool (J) from the Toolbox. Simply Alt-click the Healing Brush in a light area under the dark circles, and then paint the circles away.

Before

After

senior portrait retoucher) and don't have the time to use the methods shown

previously, where you deal with each blemish individually.

Lessening Freckles or Facial Acne

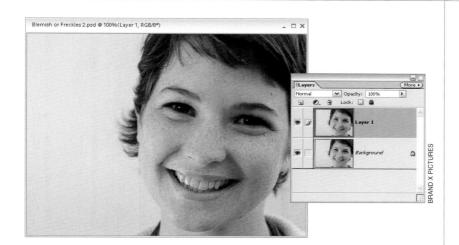

Step One:

Open the photo that you need to retouch. Make a duplicate of the Background layer by going to the Layer menu, under New, and choosing Layer via Copy (or just press Control-J). We'll perform our retouch on this duplicate of the Background layer, named "Layer 1."

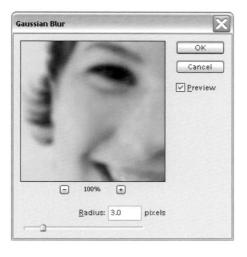

Step Two:

Go under the Filter menu, under Blur, and choose Gaussian Blur. When the Gaussian Blur dialog appears, drag the slider all the way to the left, then drag it slowly to the right until you see the freckles blurred away. The photo should look very blurry, but we'll fix that in just a minute, so don't let that throw you off—make sure it's blurry enough that the freckles are no longer visible. Click OK.

Continued

Hold the Control key and click once on the Create a New Layer icon at the top of the Layers palette. This creates a new blank layer (Layer 2) directly beneath your current layer (the blurry Layer 1).

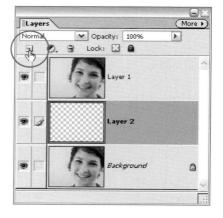

Step Four:

Now, in the Layers palette, click back on the top layer (the blurry Layer 1), then press Control-G to group the blurry layer with the blank layer beneath it (Layer 2). You'll notice that doing this removes all the blurriness from view (and that's exactly what we want to do at this point).

Step Five:

In the Layers palette, click on the middle layer (the blank Layer 2), as you're going to paint on this layer. Press the letter D to set your Foreground color to black. Press the letter B to switch to the Brush tool, then click on the Brush Preset icon in the Options Bar, and from the Brush Picker choose a soft-edged brush.

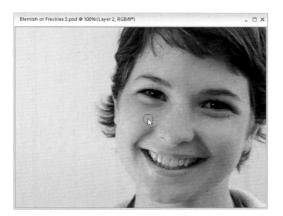

Step Six:

Lower the Opacity setting of your brush in the Options Bar to 50%, and change the Mode pop-up menu from Normal to Lighten. Now when you paint, it will affect only the pixels that are darker than the blurred state. Ahhh, do you see where this is going?

Step Seven:

Now you can paint over the freckle areas, and as you paint you'll see them diminish quite a bit. If they diminish too much, and the person looks "too clean," undo (Control-Z), then lower the Opacity of the brush to 25% and try again.

Before

After

Wrinkles

This is a great trick for removing wrinkles, with a little twist at the end (courtesy of my buddy Kevin Ames) that helps make the technique look more realistic. His little tweak makes a big difference because (depending on the age of the subject) removing every wrinkle would probably make the photo look obviously retouched (in other words, if you're retouching someone in their 70s and you make them look as if they're 20 years old, it's just going to look weird). Here's how to get a more realistic wrinkle removal.

Step One:

Open the photo that needs some wrinkles or crow's-feet lessened or removed.

Step Two:

Duplicate the Background layer by going to the Layer menu, under New, and choosing Layer via Copy (or press Control-J). You'll perform your "wrinkle removal" on this duplicate layer, named "Layer 1" in the Layers palette.

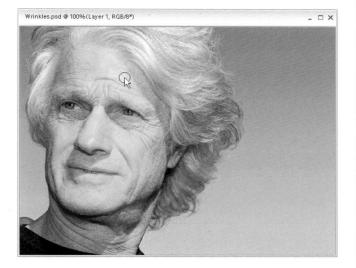

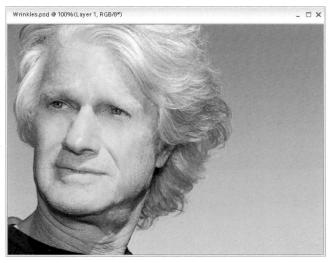

Get the Healing Brush tool from the Toolbox (or press the J key). Then, choose a soft-edged brush from the Brush Picker (which opens when you click the Brush Preset icon in the Options Bar). Choose a brush size that's close to the size of the wrinkles you want to remove.

Step Four:

Find a clean area that's somewhere near the wrinkles (perhaps the upper cheek if you're removing crow's-feet, or if you're removing forehead wrinkles, perhaps just above or below the wrinkle). Hold the Alt key and click once to sample the texture of the skin from that area. Now, take the Healing Brush tool and paint over the wrinkles. As you paint, the wrinkles will disappear, yet the texture and detail of the skin remains intact, which is why this tool is so amazing.

Step Five:

Now that the wrinkles are gone, it's time to bring just enough of them back to make it look realistic. Simply go to the Layers palette and reduce the Opacity of this layer to bring back some of the original wrinkles. This lets a small amount of the original photo (the Background layer, with all its wrinkles still intact) show through. Keep lowering the Opacity until you see the wrinkles, but not nearly as prominent as before.

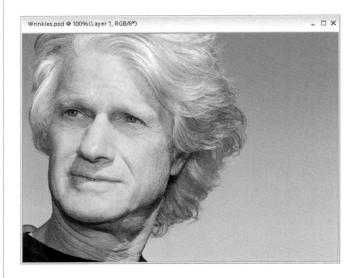

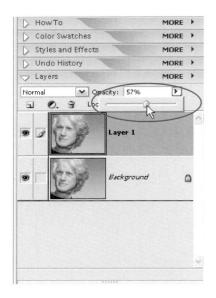

Before

After

If you've ever used Elements' Dodge and Burn tools, you already know how lame they are. That's why the pros choose this method instead—it gives them a level of control that the Dodge and Burn tools just don't offer, and best of all, it doesn't "bruise the pixels." (That's digital retoucher-speak for "it doesn't mess up your original image data while you're editing.")

Step One:

In this tutorial, we're going to dodge areas to add some highlights, then we're going to burn in the background a bit to darken some of those areas. Start by opening the photo you want to dodge and burn.

Step Two:

Go to the Layers palette, and from the More flyout menu choose New Layer (or just Alt-click on the Create a New Layer icon). This accesses the New Layer dialog, which is needed for this technique to work.

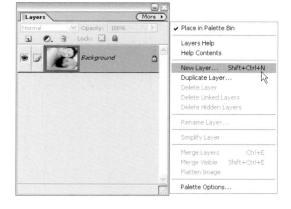

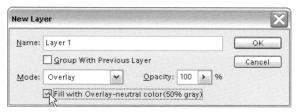

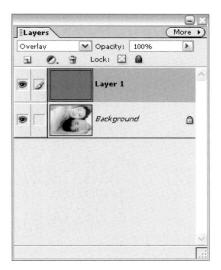

In the New Layer dialog, change the Mode to Overlay, then right below it, choose "Fill with Overlay-neutral color (50% gray)." This is normally grayed out, but when you switch to Overlay mode, this choice becomes available. Click the checkbox to make it active, then click OK.

Step Four:

This creates a new layer, filled with 50% gray, above your Background layer. (When you fill a layer with 50% gray and change the Mode to Overlay, Elements ignores the color. You'll see a gray thumbnail in the Layers palette, but the layer will appear transparent in your image window.)

Step Five:

Press B to switch to the Brush tool, and choose a medium, soft-edged brush in the Brush Picker (which opens when you click the Brush Preset icon in the Options Bar). While in the Options Bar, lower the Opacity to approximately 30%.

Continued

Step Six:

Press D then X to set your Foreground color to white. Begin painting over the areas that you want to highlight (dodge). As you paint, you'll see white strokes appear in the thumbnail of your gray transparent layer, and in the image window you'll see soft highlights.

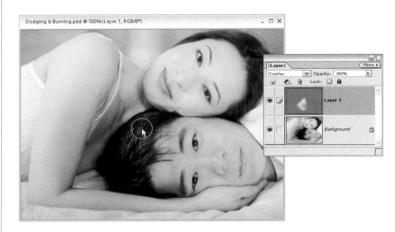

Step Seven:

If your first stab at dodging isn't as intense as you'd like, just release the mouse button, click again, and paint over the same area. Since you're dodging at a low opacity, the highlights will "build up" as you paint over previous strokes. If the highlights appear too intense, just go to the Layers palette and lower the Opacity setting until they blend in.

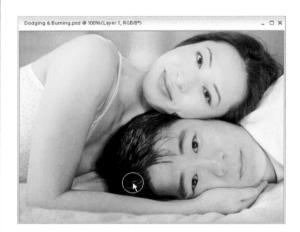

Step Eight:

If there are areas you want to darken (burn) so they're less prominent (such as the background), just press D to switch your Foreground color to black and begin painting in those areas. Okay, ready for another dodging-and-burning method? Good, 'cause I've got a great one.

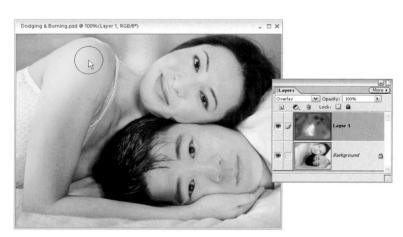

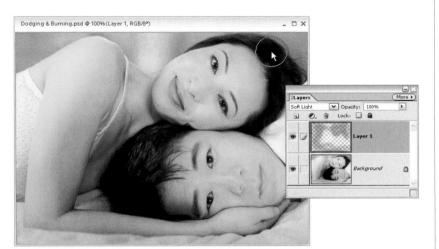

Alternate Technique:

Open the photo that you want to dodge and burn, then just click the Create a New Layer icon in the Layers palette, and change the blend mode in the Layers palette to Soft Light. Now, set white as your Foreground color and you can dodge right on this layer using the Brush tool set to 30% Opacity. To burn, just as before—switch to black. The dodging and burning using this Soft Light layer appears a bit softer and milder than the previous technique, so you should definitely try both to see which one you prefer.

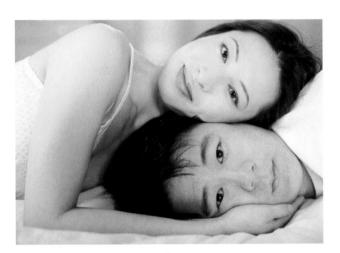

Before

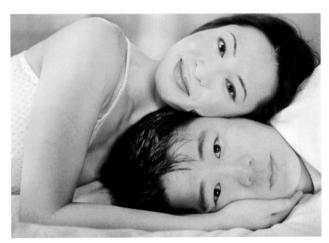

After

Colorizing Hair

This technique (that I learned from Kevin Ames) gives you maximum control and flexibility while changing or adjusting hair color, and because of the use of an adjustment layer, you're not "bruising the pixels." Instead, you're following the enlightened path of "non-destructive retouching."

Step One:

Open the photo you want to retouch. Choose Hue/Saturation from the Create Adjustment Layer pop-up menu at the top of the Layers palette.

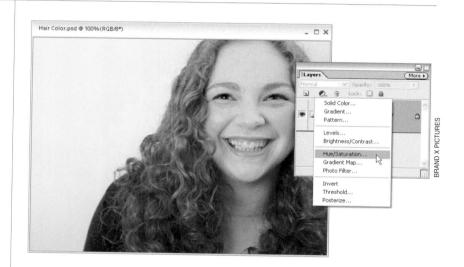

Step Two:

When the dialog appears, click on the checkbox for Colorize (in the bottom right-hand corner of the dialog) and then drag the Hue slider to the approximate color you'd like for the hair. Doing this will colorize the entire image, but don't let that throw you—just focus on the hair color. You may also have to drag the Saturation slider to the right a bit to make the color more vibrant. Now, click OK and the entire photo will have a heavy color cast over it.

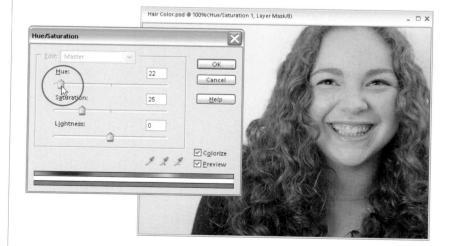

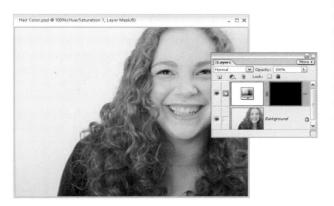

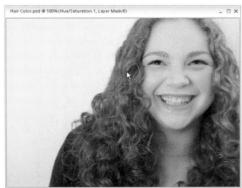

The Photoshop Elements 3 Book

Press the letter X until your Foreground color is black, and then press Alt-Backspace to fill the layer mask of the Hue/Saturation adjustment layer with black. Doing so removes the colorized tint from the photo.

Step Four:

Press B to switch to the Brush tool. Choose a soft-edged brush from the Brush Picker in the Options Bar. Press X to set your Foreground color to white and begin painting over the hair. As you paint, the tint you added with Hue/Saturation is painted back in. Once the hair is fully painted, change the layer blend mode of your Hue/Saturation adjustment layer to Color, then lower the Opacity in the Layers palette until the hair color looks natural.

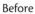

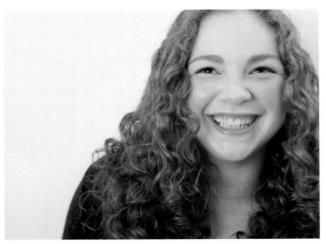

After

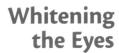

This is a great little technique for quickly whitening the whites of the eyes, and it has the added benefit of removing any redness in the eye along the way. Note: By redness, I mean the "bloodshot-I-stayed-up-too-late" type of redness, not the "red-eye-from-a-flash-mounted-above-the-lens" type of redness, which is addressed in Chapter 4.

Step One:

Open the photo where the subject's eyes need whitening. Press the letter Z to switch to the Zoom tool and zoom in if needed.

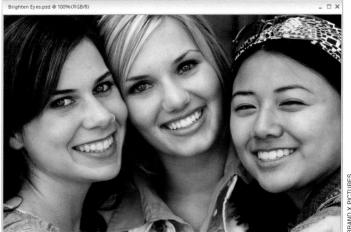

Step Two:

Choose the Lasso tool from the Toolbox (or press the L key) and draw a selection around one side of whites in one of the eyes. Press-and-hold the Shift key and draw selections around the other area of whites in the same eye and the whites of the other eye, until all the whites are selected in both eyes.

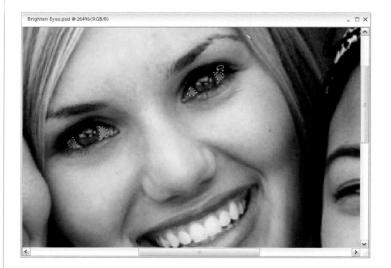

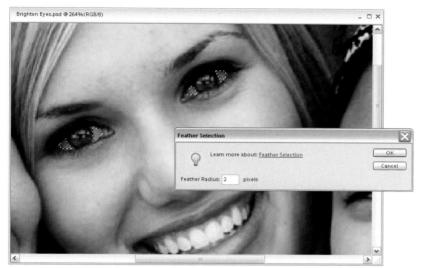

Go under the Select menu and choose Feather. You'll need to use Feather to soften the edges of your selection so your retouch isn't obvious. In the Feather Selection dialog, enter 2 pixels and click OK.

Step Four:

Go under the Enhance menu, under Adjust Color, and choose Adjust Hue/ Saturation. When the Hue/Saturation dialog appears, choose Reds from the Edit pop-up menu at the top (to edit just the reds in the selection). Now, drag the Saturation slider to the left to lower the amount of saturation in the reds (which removes any bloodshot appearance in the whites of the eyes).

Step Five:

While you're still in the Hue/Saturation dialog, from the Edit menu switch back to Master. Drag the Lightness slider to the right to increase the lightness of the whites of the eyes.

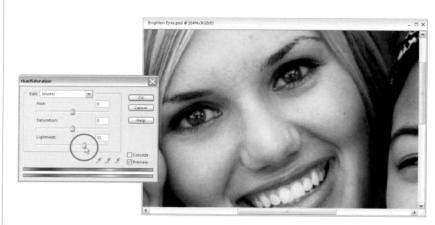

Step Six:

Click OK in the Hue/Saturation dialog to apply your adjustments, and then press Control-D to deselect and complete the enhancement.

Before

After

Making Eyes that Sparkle

This is another one of those "30-second miracles" for enhancing the eyes. This technique makes the eyes seem to sparkle by accentuating the catch lights, and generally draws attention to the eyes by making them look sharp and crisp (crisp in the "sharp and clean" sense, not crisp in the "I-burnedmy-retina-while-looking-at-the-sun" sense).

Step One:

Open the photo that you want to retouch. Make a duplicate of the Background layer by going under the Layer menu, under New, and choosing Layer via Copy (or press Control-J), which creates a new layer named "Layer 1." Press the Z key to switch to the Zoom tool and zoom in if needed.

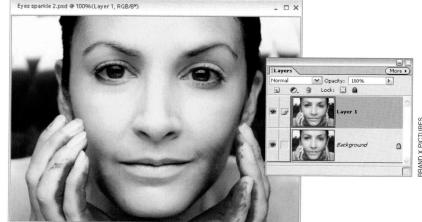

Step Two:

Go under the Filter menu, under Sharpen, and choose Unsharp Mask. (It sounds like this filter would make things blurry, but it's actually for sharpening photos.) When the Unsharp Mask dialog appears, enter your settings. (If you need some settings, go to the first technique, named "Basic Sharpening," in Chapter 11, or you can use my favorite all-around sharpening settings of Amount: 85%, Radius: 1, and Threshold: 4 for now). Then click OK to sharpen the entire photo.

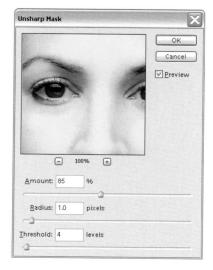

After you've applied the Unsharp Mask filter, apply it again using the same settings by pressing Control-F, and then apply it one more time using the same keyboard shortcut (you'll apply it three times in all). The eyes will probably look nice and crisp at this point, but the rest of the person will be severely oversharpened, and you'll probably see lots of noise and other unpleasant artifacts.

Step Four:

Hold the Control key and click once on the Create a New Layer icon at the top of the Layers palette. This creates a new blank layer directly beneath your sharpened layer. Now, in the Layers palette, click back on the top layer (the sharpened layer), then press Control-G to group the sharpened layer with the blank layer beneath it. This removes all the visible sharpness (at least for now). In the Layers palette, click on the middle layer (the blank layer), as you're going to paint on this layer.

Step Five:

Press the letter D to set your Foreground color to black. Then, press B to switch to the Brush tool, and from the Brush Picker in the Options Bar, choose a softedged brush that's a little smaller than your subject's eyes. Now paint over just the irises and pupils of the eyes to reveal the sharpening, making the eyes really sparkle and completing the effect.

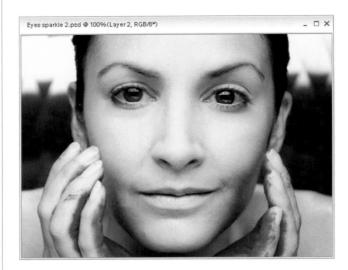

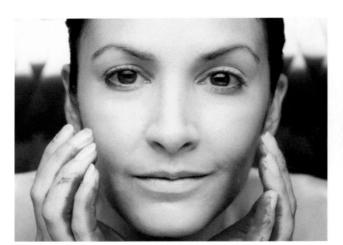

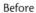

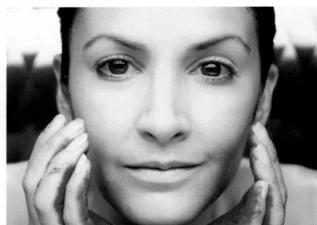

After

Let's face it—not every face is perfect, so we sometimes resort to using make-up to enhance our facial features. So what happens when the model for your photo shoot forgets to wear mascara—or worse yet—has transparent eyebrows? Well, don't browbeat her (okay, that was lame)—just fix it in Elements.

Enhancing Eyebrows and Eyelashes

Step One:Open the photo that you want to enhance.

Step Two:

Go to the Layers palette and choose Levels from the Create Adjustment Layer pop-up menu (it's the half white/half black circle icon at the top of the palette).

Step Three:

When the Levels dialog appears, drag the shadow Input Levels slider to the right to darken the image. The entire image will darken, but don't worry, we'll fix that later—just focus on the eyebrows and eyelashes as you drag the slider. When the eyebrows and eyelashes look good to you, click OK.

Step Four:

Press the letter X until your Foreground color is set to black. Then, press Alt-Backspace to fill your adjustment layer's layer mask with black. This hides the Levels adjustment you just made, revealing your original Background layer.

Step Five:

Now, press the letter B to switch to the Brush tool. Click on the Brush Preset icon in the Options Bar and in the resulting Brush Picker choose a small, soft-edged brush that's the same size as the largest area of the eyebrows. Press the X key again to switch your Foreground color to white and begin painting over the eyebrows. As you get to smaller areas of the eyebrows, press the Left Bracket key ([) to decrease the size of your brush.

Step Six:

If the eyebrows are too dark, don't sweat it—we'll fix that later. Now let's move on to the eyelashes, so press the Left Bracket key ([) to decrease the size of your Brush tool. (You may have to press the Bracket key several times to make the brush the size of the eyelashes.)

Step Seven:

With your small Brush tool, lightly paint over the eyelashes on both eyes. *Note:* If needed, press the Z key to switch to the Zoom tool and zoom into the image for a better look. Then, press the B key to switch back to the Brush tool and begin painting.

Step Eight:

Now the effect may be too intense, so lower the Opacity in the Layers palette to around 65% or until the effect looks natural.

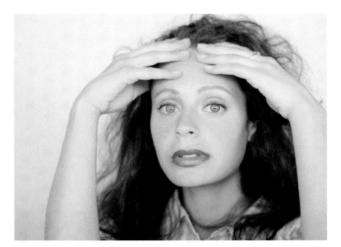

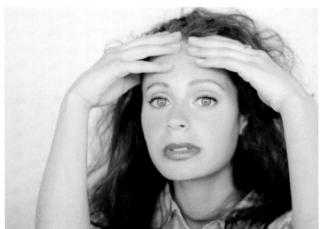

Before After

Whitening and Brightening Teeth

This really should be called "Removing Yellowing, Then Whitening Teeth" because almost everyone has some yellowing, so we remove that first before we move on to the whitening process. This is a simple technique, but the results have a big impact on the overall look of the portrait, and that's why I do this to every single portrait where the subject is smiling.

Step One:

Open the photo you need to retouch. Press Z to switch to the Zoom tool, and zoom in if needed.

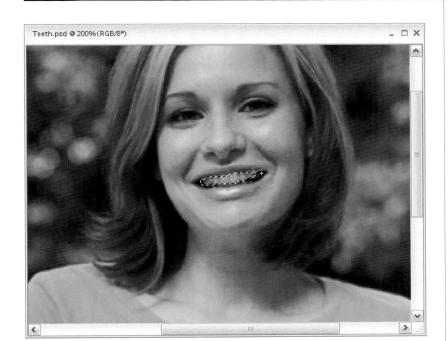

Step Two:

Press L to switch to the Lasso tool, and carefully draw a selection around the teeth, being careful not to select any of the gums or lips. If you've missed a spot, press-and-hold Shift while using the Lasso tool to add to your selection, or press-and-hold Alt and drag the Lasso to remove parts of the selection.

Step Three:

Go under the Select menu and choose Feather. When the Feather Selection dialog appears, enter 1 pixel and click OK to smooth the edges of your selection. That way, you won't see a hard edge along the area you selected once you've whitened the teeth.

Step Four:

Go under the Enhance menu, under Adjust Color, and choose Adjust Hue/Saturation. When the dialog appears, choose Yellows from the Edit popup menu at the top. Then, drag the Saturation slider to the left to remove the yellowing from the teeth.

Step Five:

Now that the yellowing is removed, switch the Edit pop-up menu back to Master, and drag the Lightness slider to the right to whiten and brighten the teeth. Be careful not to drag it too far, or the retouch will be obvious. Click OK in the Hue/Saturation dialog and your enhancements will be applied. Press Control-D to deselect and see your finished retouch.

Before After

Removing Hot Spots

If you've ever had to deal with hot spots (shiny areas on your subject's face caused by uneven lighting, or the flash reflecting off shiny surfaces, making your subject look as if they're sweating), you know they can be pretty tough to correct. That is, unless you know this trick.

Step One:

Open the photo that has hot spots that need to be toned down. Press the Z key to switch to the Zoom tool and zoom in if needed. Select the Clone Stamp tool in the Toolbox (or press the S key). Go to the Options Bar and change the Mode pop-up menu from Normal to Darken and lower the Opacity to 50%. By changing the Mode to Darken, we'll only affect pixels that are lighter than the area we're sampling, and those lighter pixels are the hot spots.

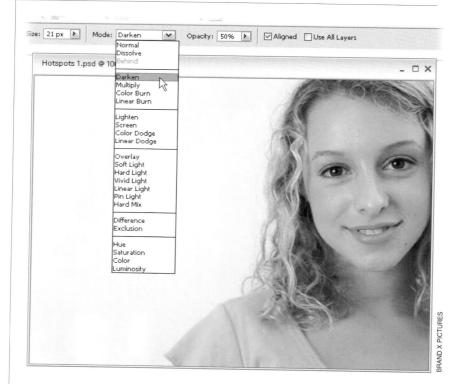

Step Two:

Choose a medium, soft-edged brush from the Brush Picker (found by clicking the Brush Preset icon in the Options Bar), then hold the Alt key and click once in a clean area of skin (an area with no hot spots). This will be your sample area, or reference point, so Elements knows to affect only pixels that are lighter than this.

Step Three:

Start gently painting over the hot spot areas with the Clone Stamp tool, and as you do, the hot spots will fade away.

Step Four:

As you work on different hot spots, you'll have to resample (Alt-click) on nearby areas of skin so the skin tone matches. For example, when you move on to another hot spot, sample an area of skin near the new hot spot that you'll be working on.

Step Five:

Here's the result after about 60 seconds of hot-spot retouching using this technique. Notice how the hot spots are now gone. Much of this was done with brush strokes, but just clicking once or twice with the Clone Stamp tool often works, too.

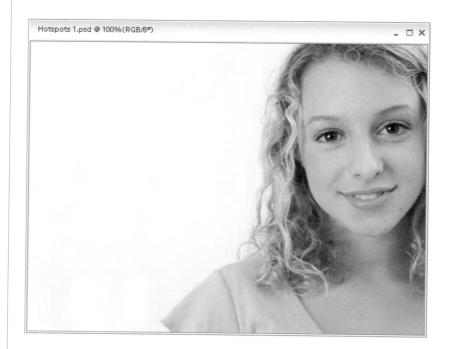

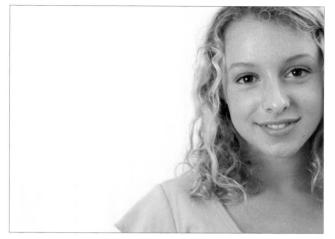

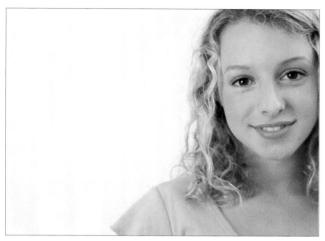

Before

After

Softening

This is a technique I learned from Chicago-based retoucher David Cuerdon. David uses this technique in fashion and glamour photography to give skin a smooth, silky look, and it's also popular in shots of female seniors (not high school seniors. The other seniors).

Step One:

Open the photo that you want to give the glamour skin-softening effect and duplicate the Background layer by going under the Layer menu, under New, and choosing Layer via Copy (or press Control-J).

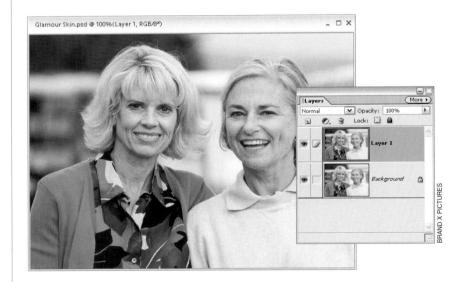

Step Two:

Go under the Filter menu, under Blur, and choose Gaussian Blur. When the dialog appears, enter from 3 to 6 pixels of blur (depending on how soft you want the skin), to put a blur over the entire photo. When it looks good to you, click OK in the dialog.

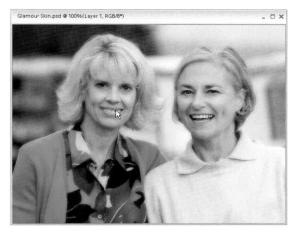

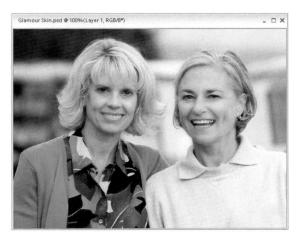

Next, lower the Opacity of this layer by 50%. At this point, the blurring effect is reduced and now the photo has a soft glow to it. In some cases, you may want to leave it at this, with an overall soft, glamorous effect (you sometimes see portraits of people over 60 with this overall softening), so your retouch is complete. If this is too much softening for your subject, go on to the next steps.

Step Four:

What really pulls this technique together is selectively bringing back details in some of the facial areas. Press E to switch to the Eraser tool, choose a soft-edged brush from the Brush Picker in the Options Bar, and erase over the facial areas that are supposed to have sharp detail, such as eyebrows, lips, and teeth. What you're doing is erasing the blurriness, and thereby revealing the original features on the Background layer beneath your blurry layer.

Step Five:

David completes his retouch at Step Four, leaving the subject's clothes, hair, background, etc. with the soft glow. I prefer to switch to a larger, soft-edged Eraser tool and erase over everything else except the skin—so I erase over the hair, the background, etc., so everything has sharp detail except the skin. This is totally a personal preference, so I recommend trying both and seeing which fits your particular needs.

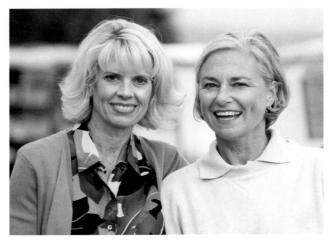

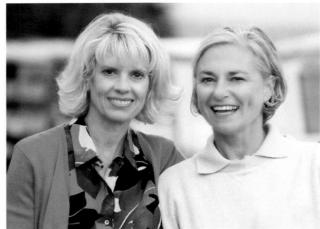

Before

After

Transforming a Frown into a Smile

Step One:Open the photo that you want to retouch.

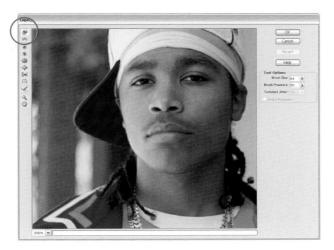

Step Two:

Go under the Filter menu, under Distort, and choose Liquify. When the Liquify dialog appears, choose the Zoom tool (it looks like a magnifying glass) from the Liquify Toolbar (found along the left edge of the dialog). Click it once or twice within the preview window to zoom in closer on your subject's face. Then, choose the Warp tool (it's the top tool in the Liquify Toolbar).

In the Tool Options on the right side of the dialog, choose a brush size that's roughly the size of the person's cheek. Place the brush at the base of a cheek and click-and-"tug" slightly up. This tugging of the cheek makes the corner of the mouth turn up, creating a smile.

Step Four:

Repeat the "tug" on the opposite side of the mouth, using the already tugged side as a visual guide as to how far to tug. Be careful not to tug too far, or you'll turn your subject into the Joker from *Batman Returns*. Click OK in Liquify to apply the change, and the retouch is applied to your photo.

Before

After

Digital Nose Job

This is a very simple technique for decreasing the size of your subject's nose by 15 to 20%. The actual shrinking of the nose is a breeze and only takes a minute or two—you may spend a little bit of time cloning away the sides of the original nose, but since the new nose winds up on its own layer, it makes this cloning a lot easier. Here's how it's done:

Step One:

Open the photo that you want to retouch. Press the Z key to switch to the Zoom tool and zoom in if needed. Press L to switch to the Lasso tool, and draw a loose selection around your subject's nose. Make sure you don't make this selection too close or too precise—you need to capture some flesh-tone area around the nose as well.

Step Two:

To soften the edges of your selection, go under the Select menu and choose Feather. When the Feather Selection dialog appears, for Feather Radius enter 10 pixels (for high-res, 300-ppi images, enter 22 pixels), then click OK.

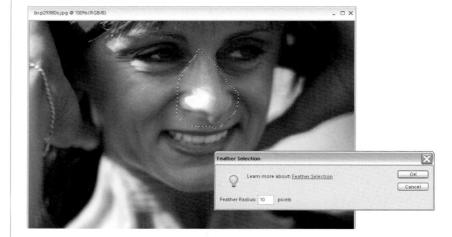

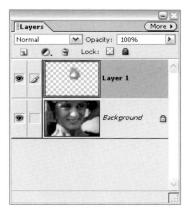

Now, go under the Layer menu, under New, and choose Layer via Copy. This will copy just the selected area to a new layer (Layer 1).

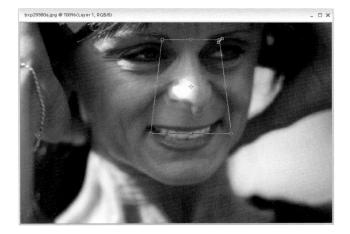

bxp29980s.jpg \$ 1004(Background, RGR8)

Step Four:

Press Control-T to bring up the Free Transform bounding box. Hold Shift-Alt-Control, then grab the upper right-hand corner point of the bounding box and drag inward to add a perspective effect to the nose. Doing this gives the person a pug nose, so release all the keys, then grab the top center point and drag straight downward to undo the "pug effect" and make the nose look natural again, but now it's smaller.

Step Five:

When the new size looks about right, press Enter to lock in your changes. If any of the old nose peeks out from behind the new nose, go to the Layers palette, click on the Background layer, and then use the Clone Stamp tool (S) to clone away those areas: Sample an area next to the nose by Alt-clicking, and then clone right over the old nose, completing the effect.

Before After

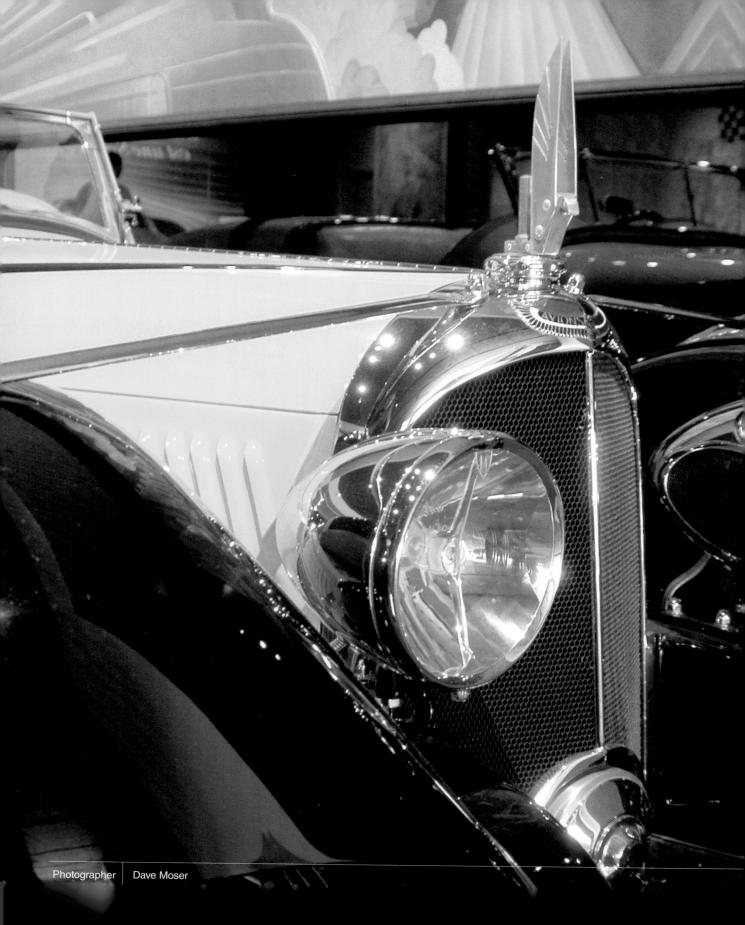

Okay, if you remember that movie (Invasion of the Body Snatchers) you're way older than I am (remember, I'm only 19), and therefore, for the rest of this chapter intro, I'll refer to you as either "gramps" or

Invasion of the Body Snatchers body sculpting

"meemaa" (depending on your gender and what kind of mood I'm in). This chapter is a testament to the fact that people's bodies are simply not perfect, with the possible exception of my own, which I might say is pretty darn fine because of all the healthy food I eat at sundry drive-thru eating establishments that shall remain nameless (Wendy's). Anyway, your goal (my goal, our common goal, etc.) is to make people look as good in photos as they look in real life. This is a constant challenge because many people eat at McDonald's. Luckily, there are a ton of tricks employed by professional retouchers (who use terms like digital plastic surgery, Botox in a box, digital liposuction, liquid tummy tucks, noselectomies, stomalectomies, and big ol' nasty feetalectomies) that can take a person who hasn't seen a sit-up or a stomach crunch since they tested for the President's Council on Physical Fitness and Sports (which for me, was just one year ago, when I was a senior) and make them look like Wonder Woman or Superman on a good day. In this chapter, you'll learn the pros' secrets for transforming people who basically look like Shrek into people who look like the person who produced Shrek (I don't really know who that is, but those Hollywood types always look good, what with their personal trainers and all).

Slimming and Trimming

This is an incredibly popular technique because it consistently works so well, and because just about everyone would like to look about 10 to 15 pounds thinner. I've never applied this technique to a photo and (a) been caught, or (b) not had clients absolutely love the way they look. The most important part of this technique may be not telling the client you used it.

Step One:

Open the photo of the person that you want to put on a quick diet.

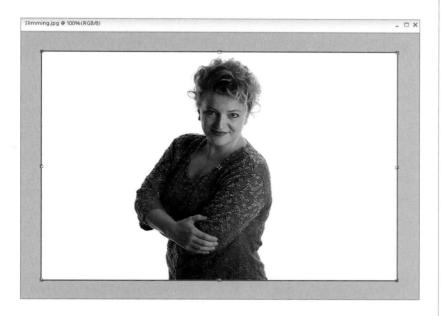

Step Two:

Maximize your view if needed by going under Window, under Images, and choosing Maximize Mode or click the Maximize button in the upper right-hand corner of the image window. Now, press Control-A to put a selection around the entire photo. Then, press Control-T to bring up the Free Transform command. The Free Transform handles will appear at the corners and sides of your photo.

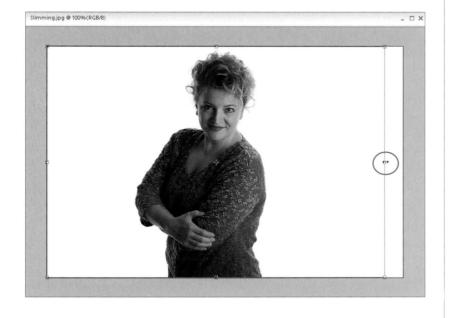

Step Three:

Grab the right-center handle and drag it horizontally toward the left to slim the subject. The farther you drag, the slimmer the subject becomes. How far is too far (in other words, how far can you drag before people start looking like they've been retouched)? Look in the Options Bar at the Width field as a guide.

Step Four:

You're pretty safe to drag inward to around 95%, although I've been known to go to 94% or even 93% once in a while (it depends on the photo).

Step Five:

Press Enter to lock in your transformation and press Control-D to deselect. Now that you've moved the image area over a bit, you'll have to use the Crop tool (C) to crop away the background area that is now visible on the right side of your photo. After you drag out your cropping border over your image, press the Enter key to complete your crop.

You can see how effective this simple little trick is at slimming and trimming your subject. Also, notice that because we didn't drag too far, the subject still looks very natural.

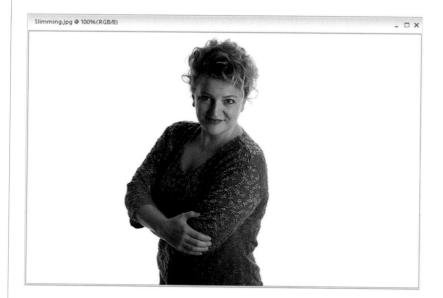

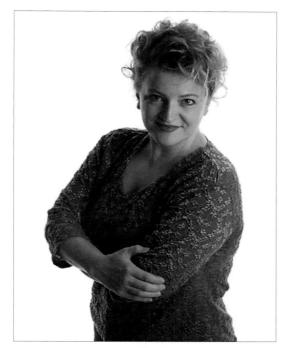

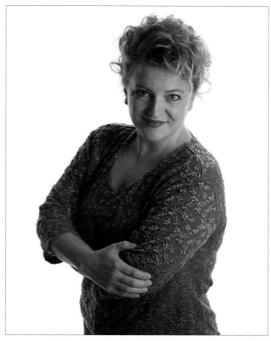

Before

After

Removing Love Handles

This is a very handy body-sculpting technique, and you'll probably be surprised at how many times you'll wind up using it. It uses Liquify, which many people first dismissed as a "toy for giving people bug-eyes and huge lips," but it didn't take long for professional retouchers to see how powerful this tool could really be.

Step One:

Open the photo that has a love handle repair just waiting to happen.

Step Two:

Go under the Filter menu, under Distort, and choose Liquify. When the Liquify dialog appears, click on the Zoom tool in the Toolbar on the lefthand side of the dialog, and then drag out a selection around the area you want to work on to give you a close-up view for greater accuracy.

Get the Shift Pixels tool from Liquify's Toolbar (it's the seventh tool down). Choose a relatively small brush size using the Brush Size field near the top-right of the Liquify dialog. With it, paint a downward stroke starting just above and outside of the left love handle and continuing downward. The pixels will shift back in toward the body, removing the love handle as you paint. (Note: When removing love handles on the right side, paint upward rather than downward. Why? That's just the way it works.) When you click OK, the love handle repair is complete, and you'll see the difference a quick 30-second retouch can make.

Before

After

Slimming Buttocks, Thighs, and Arms

This technique (which I picked up from Helene DeLillo) works great for trimming up thighs and buttocks by repositioning parts of the existing areas. It's deceptively simple and amazingly effective. At the end of this tutorial, I also show how to use the same technique to slim arms (helpful in getting rid of "grannies," which is an industry term for loose skin under a person's arm. Hey, I didn't make up the term, I just fix the problems).

Step One:

Open the photo that you need to retouch. In this case, we're going to reduce the size of this person's buttocks.

Step Two:

Press L to switch to the Lasso tool and make a selection loosely around the area you want to retouch. It's important to select some background area, because that background will be used to cover over the existing area. Once you have your selection in place, soften the edges just a bit by going under the Select menu and choosing Feather. Enter 1 to 2 pixels and click OK to soften the edges of your selection.

Go under the Layer menu, under New, and choose Layer via Copy (or press Control-J). This will create a new layer with just your selected area on it.

Step Four:

Press V to switch to the Move tool, click on the area you had selected (it's on its own separate layer now), and drag inward toward the rest of the body. You're literally moving the edge of the body, thereby reducing the width of the hips and buttocks at the same time.

Step Five:

When you do this, you'll usually have a small chunk of the old body left over that you'll have to remove from the original Background layer. Press Z to switch to the Zoom tool and zoom in, then click on the Background layer in the Layers palette to make it the active layer. Get the Clone Stamp tool from the Toolbox (or press the S key), choose a small, hard-edged brush from the Brush Picker in the Options Bar, and Alt-click in an area on the background that's very near to where you need to retouch. Then clone the background over the leftover body to produce smooth curves.

Step Six:

Once you've removed those little chunks (I know, chunks probably isn't the best word to use, but yet on some level, it fits), the retouch is done.

Before

JUST THE THIGHS

Step One:

This time, we're going to select the top of a person's thigh with the Lasso tool (L). Depending on the photo, you may not have to feather the edges (as we did in Step Two of the previous technique), but it probably wouldn't hurt.

Step Two:

Once it's selected, go under the Layer menu, under New, and choose Layer via Copy. This will create a new layer with just your selected area on it. Press V to switch to the Move tool, and drag the copied area upward to slim the thigh.

Step Three:

Again, you'll probably have little chunks (okay, how about "shards" or "pieces" instead? Nah. They're chunks) that you'll have to remove, so switch to the Background layer, get the Clone Stamp tool again (S), Alt-click near the area you need to retouch, and click to clone the background area over the chunks.

Once you've cloned over all the chunks (this process is called "dechunk-inization"—not really, but it should be), the retouch is complete. In the next technique, we're going to apply the same effect to trim a subject's arm.

Before

After

SLIMMING ARMS

Step One:

Here's the technique applied to the arms. Start by selecting the area you want to slim with the Lasso tool (L) (sound familiar?). Once it's selected, go under the Layer menu, under New, and choose Layer via Copy. This will create a new layer with just your selected area on it.

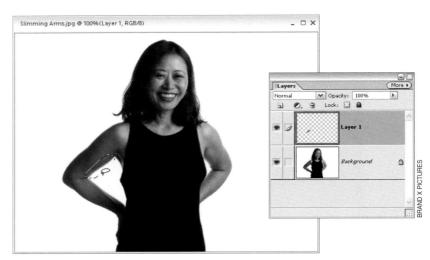

Step Two:

Press the letter V to switch to the Move tool and drag your copied area toward the inside of the arm to slim the arm.

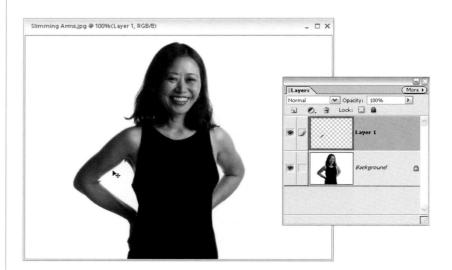

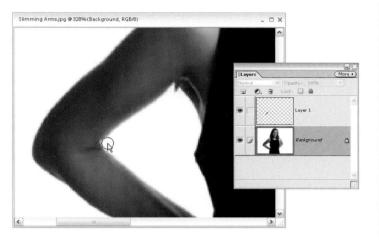

As usual, dragging this area will leave little chunks on the background, so go to the Layers palette and click on the Background layer, switch to the Clone Stamp tool (S), Alt-click the background, and then click to clone away those excess areas. It's a subtle retouching effect, but on the right person, it's worth a million bucks (meaning, you can charge a million bucks).

Before

After

This is where the fun begins. Okay, I don't want to discount all the immeasurable fun you've had up to this point, but now it gets really fun. This is where we get to play around in Elements and change reality,

38 Special photographic special effects

and then send the client an invoice for our "playtime." Did the model not have the right color blouse on? No sweat, change it in Elements. Was it an overcast day when you shot the exterior of your client's house? Just drop in a new sky. Do you want to warm up a cold photo like you did in the old days by screwing on an 81A filter? Now you can do it digitally. Do you want to take your income to the next level? Just shoot a crisp shot of a \$20 bill, retouch it a bit, print out a few hundred sheets on your color laser printer and head for Vegas. (Okay, forget that last one, but you get the idea.) This is where the rubber meets the road, where the nose gets put to the grindstone, where the meat meets the potatoes... (Where the meat meets the potatoes? Hey, it's late.)

Blurred Lighting Vignette

This technique is very popular with portrait and wedding photographers. It creates a dramatic effect by giving the appearance that a soft light is focused on the subject, while dimming the surrounding area (which helps draw the eye to the subject).

Step One:

Open the photo that you want to add a soft light vignette to. Go under the Layer menu and choose Duplicate Layer (or just drag-and-drop the Background layer on the Create a New Layer icon at the top left of the Layers palette). This will duplicate the Background layer onto its own layer (Background copy).

Step Two:

Get the Elliptical Marquee tool from the Toolbox (or press Shift-M until you have the tool) and draw an oval-shaped selection where you'd like the soft light to fall on your subject. In the Layers palette, hold the Control key and click on the Create a New Layer icon. This creates a layer (Layer 1) directly beneath your current layer (Background copy).

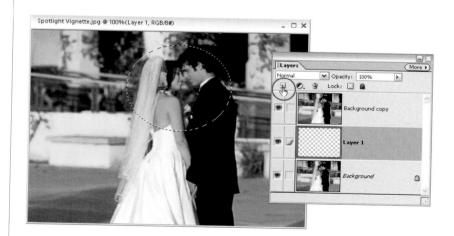

In the Layers palette, click back on the top layer (Background copy). Now, press Control-G to group your copied Background layer with the blank layer beneath it. Don't deselect yet.

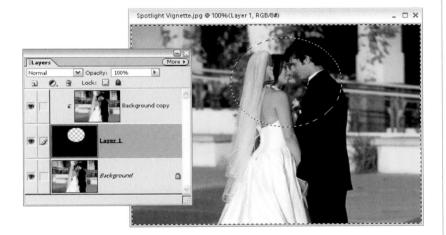

Step Four:

In the Layers palette, click on the middle layer (the blank Layer 1). Go under the Select menu and choose Inverse (which selects everything but the oval). Press the letter D to set your Foreground color to black, then press Alt-Backspace to fill the area around the oval with black. You won't see the black onscreen, but you'll see it in Layer 1's thumbnail in the Layers palette.

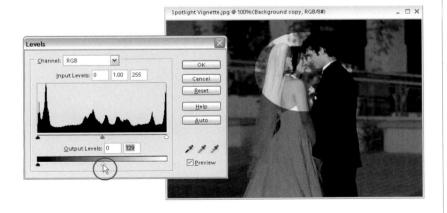

Step Five:

Press Control-D to deselect. In the Layers palette, click back on the top layer. Press Control-L to bring up the Levels dialog. Grab the lower right-hand Output Levels slider and drag it to the left to darken the area outside the oval. When it looks fairly dark, click OK.

Step Six:

In the Layers palette, click on the middle layer again. Go under the Filter menu, under Blur, and choose Gaussian Blur. When the Gaussian Blur dialog appears, drag the slider all the way to the left, then start dragging it to the right to soften the edges of the oval until the oval area in your photo looks like a soft light. When you click OK to apply the Gaussian Blur, the effect is complete, and now you have a soft-lighting vignette falling on your subject that fades as it moves farther away.

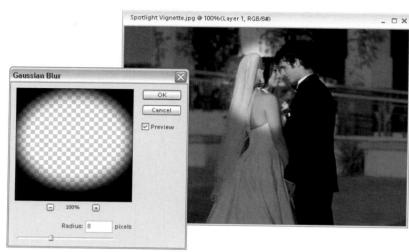

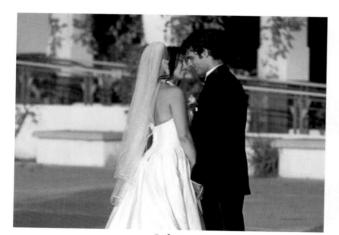

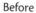

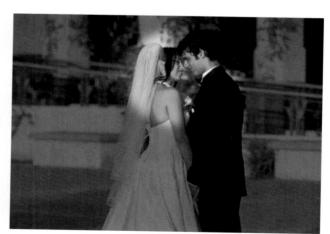

After

This is a popular technique for focusing attention by the use of color (or really, it's more like the use of less color—if everything's in black-and-white, anything that's in color will immediately draw the viewer's eye). As popular as this technique is, it's absolutely a breeze to create. Here's how.

Using Color for Emphasis

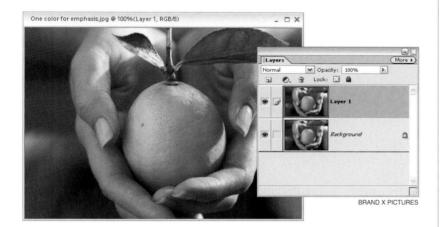

Step One:

Open a photo containing an object you want to emphasize through the use of color. Go under the Layer menu, under New, and choose Layer via Copy (or just press Control-J). This will duplicate the Background layer onto its own layer (Layer 1).

Step Two:

Press B to get the Brush tool from the Toolbox and choose a medium, soft-edged brush from the Brush Picker in the Options Bar (just click on the arrow next to the Brush Preset icon to open the Picker). Also in the Options Bar, change the Mode pop-up menu of the Brush tool to Color.

Set your Foreground color to black by pressing the letter D and begin painting on the photo. As you paint, the color in the photo will be removed. The goal is to paint away the color from all the areas except the areas you want emphasized with color.

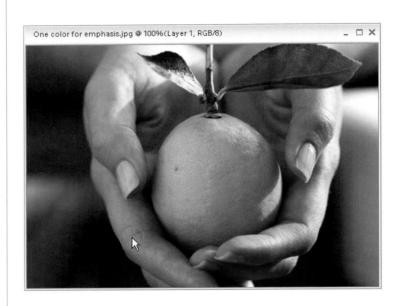

TIP: If you make a mistake while painting away the color or later decide that there was something else that you really wanted to keep in color (such as the stem and leaves of the fruit in this example), just switch to the Eraser tool by pressing the E key, paint over the "mistake" area, and the original color will return as you paint. (What you're really doing here is erasing part of the top layer, which is now mostly black-and-white, and as you erase, it reveals the original layer, which is still in full color.)

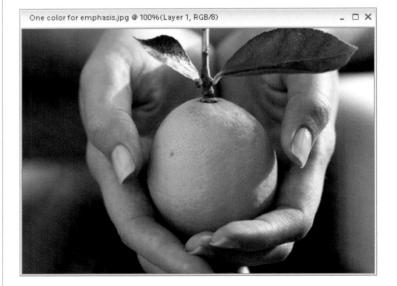

After

Adding Motion Where You Want It

This is a painless way to add motion to a still photo, and because you're using a brush to apply the blur, you have a lot of flexibility in where the effect is applied.

Step One:

Open the photo to which you want to give a motion effect.

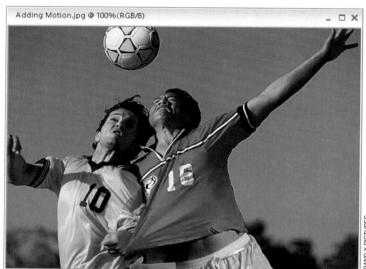

RAND X PICTUR

Step Two:

Duplicate the Background layer by going under the Layer menu, under New, and choosing Layer via Copy (or pressing Control-J). This will duplicate the Background layer onto its own layer (Layer 1).

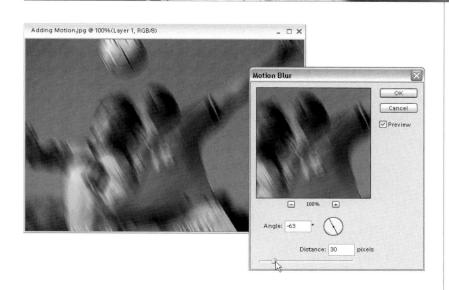

Go under the Filter menu, under Blur, and choose Motion Blur. The Motion Blur dialog will appear presenting two settings: Angle lets you choose which direction the blur comes from, and Distance actually determines the amount of blur. In this case, set the Angle to around -63° so the blur is almost vertical to match the up-and-down motion of the soccer players. Then, increase the Distance amount by dragging the slider until it looks realistic, and click OK.

Step Four:

In the Layers palette, hold the Control key and click on the Create a New Layer icon. This creates a layer (Layer 2) directly beneath your current layer. Now, click back on the top layer, then press Control-G to group your blurred copy with the blank layer beneath it. Doing this hides the Motion Blur effect you applied to this layer.

Step Five:

Click on the middle layer (the blank layer). Press B to get the Brush tool from the Toolbox, and choose a medium-sized, soft-edged brush from the Brush Picker (found by clicking the Brush Preset icon in the Options Bar). Press the letter D to set your Foreground color to black, then begin painting over the areas you want to have motion. As you paint, you'll reveal the Motion Blur that's already applied to the top layer.

After

Changing an Object's Color

Have you ever wanted to change the color of an object (such as a shirt, a car, etc.) in a photo? You have? Then here's perhaps the fastest, easiest way to change the color of, well...whatever.

Step One:

Open a photo containing an element that needs to be a different color.

Step Two:

Choose the Color Replacement tool (found in the Brush tool's flyout menu) in the Toolbox.

TIP: You can adjust the Color Replacement tool's settings by going to the Options Bar, clicking the down-facing arrow next to the word "Brush," and choosing your settings in the palette.

Open another image that has the color you want to use. Alt-click the Color Replacement tool on the color you want to sample within that image. (In this example, I'm sampling the color from another flower.)

Step Four:

Return to the photo you want to colorize. Now paint with the Color Replacement tool using the sampled color.

Before

After

When shooting outdoors, there's one thing you just can't count on—the sun. Yet, you surely don't want to take a photo of your house on a dreary day, or shoot a photo of your car on a gray overcast day. That's why having the ability to replace a gloomy gray sky with a bright sunny sky is so important. Is it cheating? Yes. Is it easy? You betcha. Do people do it every day? Of course.

Replacing the Sky

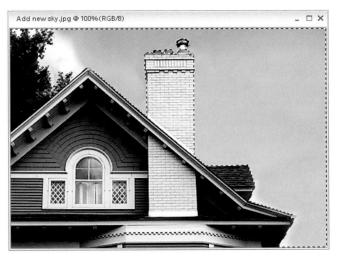

Step One:

Open the photo that needs a new, brighter, bluer sky.

Step Two:

You have to make a selection around the sky. Usually, you can click in the sky area with the Magic Wand tool (W) to select most of it, and then chose Similar from the Select menu to select the rest of the sky—but as usual, it likely selected other parts of the image besides just the sky. So hold the Alt key and use the Lasso tool (L) to deselect any excess selected areas on your image. If needed, hold the Shift key while using the Lasso tool to select any unselected areas of the sky. You can use any combination of selection tools you'd like—the key is to select the entire sky area.

Continued

Shoot some nice blue skies and keep them handy for projects like this. Open one of those "blue sky" shots, and then go under the Select menu and choose All to select the entire photo. Then, press Control-C to copy this sky photo into memory.

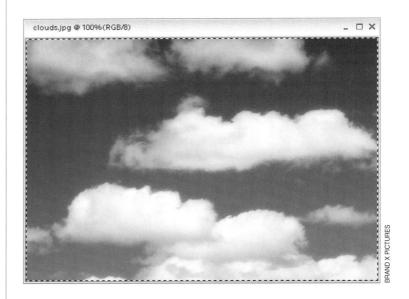

Step Four:

Switch back to your original photo (the selection should still be in place). Create a new layer by clicking on the Create a New Layer icon at the top of the Layers palette, then go under the Edit menu and choose Paste Into Selection. The new sky will be pasted into the selected area in your new layer, appearing over the old sky. Press Control-D to deselect.

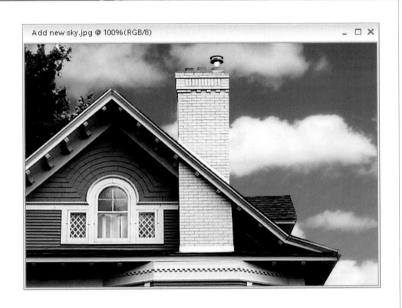

Step Five:

If the sky seems too bright for the photo, simply lower the Opacity of the layer in the Layers palette to help it blend in better with the rest of the photo. That's it—newer, bluer sky.

Putting One Photo Inside Another

Putting a photo inside another is a fairly popular collaging technique. In the technique you're going to do here, you'll realistically put one image inside another, matching the angles of the photo. Here's how it's done.

Step One:

Open the photo that you want to put inside another photo. Press Control-A to put a selection around your entire photo, then press Control-C to copy that photo into memory. Next, open the image that you want the copied photo to appear within.

Step Two:

Press Shift-L until you get the Polygonal Lasso tool in the Toolbox (this tool draws perfectly straight selections; if your object doesn't have straight sides, use another selection tool to create a selection within your image's object). Click the Polygonal Lasso tool once on the bottom-left corner of your object, and then move your cursor up to the top-left corner and click again (a straight line is drawn between your two clicks). Keep clicking at each corner until you have all sides of the object selected (as shown here).

Now go under the Edit menu and choose Paste Into Selection, and the photo you had in memory will be pasted into your selection. Then press Control-D to deselect. But there's a problem—the object is likely angled and your photo probably isn't, so it looks fake. Here's how to fix it. Press Control-T to bring up the Free Transform command. Hold the Control key, grab the bottom-left corner point, and move it to where it touches the bottom-left corner of your object. You'll do the same with the other corners—dragging each one to the corresponding corner of your object.

Step Four:

When all four corners are lined up, and your photo has transformed to fit perfectly within the object, press Enter to lock in your changes and complete the effect.

Creating Photo Montages

Here's a great way to blend any two (or more) photos together to create a photo montage (often referred to as a collage).

Step One:

Open the photo that you want to use as your base photo (this will serve as the background of your collage). Make sure you're not in Maximize Mode by deselecting it under Window, under Images, and choosing Maximize Mode. Now open the first photo that you want to collage with your background photo.

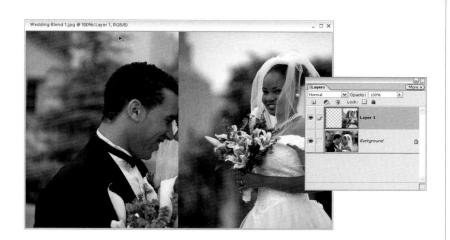

Step Two:

Press V to switch to the Move tool, and then click-and-drag the photo from this document right onto your background photo, positioning it where you want it. It will appear on its own layer (Layer 1) in the Layers palette.

Step Three:

Hold the Control key and at the top of the Layers palette, click on the Create a New Layer icon. This creates a layer directly beneath your current layer. Now, click back on the top layer, then press Control-G to group your photo with the blank layer beneath it. Press the letter D to set your Foreground color to black.

Step Four:

Switch to the Gradient tool by pressing G, and then press Enter to bring up the Gradient Picker. Choose the second gradient in the Picker (this is the Foreground to Transparent gradient).

Step Five:

Click on the middle (blank) layer in the Layers palette to make it active. Click the Gradient tool in the center of your top photo and drag inward toward the center of the document. The point where you first click on the top layer will be at 100% opacity, and the point where you stop dragging will be totally transparent. Everything else will blend in between. If you want to start over—easy enough—just press Control-Z to undo and click-and-drag again. (Be careful: If you drag beyond the image's border, your Foreground color will appear in the gradient.)

Step Six:

If you want to blend in another photo, click-and-drag that image onto your montage, click on the top layer in the Layers palette, then start again from Step Three. Add as many images as you'd like.

Before

After

Simple Depth-of-Field Effect

If you want to create a quick depth-of-field effect (where the part of the subject closest to the camera is in sharp focus, and the background is out of focus), I don't know of a faster, easier way than this.

Step One:

Open the photo that you want to apply the depth-of-field effect to. Press Control-J to duplicate the Background layer (which is named "Layer 1").

Step Two:

Go under the Filter menu, under Blur, and choose Gaussian Blur. When the dialog appears, change the Radius to 4 pixels and click OK to put a blur over the entire image.

Press the E key to switch to the Eraser tool and choose a large, soft-edged brush from the Brush Picker (which is found by clicking the Brush Preset icon in the Options Bar). Start erasing over the parts of the image that appear in the foreground. Erasing on this blurred layer reveals the original unblurred image on the Background layer.

Step Four:

By leaving these areas sharp, while leaving the background areas still blurry, it creates a simple depth-of-field effect as if you had shot it that way with a camera.

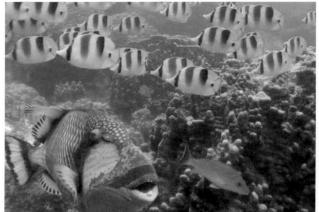

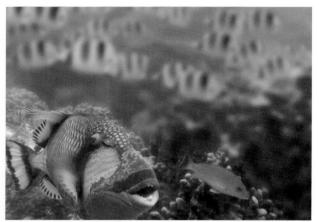

After

In the previous technique, you learned how to create a quick depth-of-field effect using the Gaussian Blur filter. This technique uses the Gaussian Blur filter as well, but I'll show you a way that you can create a blur that graduates smoothly from the in-focus area to the out-of-focus area.

Advanced Depth of Field

Step One:

Open the photo to which you want to apply a depth-of-field effect.

Step Two:

You're going to need to create a layer mask for the Gaussian Blur filter to use, but Elements doesn't really have a layer mask feature like Photoshop CS—but we have a sneaky way around that. Go to the Layers palette and choose Levels from the Create Adjustment Layer pop-up menu. When the Levels dialog appears, don't do anything, just click OK.

Continued

When you create an adjustment layer, a little layer mask is tied to it, and that's what we're going to use to create our mask. Press G to switch to the Gradient tool, then press Enter to open the Gradient Picker. When it appears, choose the Black to White gradient (the third one in the Picker).

Step Four:

Take the Gradient tool and click it in the area of the photo that you want to remain in focus (the part that's the closest to the camera) and drag it to the part of the photo that you want to appear out of focus (toward the background of the image).

Step Five:

Now you'll need to make a selection of that gradient (it's easier than it sounds). Go to the Layers palette, hold the Control key, and click directly on the layer mask thumbnail (you'll see the gradient you created in that thumbnail) that appears to the immediate right of your Levels adjustment layer thumbnail. This loads your gradient as if it were a selection. *Note:* It will only appear as a selection on one side of your image, and that's okay.

Step Six:

Okay, you've done all the hard work—the rest is easy. In the Layers palette, click on your Background layer, then go under the Filter menu, under Blur, and choose Gaussian Blur to bring up the Gaussian Blur dialog. Drag the Radius slider to the right to increase the amount of blur (I used a Radius amount of 4 in this example).

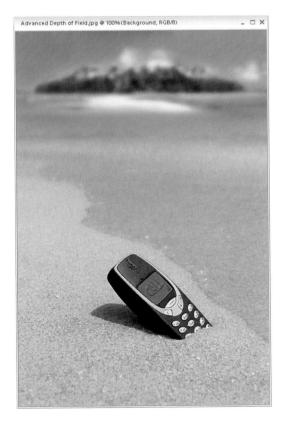

Step Seven:

When the preview looks good to you, click OK to apply your depth-of-field effect. Now deselect by pressing Control-D. This technique makes the Gaussian Blur move smoothly from the in-focus area to the out-of-focus area.

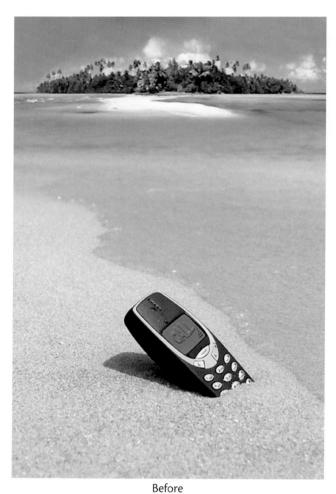

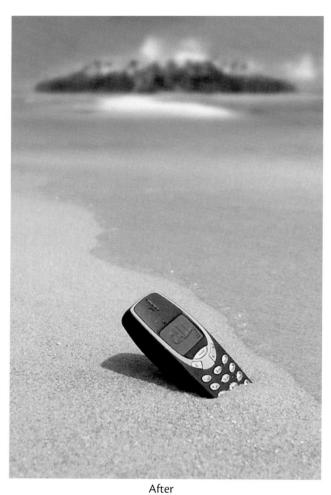

Before

Creating the Classic Vignette Effect

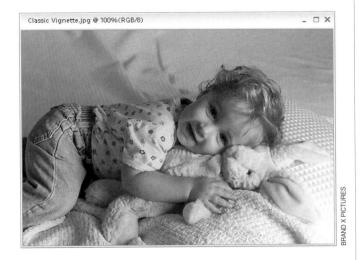

Step One:

Open the photo to which you want to apply the classic vignette effect.

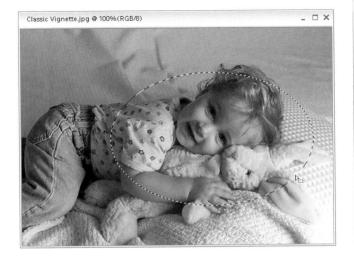

Step Two:

Press Shift-M until you get the Elliptical Marquee tool from the Toolbox and draw an oval-shaped selection around the part of the photo you want to remain visible.

Continued

To soften the edge of your selection, go under the Select menu and choose Feather. When the Feather Selection dialog appears, enter 35 or more pixels (the higher the number, the softer the edge) and click OK.

Step Four:

Here's the thing—you have your subject in a circular selection, and that's the part you want to keep intact. However, you want everything else deleted, so go under the Select menu and choose Inverse. Doing this selects everything except the area you want to keep intact.

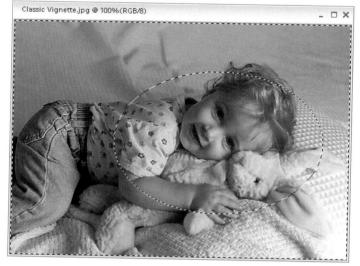

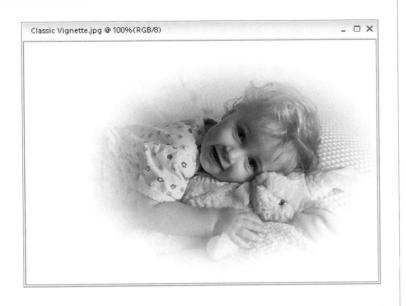

Step Five:

Now, press Backspace to remove the background areas, then press Control-D to deselect. Because you feathered the oval in Step Three, the edges are soft, completing the vignette effect.

TIP: If you'd like to use this soft-edged vignette for collaging with other photos, you'll need the white areas outside the edge to be transparent and not solid white. To do that, just before Step Two, double-click on the Background layer in the Layers palette. A dialog will appear; just click OK to change your Background layer to Layer 0, and then go on to Step Two.

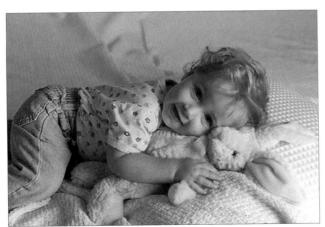

Before

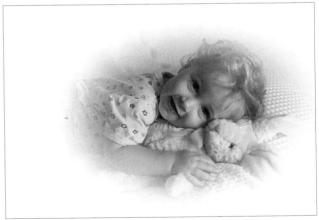

After

Sepia Tone Effect

Here's another technique that was quite popular in the early days of photography. Today, it's normally used either as a special effect, or in photo-restoration projects where you sometimes have to remove the bad sepia tone from the original (during the tonal correction process) and then add it back in when your restoration is complete.

Step One:

Open the photo to which you want to apply the sepia tone effect.

Step Two:

Go under the Enhance menu, under Adjust Color, and choose Adjust Hue/Saturation. When the Hue/Saturation dialog appears, drag the Saturation slider all the way to the left to remove all the color from the image, making it look like a black-and-white photo. Click OK.

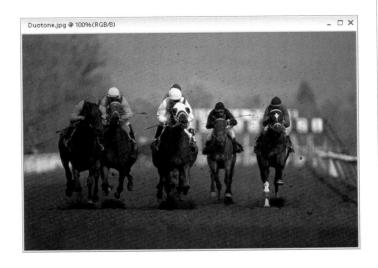

Go under the Enhance menu, under Adjust Color, and choose Color Variations. This dialog shows you what your color photo would look like by adding or subtracting different colors, and you do so by clicking on the thumbnails at the bottom of the dialog. However, in this case, there is no color in the photo, so clicking on a swatch will actually add color (even if it says it's decreasing it). So start by clicking once on the tiny thumbnail preview named "Decrease Blue." As you can see from the After preview at the top of the dialog, it added in a bit of a sepia tone effect to our photo.

Step Four:

The rest is easy—just click on any of the thumbnail previews at the bottom of dialog that look more like a sepia tone than what you already have. Keep an eye on the preview at the top of the dialog to see how you're doing. Click on the Lighten and/or Darken thumbnails to adjust the color. *Note:* If you click a swatch and it doesn't look right, there's an Undo button on the right side of the dialog. Just click it and it reverts your swatch clicking (known as "swatch-clickination" in some circles).

Step Five:

Click OK and the sepia tone effect is applied to your photo.

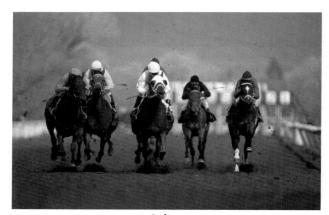

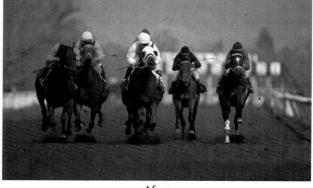

Before

After

This is a quick technique for creating a traditional photographic background (a muslin, a backdrop, etc.) that you can composite portraits into. This technique is pretty handy if you need to take a snapshot of a person and make it look like a studio shot.

Creating a Photo Backdrop

Step One:

Start by creating a custom gradient that will form the basis of the backdrop. Press the G key to switch to the Gradient tool, then in the Options Bar click on the Edit button.

Step Two:

When the Gradient Editor appears, you're going to create a simple custom gradient that goes from light gray to dark gray. Here's how: Double-click on the bottom far-left color stop underneath the gradient ramp to bring up the Color Picker. When the Color Picker appears, to create a light gray color, enter these figures: R=220, G=220, and B=220, and then click OK to assign that gray color for the left side of your gradient.

Now double-click the color stop on the bottom-right side of the gradient ramp, and this time you'll want to choose a dark gray, so enter R=105, G=105, and B=105, then click OK. Save your gradient for future use by clicking on the New button in the Gradient Editor, then click OK to save this gradient.

Step Four:

Create a new document (go under File, under New, and choose Blank File) in RGB mode (the one shown here is a 5x7"). Take the Gradient tool, click near the bottom of your image area and drag upward. Make sure the lighter gray appears at the bottom of the image. Next, press the letter D to set your Foreground color to black.

Step Five:

At the top of the Layers palette, click on the Create a New Layer icon to create a new blank layer. Then, go under the Filter menu, under Render, and choose Clouds. The effect is way too intense, so to tone it down and have it blend in with the background, lower the Opacity of this layer to 20% in the Layers palette.

Step Six:

To keep the background from looking too synthetic, we'll add a little "noise" to give it some grain. Go under the Filter menu, under Noise, and choose Add Noise. Lower the Amount to 2%, set the Distribution to Gaussian, and then click on the Monochromatic checkbox. Then click OK to add this slight bit of noise to the background.

Open an image of a person (an object, etc.) that you want to put on the new background. Then use any selection tool you'd like to draw a selection around the person. (For instance, I clicked the Magic Wand tool [W] on the white background, and then I went to the Select menu and chose Inverse.)

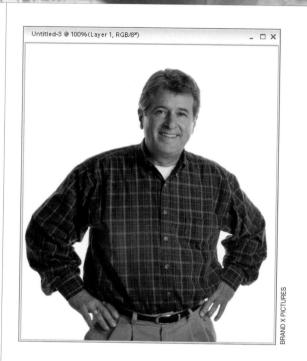

Step Eight:

Now, switch to the Move tool by pressing the V key and drag-and-drop the person from his photo onto your new background.

Step Nine:

In the Layers palette, Control-click on the Create a New Layer icon to create a new blank layer beneath your person's layer. Press Shift-M until you get the Elliptical Marquee tool. Then, hold the Shift key again, and draw a circular selection around the person's head. Press the letter X to set your Foreground color to white, then fill your selection with white by pressing Alt-Backspace.

Step Ten:

Press Control-D to deselect your circle. Go under the Filter menu, under Blur, and choose Gaussian Blur. You're going to use this filter to soften the edges of the white circle to make it look like a spotlight aiming at the gray background. On a 72-ppi photo, choose a Radius amount of approximately 30. (On a high-resolution, 300-ppi image, try 60 or 70.) Click OK when the edges look nice and soft.

Step Eleven:

To help the spotlight blend into the background more realistically, lower the Opacity of this layer to around 70% in the Layers palette.

Step Twelve:

You can use the background as-is for a realistic looking backdrop, or you can add some color by switching back to the cloud layer in the Layers palette, going under the Enhance menu, under Adjust Color, and choosing Adjust Hue/Saturation. When the dialog appears, click the Colorize checkbox in the lower right-hand corner, then move the Hue slider to the color you'd like. If the intensity of the color isn't right, drag the Saturation slider until it looks good to you. Click OK to apply a color to the background.

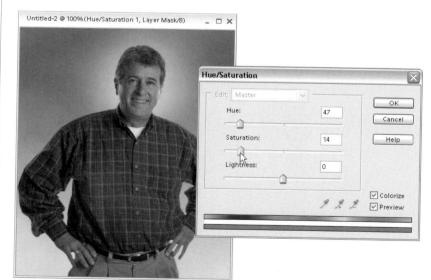

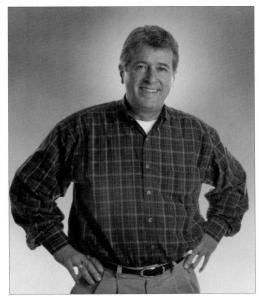

After

Photo to Sketch in 60 Seconds Flat

I learned this technique from Rich Harris, the former creative guru over at Wacom Technologies. He sent me a bunch of PDFs with some special effects he had come up with, and this one just blew me away, so I asked Rich if I could include it in the book. It does the best job I've seen yet of converting a photo into a color pencil sketch.

Step One:

Open the photo you want to convert into a color sketch. Duplicate the Background layer by going to the Layer menu, under New, and choosing Layer via Copy (or by pressing Control-J). Hide this duplicate layer (Layer 1) by going to the Layers palette and clicking on the Eye icon to the left of this layer. Now click on the Background layer.

Step Two:

Press Shift-Control-U to remove the color from the Background layer (technically, this is called "desaturating," but in Enhance it's the Remove Color command, which is found under the Enhance menu's Adjust Color submenu). Then press Control-J to duplicate the Background layer (this copied layer is titled "Background copy").

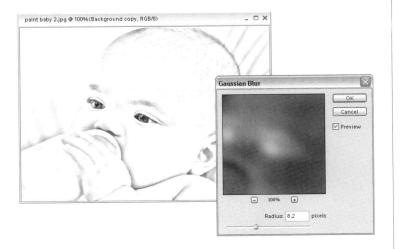

Press Control-I to invert the photo (giving you a photo negative look).

Step Four:

Go to the Layers palette and change the layer blend mode for this layer to Color Dodge. This turns your photo white (it looks like a blank document, but in the next step, you'll bring back the photo).

Step Five:

Go under the Filter menu, under Blur, and choose Gaussian Blur. When the dialog appears, drag the Radius slider all the way to the left, and then slowly drag it back to the right, and as you do your sketch will begin to appear. Click OK when the lines look dark, and the photo doesn't look too blurry.

Military L. L. L.

Step Six:

Go to the Layers palette and make the top layer (the color layer) visible again by clicking in the empty box where the Eye icon used to be. Now lower the Opacity of this layer to 20% to bring back a hint of the original color of the photo.

Step Seven:

To add some texture to your sketch, go under the Filter menu, under Texture, and choose Texturizer. When the Texturizer dialog appears, you'll use the default settings (which are: Texture pop-up menu set to Canvas, Scaling set at 100%, Relief at 4, and Light set to Top). Click OK to apply your canvas texture. Now press Control-F to apply the filter again to make the effect a little more intense.

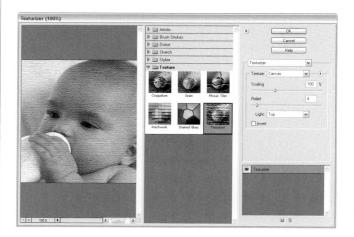

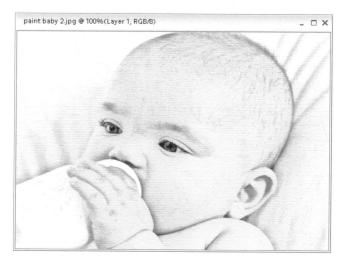

Before

After

Getting the Polaroid™ Look

This is a quick technique that lets you turn any photo into what looks like a Polaroid™ snapshot. This is an ideal effect to apply when you really want that "scrapbook" feel, or you're looking for that spontaneous "my-family-on-vacation" feel. Give this one a try—it's much, much easier than it looks.

Step One:

Open the photo you want to turn into a Polaroid. Press Control-A to put a selection around the entire image. Go under the Layer menu, under New, and choose Layer via Cut to remove the photo from the Background layer and put it on a separate layer (Layer 1) above the background. Now press D to set your colors to the default black and white.

Step Two:

To create this effect, you'll need a little more working room around your photo, so go under the Image menu, under Resize, and choose Canvas Size. When the Canvas Size dialog appears, click the Relative checkbox, then add at least 2 inches of space to both the Width and Height. Choose Background in the Canvas Extension Color pop-up menu, and click OK.

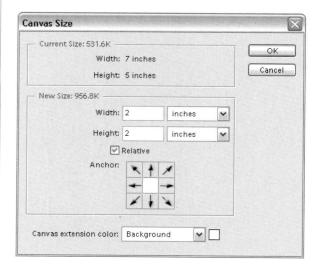

Create a new blank layer directly beneath your current layer by Control-clicking on the Create a New Layer icon at the top of the Layers palette (the new layer will be titled "Layer 2"). Press the M key to switch to the Rectangular Marquee tool, and on this layer draw a selection that's about a ½-inch larger than your photo on all sides. This will act as the border for your Polaroid image.

Step Four:

Click on the Foreground color swatch in the Toolbox, choose a very light gray in the Color Picker (I used R=232, G=232, B=232), and then fill your selection with this light gray by pressing Alt-Backspace. Now you can deselect by pressing Control-D. In the Layers palette, click on your top layer (your photo layer) and press Control-E to combine (merge) your photo with the gray rectangle layer below it, creating just one layer.

Step Five:

Make a duplicate of this merged layer by dragging it to the Create a New Layer icon at the top of the Layers palette (this copied layer will be titled "Layer 2 copy"). Press the D key to set your Foreground color to black. Then, press Shift-Alt-Backspace to fill your copied layer with black. Now, in the Layers palette, drag the black layer directly beneath your photo layer. You're going to "bend" this black-filled layer and use it as the shadow for the Polaroid.

Step Six:

Go under the Filter menu, under Distort, and choose Shear. When the Shear dialog appears, click on the center of the line that appears at the center of the grid. This adds a center point to the line. Click-anddrag this point to the left. The bottom of the dialog shows a preview of how your shear will look. When it looks good to you, click OK.

Step Seven:

With the "shadow" layer still active in the Layers palette, press the V key to switch to the Move tool. Then drag this black, sheared layer directly to the right until the corners are peering out, giving the impression that the Polaroid's shadow is bent.

O Repeat Edge Pixels

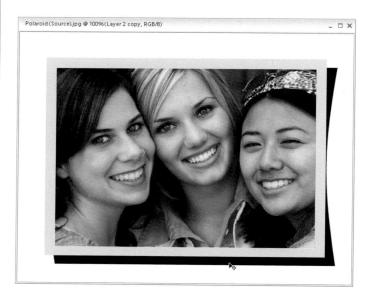

Step Eight:

To soften the edges of your shadow (and make them look, well...shadow-like), go under the Filter menu, under Blur, and choose Gaussian Blur. Enter a Radius of 6 and click OK (enter a Radius of 14 for high-res, 300-ppi images).

318

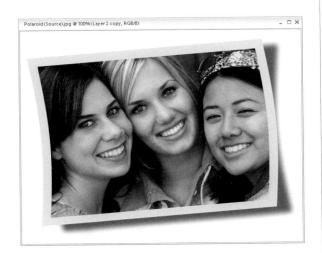

Step Nine:

Now that the shadow is soft, you'll need to lower its opacity to make it appear more subtle. Go to the Layers palette and lower the Opacity setting to around 65%. (You can go lower if you like—it's up to you.) Now that your shadow is finished, to make the effect look more realistic, you'll have to bend the edges of the photo itself.

Step Ten:

In the Layers palette, click on your photo layer (Layer 2) to make it active. Then, go under the Filter menu, under Distort, and choose Shear. When the Shear dialog appears, it will still have the last settings you applied in the grid. Click-and-drag the center point on the line to the right to bend your photo in the opposite direction of the shadow. When it looks good to you, click OK.

Step Eleven:

Merge the shadow layer and the photo layer into one layer by pressing Control-E. Then, press Control-T to bring up the Free Transform bounding box. Move your cursor outside the bounding box to the right, then click-and-drag upward to rotate the Polaroid. Press Enter to lock in your transformation, giving you the final effect.

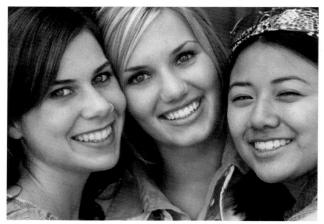

Before

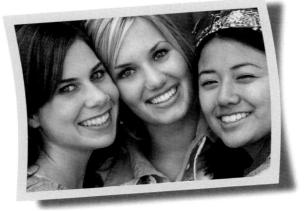

After

If you've taken the time to get your pano set up right during the shoot (in other words, you used a tripod and overlapped the shots by about 15 to 20% each), then you can have Elements 3's Photomerge feature automatically stitch your panorama images together. If you handheld your pano shoot, you can still use Photomerge: It's just going to be much more manual with you doing most of the work rather than Elements doing it for you.

Automated Pano Stitching with Photomerge

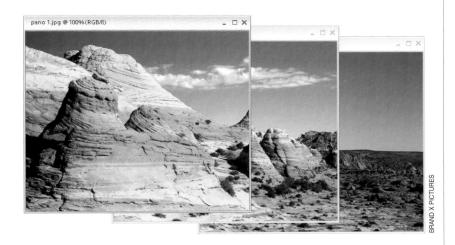

Step One:

Open the photos that you want Photomerge to stitch together as one panoramic image (you can also open individual images or a folder of images directly from within the Photomerge dialog if you like). In the example shown here, I had three shots already open in Elements.

Step Two:

Go under the File menu, under New, and choose Photomerge Panorama.

When you choose Photomerge, a dialog appears asking which files you want to combine into a panorama. Any files you have open will appear in the window, or you can click the Browse button and navigate to the photos you need to open. Control-click to select individual files in the Open dialog or if the files are contiguous, click on the first file, press-and-hold the Shift key, then click on the last file. Now click Open and then click OK in the Photomerge dialog.

Step Four:

If your pano images were shot correctly (as I mentioned in the introduction of this technique), Photomerge will generally stitch them together seamlessly. *Note:* By default, Photomerge creates a flattened image, but if you want a layered file instead (great for creating panoramic video effects) turn on the Keep as Layers checkbox on the right-hand side of the dialog.

Step Five:

Click OK and your final panorama will appear as one image. This is what we call the "best-case scenario," when you've shot the panos on a tripod and overlapped them just like you should so Photomerge had no problems and did its thing right away. It was perfect the first time. But you know, and I know, life just isn't like that.

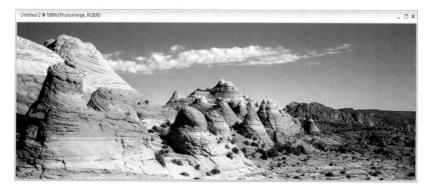

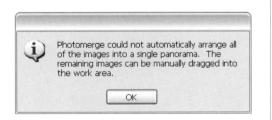

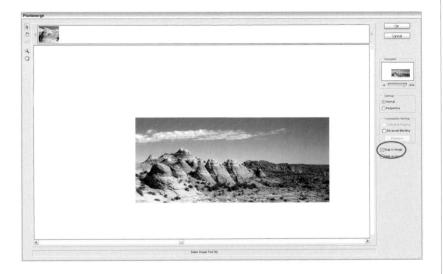

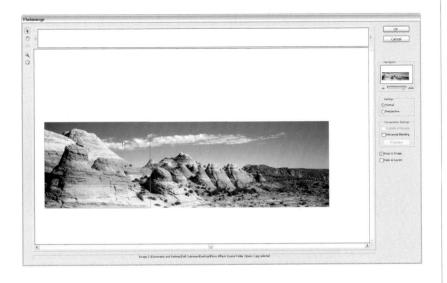

Step Six:

More likely what you'll get (especially if you handheld your camera or didn't allow enough overlap) is this warning dialog that lets you know that Photomerge "ain't gonna do it for you" (that's a technical phrase coined by Adobe's Alabama tech office). In other words—it's up to you.

Step Seven:

Once you click OK in that warning dialog, Photomerge will at least try to merge as many segments together as possible. The segments it couldn't merge will appear in the "Lightbox" (that horizontal row across the top). Although Photomerge didn't do all the work for you, it still can help—just make sure the Snap to Image checkbox on the right-hand side is turned on.

Step Eight:

Get the Select Image tool (it looks like the Move tool) from the Toolbox on the left of the dialog and drag the image's thumbnail from the Lightbox down to your work area near the first image. Slightly overlap the image above the other merged images, release your mouse button, and if Photomerge detects a common overlapping area, it will snap them together, blending any visible edges. It actually works surprisingly well. If you need to rotate a segment to get it lined up, click on it with the Select Image tool first, then switch to the Rotate tool and click-and-drag within the segment to rotate. See, it's not that bad (especially using the Snap to Image option).

Before

After

324

Okay, I know you're thinking, "Hey, this is a supposed to be a book for digital photographers. Why are we restoring old damaged photos taken 50 years before digital cameras were invented?" Well, a secret loophole in

Get Back photo restoration techniques

my book contract enables me, once in every book, to cover a topic that doesn't fall within the general purview of the book. For example, in Photoshop CS Down & Dirty Tricks, I included a full chapter called "Underrated Breakfast Cereals." So when you're working your way through this chapter, keep thinking to yourself, "Hey, this could be another cereal chapter." Then you'll find not only does this chapter fit, but on some level it fits so well that it makes you want to fix yourself a huge bowl of Kellogg's® Smart Start™. Besides, there's another useful loophole: the theory that once a torn, washed-out, scratched photo of your great-grandfather is scanned, it then becomes a "digital," torn, washed-out, scratched photo of your great-grandfather. And once you open it in Elements 3, you'll be engulfed with a burning desire to repair that photo. If I hadn't included this chapter on how to repair and restore these old photos, then where would you be, Mr. "Hey-this-is-supposed-to-be-a-bookfor-digital-photographers" frumpy-pants? Don't you feel just a little guilty? I thought so. Now put down your spoon and start restoring some photos. (Note: My publisher told me that if I found a way to work the phrase "burning desire" into the book, it would increase sales by as much as 7%. If that somewhat suggestive phrase makes you uncomfortable, feel free to mentally replace "burning desire" with "uncontrollable urge," even though its response rate is more along the lines of 3 to 4%.)

If you've got an old photo that's washed out, lacking detail, and generally so light that it's just about unusable, try this amazingly fast technique to quickly bring back detail and tone.

Step One: Open the washed-out photo.

Step Two:

Duplicate the Background layer by dragging it to the Create a New Layer icon at the top of the Layers palette. This creates a layer called "Background copy."

Step Three:

Change the layer blend mode of the Background copy layer by choosing Multiply from the pop-up menu at the top of the Layers palette. As the name implies, this has a "multiplier" effect that darkens the photo and brings back some of the tonal detail.

Step Four:

If the image is still too blown out, continue making copies of this duplicate layer (which is already set to Multiply mode) until the photo no longer looks washed out. If the last layer that you add makes it too dark, just lower the Opacity setting of this layer until it looks right.

Step Five:

Now you may have a new problem—you've got a bunch of layers. The more layers you have, the larger your Elements file, and the larger your Elements file, the slower Elements goes, so there's no sense in having a bunch of extra layers. It just slows things down. So, once the photo looks good, go to the Layers palette, click the More flyout menu, and choose Flatten Image to flatten all those layers down into one Background layer.

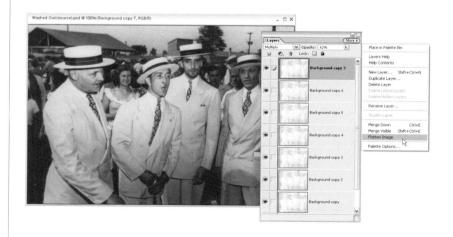

Before

After

Colorizing Black-and-White **Photos**

Once you've restored a black-and-white photo, you might want to consider colorizing (hand tinting) the photo to give it added depth. This particular technique doesn't take a lot of Elements skills, it just takes a bit of patience, because colorizing a photo can take some time.

Step One: Open the black-and-white photo you want to colorize.

Step Two:

To colorize a photo, your Elements image has to be in a color mode, so if your photo is in Grayscale mode (it will say "Gray" up in your document's title bar), you'll have to convert it to RGB mode by going under the Image menu, under Mode, and choosing RGB Color.

Press L to switch to the Lasso tool and draw a selection around the first area within your photo that you want to colorize. Press-and-hold the Alt key to subtract from your selection or hold the Shift key to add to it. Then, go under the Select menu and choose Feather. When the dialog appears, enter 2 pixels to soften the edge of your selection just a tiny bit, then click OK. Now, you could do all of your colorization on the Background layer, but I recommend pressing Control-J to copy your selected area onto its own layer. That way if a color you've applied winds up looking too intense, you can lower the layer's Opacity to "tone it down" a bit.

Step Four:

Go under the Enhance menu, under Adjust Color, and choose Adjust Hue/Saturation. When the Hue/Saturation dialog appears, click on the Colorize checkbox in the bottom right-hand corner of the dialog, drag the Hue slider (at the top of the dialog) to the tint you'd like for this selected area, and then click OK.

Step Five:

In the Layers palette, click on the Background layer to make it active and with the Lasso tool, select the next area to be colorized (in this case, her blouse). Apply a feather to your selection (as you did in Step Three), and press Control-J to copy your selection to its own layer. Now apply your Hue/Saturation adjustment again (like you did in Step Four). When you're applying the color, if the color looks too intense, drag the Saturation slider to the left to reduce the color's intensity, giving it a pastel look that's typical of color tinting. When it looks good to you, click OK.

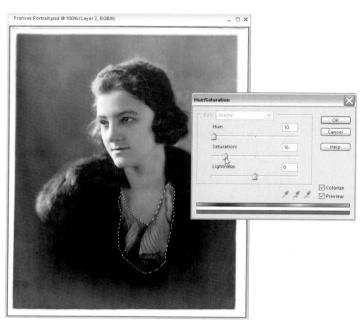

Step Six:

You'll basically repeat this process to colorize the rest of the photo. Each time you'll go to the Background layer, select an area to be colorized, add a slight feather, copy the selection to its own layer by pressing Control-J, apply the Hue/Saturation command, click the Colorize checkbox, and choose your desired color using the Hue slider. When you're finished, if any of the colors look too intense, just lower the Opacity in the Layers palette. Then choose Flatten Image from the Layers palette's More flyout menu to complete the effect.

Before

After

Removing Specks, Dust, and Scratches

If you've used Elements' Dust & Scratches filter, you've probably already learned how lame the filter really is. That is, unless you use this cool work-around that takes it from a useless piece of fluff, to a...well...reasonably useful piece of fluff. This technique works brilliantly for removing these types of artifacts (that's "Elements-speak" for specks, dust, and other junk that winds up on your photos) on the background areas of your photos.

Step One:

Open the photo that needs specks, dust, and/or scratches repaired. Duplicate the Background layer by dragging it to the Create a New Layer icon at the top of the Layers palette. This creates a layer called "Background copy."

Step Two:

Go under the Filter menu, under Noise, and choose Dust & Scratches. When the Dust & Scratches dialog appears, drag both sliders all the way to the left, then slowly drag the top one (Radius) back to the right until the specks, dust, and scratches are no longer visible (most likely this will make your photo very blurry, but don't sweat it—make sure the specks are gone, no matter how blurry it looks), then click OK.

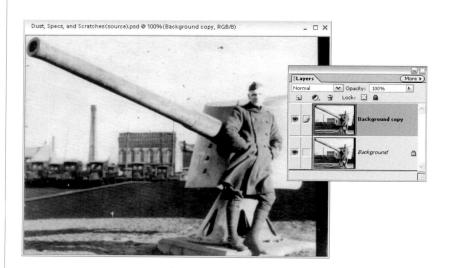

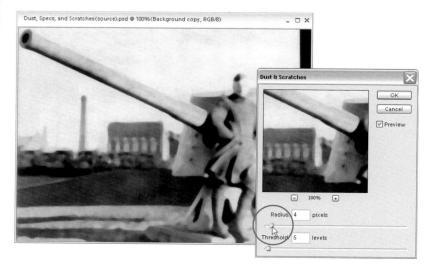

In the Layers palette, hold the Control key and click on the Create a New Layer icon to create a new blank layer beneath your current layer. Now, click back on the top layer, then press Control-G to group your blurred layer with the blank layer beneath it. Doing this hides the effect of the Dust & Scratches filter you applied earlier.

Step Four:

Press the letter D to set your Foreground color to black. Press B to switch to the Brush tool, then go to the Options Bar and change the Mode pop-up menu from Normal to Lighten. This changes the brush so that when you paint, it only affects the pixels that are darker than the area you're painting. Also, click the Brush Preset icon in the Options Bar, and when the Brush Picker appears, choose a medium-sized, soft-edged brush.

Step Five:

Click on the middle layer (you'll actually paint on this blank layer), then paint directly over the areas of your photo that have specks. As you paint, the specks and dust will disappear (you're actually revealing the blurred layer above, where you applied the Dust & Scratches filter). Again, this technique works best on background areas, but it can also be useful for cleaning detailed areas. Just use a very small brush to minimize any blurring that may occur.

After

If you have an old photo with a serious rip, tear, stain, or other major anomaly, there's a reasonable chance that one of these little nasties could affect a part of your photo's main subject (for example, if it's a photo of a person, a stain could have a body part or facial feature covered, leaving you with quite a task). Here's how to repair missing or damaged parts, the easy way.

Repairing Damaged or Missing Parts

Step One:

Open the photo that contains a damaged feature (in this case, most of his right shoulder and arm are missing).

Step Two:

Use one of Elements' selection tools (try the Lasso tool if you just need to make a loose selection or try the Rectangular Marquee tool, as I did here) to select an undamaged part of the image that you can use to fix the damaged area. For instance, if you're trying to fix a person's right shoulder and the left shoulder is undamaged, select the left shoulder to use for the repair.

To keep from having a hard edge around the selected area, you'll need to apply a feather to the edges of your selection. Go under the Select menu and choose Feather. When the dialog appears, enter a Feather Radius. For low-res images use a 1- or 2-pixel Radius. For high-res, 300-ppi images, you can use as much as 4 or 5 pixels.

Step Four:

You'll need to duplicate the selection, so go under the Layer menu, under New, and choose Layer via Copy (or press Control-J). This creates a new layer and copies your selected area to it.

Step Five:

You probably can't just simply drag this patch over to fill the empty space (because the person would end up with two left shoulders, leaving him looking slightly freakish). So, you'll need to flip the copied layer, so go under the Image menu, under Rotate, and choose Flip Layer Horizontal (or Vertical) to turn your patch layer into a mirror reflection of the original selection.

Step Six:

Now, switch to the Move tool by pressing the V key, and with the patch on its own layer, drag it over to where the tear is on the left. (*Note*: If you lower the Opacity of the patch layer to about 50%, it may help you to precisely position the patch because you'll be able to see some of the original image on the layer beneath it.) When you do this, you'll see you have a new problem—the tone of the flipped shoulder and the original shoulder don't match (the flipped shoulder is too light, so to make the restoration look real, you'll have to change the tone of the flipped shoulder layer).

Step Seven:

Press Control-L to bring up the Levels dialog. To darken the tone of the flipped shoulder, drag the midtones Input Levels slider to the right. This darkens the midtones and helps make the flipped shoulder better match the coat on the left side. Click OK when the flipped shoulder comes close to matching the original coat.

Step Eight:

Even after you match up the tones, you can see a hard edge where your flipped shoulder meets the original photo. To hide that edge, press the E key to switch to the Eraser tool, choose a soft-edged brush from the Brush Picker in the Options Bar, and erase over that edge. Now go to the Layers palette's More flyout menu and choose Flatten Layers.

Step Nine:

Although you've fixed the coat area, you still have a hard edge just above his shoulder and to the left, plus you have another rip above that. To fix these areas, press S to switch to the Clone Stamp tool. Choose a soft-edged brush from the Brush Picker in the Options Bar, and Alt-click an area near the hard edge, then click to clone over that area. Now go up to the rip on the left side and do the same thing—Alt-click near the rip and click to clone that sampled area over the rip, which completes the restoration.

Before

After

Repairing Rips and Tears

There are few things worse than rips, tears, or cracks from a photo being bent, especially when it happens to old family photos you really care about. Here's a simple technique that lets you hide these nasty rips by "covering them up."

Step One:

Scan a photo that has rips, tears, or bends, and open it in Elements. The photo here has tears from being bent.

Step Two:

The plan is to clone over the cracks using non-cracked nearby areas. Start by getting the Clone Stamp tool from the Toolbox (or press the S key). Choose a medium to small, soft-edged brush by clicking the Brush Preset icon in the Options Bar to open the Brush Picker.

Step Three:

Hold the Alt key and click in a "clean" area near the cracked area. (By clean, I mean Alt-click in an area that has no cracks or other visible problems. But to help ensure that your repair doesn't look obvious, it's important to click near the tear, and not too far away from it.)

Step Four:

Now, move the Clone Stamp tool over the rip and click a few times over the crack. Don't paint strokes—just click.

As you click, you'll see two cursors: your brush cursor where you're painting and a crosshair cursor over the area you Altclicked on earlier. This lets you see the area you're cloning from (the crosshair) and the area you're cloning to (the brush cursor). This will be your basic strategy for repairing these rips—Alt-click the Clone Stamp tool in a clean area near the crack, then move your cursor over the crack and click a few times until the crack is covered by the cloned areas.

Step Five:

Now start working on other areas. Press the Z key to switch to the Zoom tool and zoom in if needed. Then press S to switch back to the Clone Stamp tool. (Note: You also might want to try the Healing Brush tool [J] using a similar technique, depending on the photo, as it may work just as well if not better.)

Step Six:

When it comes to detail areas like the chair in this photo, the strategy is to Alt-click directly on the chair rail below the rip, then move your cursor directly up and over the rip and click. This clones the lower part of the chair rails (that are intact) over the missing parts. This is a bit tedious, but it's necessary to complete the repair. Continue cloning like this to complete the restoration.

Before

After

You're about to learn some of the same sharpening techniques used by today's leading digital photographers and retouchers. Okay, I have to admit, not every technique in this chapter is a professional technique. For example,

Sharp Dressed Man sharpening techniques

the first one, "Basic Sharpening," is clearly not a professional technique, although many professionals sharpen their images exactly as shown in that tutorial (applying the Unsharp Mask to the RGB composite—I'm not sure what that means, but it sounds good). There's a word for these professionals—"lazy." But then one day, they think, "Geez, I'm kind of getting tired of all those color halos and other annoying artifacts that keep showing up in my sharpened photos," and they wish there was a way to apply more sharpening, and yet avoid these pitfalls. Then, they're looking for professional sharpening techniques that will avoid these problems—and the best of those techniques are in this chapter. But the pros are busy people, taking conference calls, getting pedicures, vacuuming their cats, etc., so they don't have time to do a series of complicated, time-consuming steps. So they create advanced functions that combine techniques. For some unexplainable sociological reason, when pros do this, it's not considered lazy. Instead, they're seen as "efficient, productive, and smart." Why? Because life ain't fair. How unfair is it? I'll give you an example. A number of leading professional photographers have worked for years to come up with these advanced sharpening techniques, which took tedious testing, experimentation, and research, and then you come along, buy this book, and suddenly you're using the same techniques they are, but you didn't even expend a bead of sweat. You know what that's called? Cool!

Sharpening

After you've color corrected your photos and right before you save your file, you'll definitely want to sharpen them. I sharpen every digital camera photo, either to help bring back some of the original crispness that gets lost during the correction process, or to help fix a photo that's slightly out of focus. Either way, I haven't met a digital camera (or scanned) photo that didn't need a little sharpening. Here's a basic technique for sharpening the entire photo.

Step One:

Open the photo that you want to sharpen. Because Elements displays your photo in different ways at different magnifications, it's absolutely critical that you view your photo at 100% when sharpening. To ensure that you're viewing at 100%, once your photo is open, doubleclick on the Zoom tool in the Toolbox, and your photo will jump to a 100% view (look up in the image window's title bar or Options Bar, depending on your viewing mode, to see the actual percentage of zoom).

Step Two:

Go under the Filter menu, under Sharpen, and choose Unsharp Mask. (If you're familiar with traditional darkroom techniques, you probably recognize the term "unsharp mask" from when you would make a blurred copy of the original photo and an "unsharp" version to use as a mask to create a new photo whose edges appeared sharper.) Of Elements' sharpening filters, Unsharp Mask is the undisputed first choice because it offers the most control over the sharpening process.

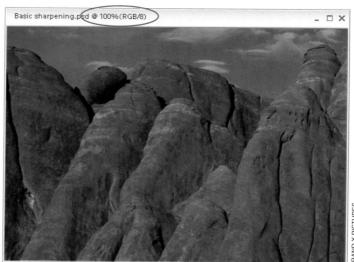

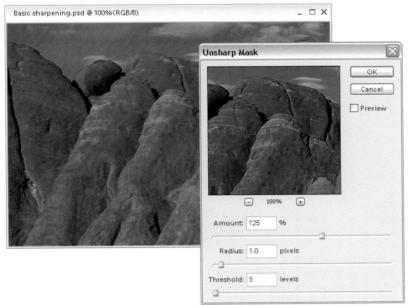

Step Three:

When the Unsharp Mask dialog appears, you'll see three sliders. The Amount slider determines the amount of sharpening applied to the photo; the Radius slider determines how many pixels out from the edge that the sharpening will affect; and the Threshold slider determines how different a pixel must be from the surrounding area before it's considered an edge pixel and sharpened by the filter. Threshold works the opposite of what you might think—the lower the number, the more intense the sharpening effect. So, what numbers do you enter? I'll give you some great starting points on the following pages, but for now, we'll just use these settings: Amount: 125%, Radius: 1, and Threshold: 3. Click OK and the sharpening is applied to the photo.

Before

After

Sharpening Soft Subjects:

At right is an Unsharp Mask setting-Amount: 150%, Radius: 1, Threshold: 10 -that works well for images where the subject is of a softer nature (e.g., flowers, puppies, people, rainbows, etc.). It's a subtle application of sharpening that is very well suited to these types of subjects.

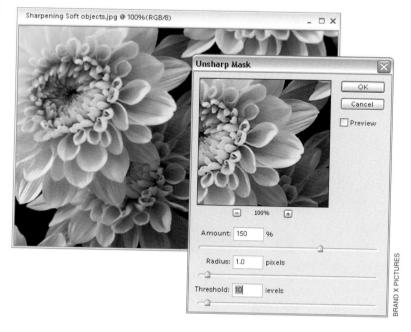

Sharpening Portraits:

If you're sharpening a close-up portrait (head and shoulders type of thing), try this setting—Amount: 75%, Radius: 2, Threshold: 3—which applies another form of subtle sharpening.

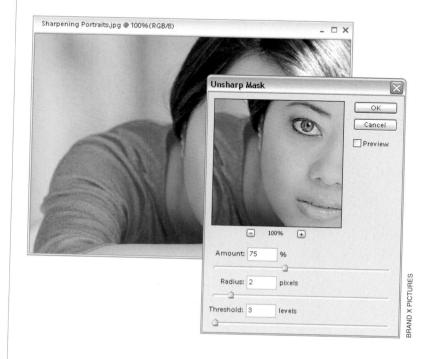

BRAND X PICTURES

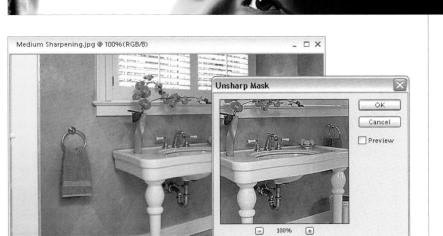

Amount: 225

Radius: .5

Threshold: 0

0

pixels

levels

Moderate Sharpening:

This is a moderate amount of sharpening that works nicely on product shots, photos of home interiors and exteriors, and landscapes. If you're shooting along these lines, try applying this setting—Amount: 225%, Radius: 0.5, Threshold: 0—and see how you like it (my guess is—you will).

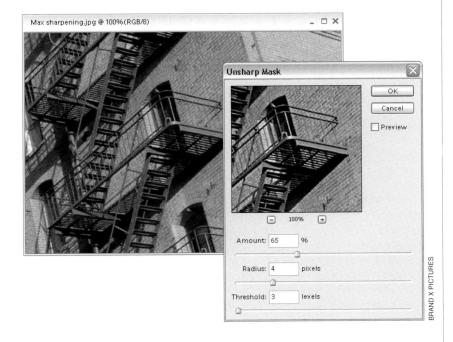

Maximum Sharpening:

I use these settings—Amount: 65%, Radius: 4, Threshold: 3—in only two situations: (1) The photo is visibly out of focus and it needs a heavy application of sharpening to try to bring it back into focus, or (2) the photo contains lots of well-defined edges (e.g., buildings, coins, cars, machinery, etc.).

Continued

All-Purpose Sharpening:

This is probably my all-around favorite sharpening setting-Amount: 85%, Radius: 1, Threshold: 4—and I use this one most of the time. It's not a "knockyou-over the-head" type of sharpening—maybe that's why I like it. It's subtle enough that you can apply it twice if your photo doesn't seem sharp enough after the first application (just press Control-F), but once will usually do the trick.

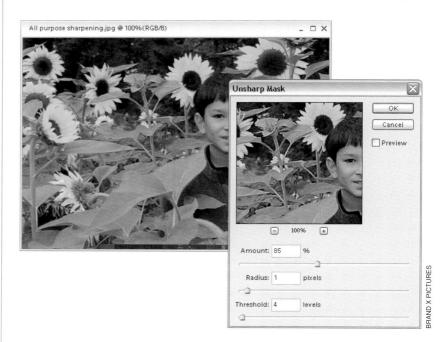

Web Sharpening:

I use this setting—Amount: 400%, Radius: 0.3, Threshold: 0—for Web graphics that look blurry. (When you drop the resolution from a high-res, 300-ppi photo down to 72 ppi for the Web, the photo often gets a bit blurry and soft.) I also use this same setting on out-of-focus photos. It adds some noise, but I've seen it rescue photos that I would have otherwise thrown away. If the effect seems too intense, try dropping the Amount to 200%.

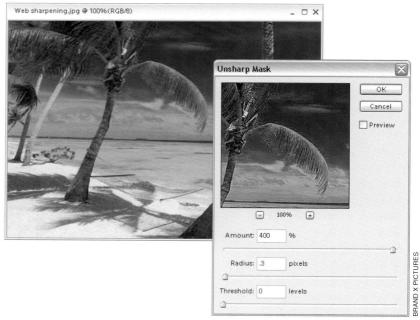

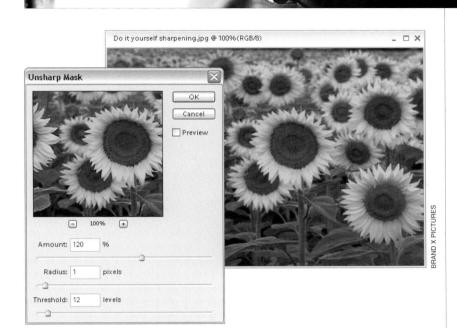

Coming Up with Your Own Settings: If you want to experiment and come up with your own custom blend of sharpening, I'll give you some typical ranges for each adjustment so you can find your own sharpening "sweet spot."

Amount:

Typical ranges go anywhere from 50% to 150%. This isn't a rule that can't be broken. It's just a typical range for adjusting the Amount, where going below 50% won't have enough effect, and going above 150% might get you into sharpening trouble (depending on how you set the Radius and Threshold). You're fairly safe to stay under 150%.

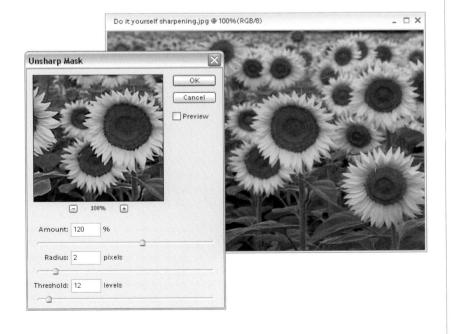

Radius:

Most of the time, you'll use just 1 pixel, but you can go as high as (get ready)—2. I gave you one setting earlier for extreme situations, where you can take the Radius as high as 4, but I wouldn't recommend it very often. I once heard a tale of a man in Cincinnati who used 5, but I'm not sure I believe it.

Continued

Threshold:

A pretty safe range for the Threshold setting is anywhere from 3 to around 20 (3 being the most intense, 20 being much more subtle. I know, shouldn't 3 be more subtle and 20 more intense? Don't get me started). If you really need to increase the intensity of your sharpening, you can lower the Threshold to 0, but keep a good eye on what you're doing (watch for noise appearing in your photo).

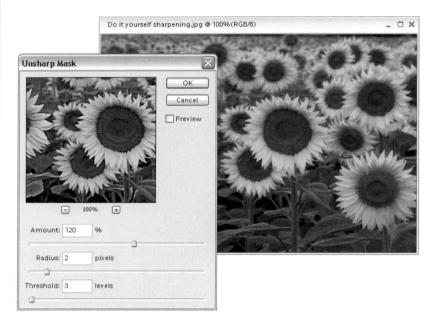

Okay, you've already learned that sharpening totally rocks, but the more you use it, the more discerning you'll become about it (you basically become a sharpening snob), and at some point, you'll apply some heavy sharpening to an image and notice little color halos. You'll learn to hate these halos, and you'll go out of your way to avoid them. In fact, you'll go so far as to use this next sharpening technique, which is fairly popular with pros shooting digital (at least with the sharpening snob crowd).

Luminosity Sharpening

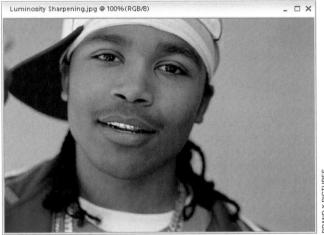

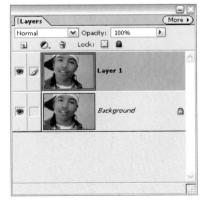

Step One:

Open a photo that needs some moderate to serious sharpening.

Step Two:

Duplicate the Background layer by going under the Layer menu, under New, and choosing Layer via Copy (or press Control-J). This will duplicate the Background layer onto a new layer (Layer 1).

Continued

Step Three:

Go under the Filter menu, under Sharpen, and choose Unsharp Mask. (*Note:* If you're looking for some sample settings for different sharpening situations, look at the "Basic Sharpening" tutorial at the beginning of this chapter.) After you've input your Unsharp Mask settings, click OK to apply the sharpening to the duplicate layer.

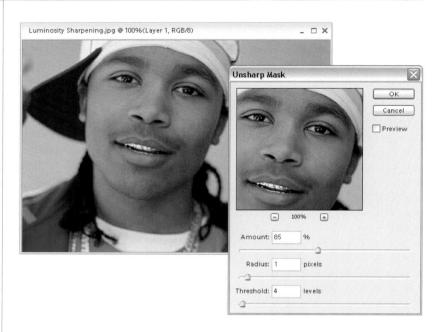

Step Four:

Go to the Layers palette and change the layer blend mode of this sharpened layer from Normal to Luminosity. By doing this, it applies the sharpening to just the luminosity (lightness details) of the image, and not the color. This enables you to apply a higher amount of sharpening without getting unwanted halos. You can now choose Flatten Image from the Layers palette's More flyout menu to complete your luminosity sharpening.

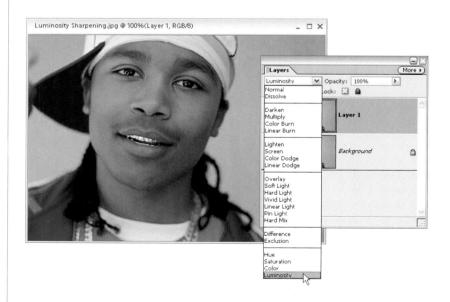

Before After

Edge Sharpening Technique

This is a sharpening technique that doesn't use the Unsharp Mask filter but still leaves you with a lot of control over the sharpening, even after it's applied. It's ideal to use when you have an image that can really hold a lot of sharpening (a photo with a lot of edges) or one that really needs a lot of sharpening.

Step One:

Open a photo that needs edge sharpening.

Step Two:

Duplicate the Background layer by going under the Layer menu, under New, and choosing Layer via Copy (or press Control-J). This will duplicate the Background layer onto a new layer (Layer 1).

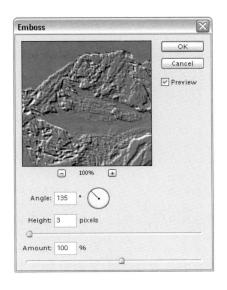

Step Three:

Go under the Filter menu, under Stylize, and choose Emboss. You're going to use the Emboss filter to accentuate the edges in the photo. You can leave the Angle and Amount settings at their defaults (135° and 100%), but if you want more intense sharpening, raise the Height amount from its default setting of 3 pixels to 5 or more pixels (in the example here, I left it at 3). Click OK to apply the filter, and your photo will turn gray, with neon-colored highlights along the edges.

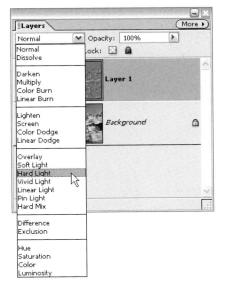

Step Four:

In the Layers palette, change the layer blend mode of this layer from Normal to Hard Light. This removes the gray color from the layer, but leaves the edges accentuated, making the entire photo appear much sharper.

Step Five:

If the sharpening seems too intense, you can control the amount of the effect by simply lowering the Opacity of this layer in the Layers palette.

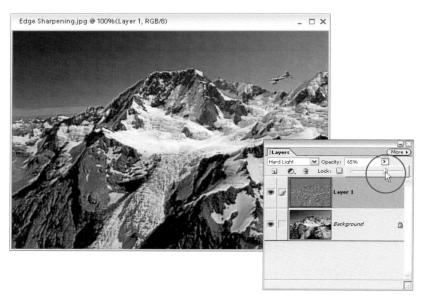

After

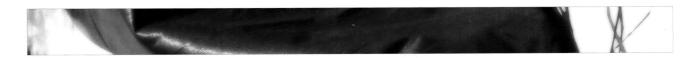

This is another technique for avoiding noise and color shifts when sharpening, and just as in some of the techniques shown earlier in this chapter, this one also makes use of layers and layer blend modes. The method is a cross between a technique that I learned from Chicago-based retoucher David Cuerdon, and a method from Jim DiVitale, in one of his articles from *Photoshop User* magazine.

Sharpening with Layers to Avoid Color Shifts and Noise

Step One:

Open the photo you want to sharpen using this technique. Duplicate the Background layer by going under the Layer menu, under New, and choosing Layer via Copy (or press Control-J). This will duplicate the Background layer onto a new layer (Layer 1).

Step Two:

Change the layer blend mode of this duplicate layer from Normal to Luminosity in the Layers palette.

Continued

Step Three:

Apply the Unsharp Mask filter to this duplicate layer. (If you've read this far, you already know which settings to use, so have at it.)

Step Four:

Now, duplicate this sharpened Luminosity layer by going under the Layer menu, under New, and choosing Layer via Copy (or press Control-J again). This will duplicate the layer onto its own layer (Layer 1 copy).

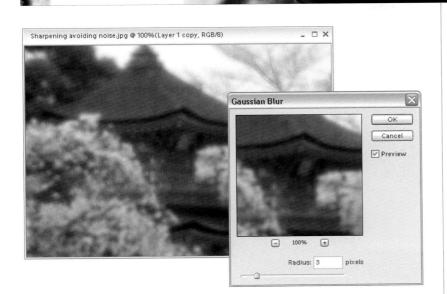

Step Five:

Go under the Filter menu, under Blur, and choose Gaussian Blur. When the dialog appears, enter 3 pixels to add a slight blur to the photo. If this setting doesn't make your photo look as blurry as the one shown here, increase the amount of blur until it does. This hides any halo or noise, but obviously, it makes the photo really blurry—just click OK.

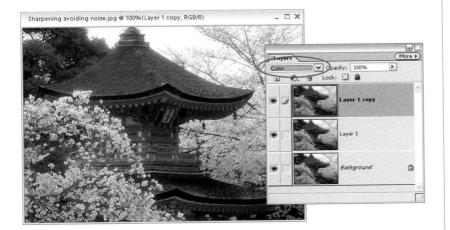

Step Six:

To get rid of the blur on this layer, but keep the good effects from the blurring (getting rid of the noise and halos), change the layer blend mode of this blurred layer from Luminosity to Color. Press the Z key and zoom in on edge areas that would normally have halos or other color shifts, and you'll notice the problems just aren't there. Now you can flatten the photo (by choosing Flatten Image in the Layers palette's More flyout menu) and move on. Note: In some cases this technique mutes some of the red in your photo. If you notice a drop-out in red, lower the Opacity of the blurred layer until the color is restored.

Continued

Before

After

Okay, you've sorted and categorized the photos from the shoot; you've backed up your digital negs to CD; and you've color corrected, tweaked, toned, sharpened, and otherwise messed with your photo

The Show Must Go On showing it to your clients

until it is, in every sense of the word, a masterpiece. But now it's time to show it to the client. Hopefully, you'll get to show it to the client in person, so you can explain in detail the motivation behind collaging a 4x4 monster truck into an otherwise pristine wedding photo. (Answer: Because you can.) There's a good chance they'll see the photo first on your screen, so I included some cool tricks on how to make your presentation look its very best (after all, you want those huge 122" tires to look good), and I even included some techniques on how to provide your own online proofing service using Elements (in case your clients smell bad, and you don't want them coming back to your studio and stinkin' up the place). I want you to really sop up the techniques (like you're using a big ol' flaky biscuit) because once you're done with this chapter, once you've come this far, there's no turning back. At this point, some people will start to scour their studio, searching for that one last roll of traditional print film, probably knocking around at the bottom of some drawer (or hidden in the back of the refrigerator, behind some leftover Moo Shoo Pork), so they can hold it up toward the light, smile, and begin laughing that hysterical laugh that only people truly on the edge can muster. These people are not Kodak shareholders.

Watermarking and Adding Copyright Info

This two-part technique is particularly important if you're putting your photos on the Web and want some level of copyright protection. In the first part of this technique, you'll add a see-through watermark, so you can post larger photos without fear of having someone download and print them; and secondly, you'll embed your personal copyright info, so if your photos are used anywhere on the Web, your copyright info will go right along with the file.

Step One:

We're going to start by creating a watermark template. Create a new blank document in the Elements Editor (go to File, under New, and choose Blank File) in RGB mode in your typical working resolution (72 ppi for low-res, 300 ppi for high-res, etc.). Click on the Foreground color swatch at the bottom of the Toolbox and choose a medium gray color in the Color Picker, then click OK. Now, press Alt-Backspace to fill the Background layer with medium gray. Press the letter D to set your Foreground color to black.

Step Two:

Press T to switch to the Type tool, and in the Options Bar choose a font like Arial Bold from the Font pop-up menu and then click on the Center Text icon. Click the cursor on the gray background, pressand-hold the Alt key, type "0169", and then release the Alt key to create a copyright symbol. Then, press Enter to move your cursor to the next line and type in the name you want to have for the copyright on the photo. If needed, adjust the leading (space between lines) by selecting all your text (Control-A) and choosing a point size in the Set the Leading pop-up menu in the Options Bar. Now hide the Background layer by clicking on the Eye icon in the far-left column beside it in the Layers palette.

Step Three:

Highlight your name (but not the copyright symbol) with the Type tool and increase the size of your name to the size you'd like by using the Set the Font Size pop-up menu in the Options Bar. When it's at the right size, highlight just the copyright symbol, and resize it upward until it's quite a bit larger than your name. Try the type at 48 points and the copyright symbol at 200 points.

Step Four:

Go to the Styles and Effects palette (if it's not visible, go under the Window menu and choose Style and Effects) and in the More flyout menu choose Thumbnail View. In the pop-up menu in the palette's upper left-hand corner, choose Effects. In the second pop-up menu, make sure All is selected. Now scroll down the palette and double-click on the effect named Clear Emboss (type). This applies a beveled effect and makes the fill transparent.

Step Five:

Now you can make the Background layer visible again by going to the Layers palette and clicking in the far-left column where the Eye icon used to be. You can now see the Clear Emboss (type) effect clearly (okay, that was pretty lame).

Step Six:

Open the photo you want to contain this transparent watermark. Make sure this photo and the document with your embossed watermark are both visible within Elements (if not, deselect Maximize Mode by going under the Window menu, under Images, and choose Cascade).

Step Seven:

Press V to switch to the Move tool, then click-and-drag the large copyright symbol's Type layer from the Layers palette (in the embossed watermark document) and drop it onto your photo (you're dragging a layer between documents). Once the copyright symbol is in your new document, you can resize it as needed. Just press Control-T to bring up Free Transform and click-and-drag one of the corner handles. Add the Shift key to resize the type proportionately. Press Enter to complete your transformation.

Continued

Step Eight:

Now go to the Layers palette and lower the Opacity of your Type layer so it's clearly visible, but doesn't dominate the photo.

Step Nine:

Now for the second part—we'll embed your personal copyright info into the photo file itself. Go under the File menu and choose File Info. This is where you enter information that you want embedded. This embedding of info is supported by all the major file formats on the Windows platform (such as TIFF, JPEG, EPS, PDF, and Photoshop's native file format).

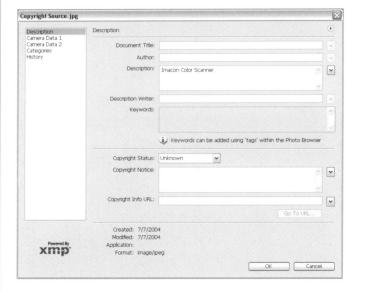

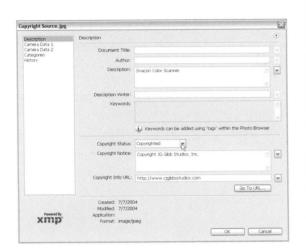

Step Ten:

In the dialog, change the Copyright Status pop-up menu from Unknown to Copyrighted. In the Copyright Notice field, enter your personal copyright info, and then under Copyright Info URL enter your full Web address. That way, when others open your file in Elements, they can go to File Info, click the Go To URL button, and it will launch their browser and take them directly to your site.

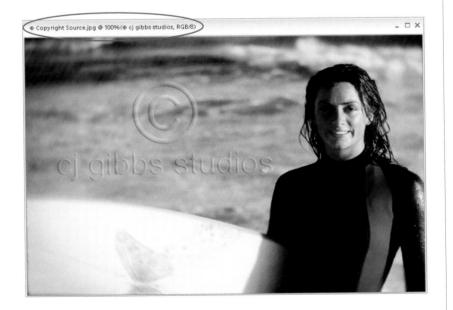

Step Eleven:

Click OK and the info is embedded into the file. Once copyright info has been added to a file, Elements automatically adds a copyright symbol before the file's name, which appears in the photo's title bar. That's it—you applied two levels of protection: one visible and one embedded.

Putting Your Photos Up on the Web

Elements has a built-in feature that not only automatically optimizes your photos for the Web, it actually builds a real HTML document for you, with small thumbnail images; links to large, full-size proofs; your email contact information; and more. All you have to do is upload it to the Web and give your friends (or clients) the Web address for your new site. Here's how to make your own.

Step One:

In the Elements Editor, open all the photos that you want to appear on your webpage. (*Note:* You can also Control-click to select images within the Elements Organizer.)

Step Two:

Go to the task bar above the Options Bar and click on the Create button.

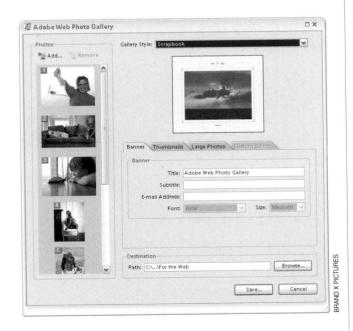

TIP: When you click this, you may get an annoying dialog letting you know that only saved photos will be included in your creation (which in this case is a webpage). If your photos have been saved (if they're named, then they're saved), click OK. If not, press Cancel, then go under the File menu and choose Save. Give them a name and click the Save button. Then click the Create button again.

Step Three:

When the Creation Setup dialog appears, you'll see a list of things you can create on the left side of the dialog. Click on the bottom option, Web Photo Gallery, and then click the OK button at the bottomright corner of the dialog.

Step Four:

When you click OK, the Adobe Web Photo Gallery dialog appears, and all your open photos will appear in a column on the left side of the dialog. This dialog is where you make your choices for how your webpage will look. At the top is a pop-up menu of preset webpage layouts (called Gallery Styles). As you choose the different styles in the pop-up menu, a thumbnail preview of each layout appears near the top of the dialog. Choose a style that looks good to you. In the next steps, you'll decide what text will appear on the page, how big the thumbnails and photos will appear on your webpage, and what quality they'll be.

Step Five:

The first choice you should probably make is where your finished webpage will be saved to (officially called its "destination"), so click on the Browse button near the bottom-right corner of the dialog to bring up the Browse For Folder dialog. Navigate to the folder where you want your finished webpage saved to, and then click OK. Now you can start customizing your webpage.

Step Six:

Now look in the Banner tab in the center section of the dialog. This is where you type in the title and subtitle of your webpage and where you enter your email address (if you want people who visit your site to be able to email you). If you're putting this up to show your work to clients, you certainly want to include a link for them to email you.

Step Seven:

Click on the Thumbnails tab. This is where you choose the size of the small thumbnail images that the people viewing your site will click on to see the full-sized photos. Choose your desired size from the Thumbnail Size pop-up menu. You can also choose captions—such as Filename, Caption (that is, if you already created captions for the images in the Organizer), or Date—to appear under each thumbnail if you like by clicking on the respective checkboxes in the Captions section.

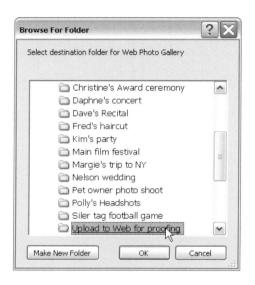

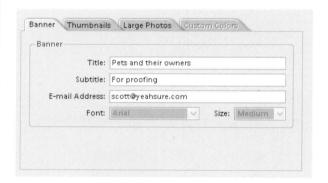

Step Eight:

Click on the Large Photos tab. This is where you choose the final size and quality of the full-size photos displayed on your webpage. Choose your desired size from the Resize Photos pop-up menu, then use the Photo Quality slider to determine their quality. (*Note:* The higher the quality, the longer the photos may take to appear onscreen.) You can again choose titles to appear under each photo in the Captions section by clicking the checkboxes.

Step Nine:

When you click Save (at the bottom of the dialog), Elements 3 will do its thing—resizing the photos, adding your text, making thumbnails, etc.—and a preview of your webpage (complete with live navigation) will appear onscreen. But your page isn't on the Web—it's just a preview within Elements 3. To get your photos actually up on the Web, you'll have to upload them to a Web server, but before you can do that, you have to go and find the files to upload.

Step Ten:

Elements automatically creates all the files and folders you'll need to upload your gallery to the Web and saves them in the location you chose earlier in the Destination section of the Adobe Web Photo Gallery dialog. These are the files and folders you need to put your photo gallery up live on the Web, including your HTML home page (index.html). Now all you have to do is upload them to a Web server and you're live!

Getting One 5x7", Two 2.5x3.5", and Four Wallet Size Photos on One Print

I've often joked that we're now one click away from becoming a Sears Portrait Studio since Adobe invented the Picture Package feature, which lets you gang-print the standard, common photo sizes together on one sheet. With Picture Package, Elements does all the work for you. All you have to do is open the photo you want gang-printed, and then Elements will take it from there—except for the manual cutting of the final print, which is actually beyond Elements' capabilities. So far.

Step One:

Open the photo in the Elements Editor that you want to appear in a variety of sizes on one page, and then go under the File menu and choose Print Multiple Photos.

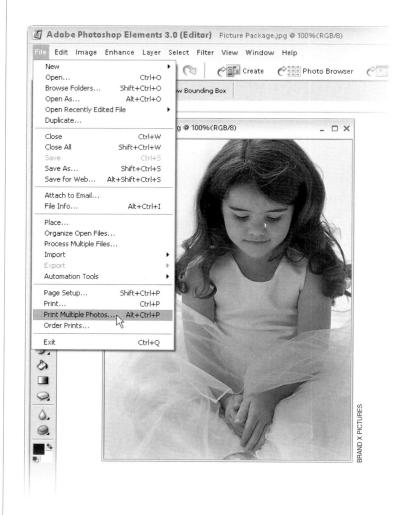

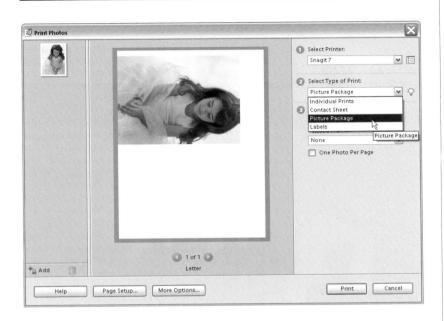

Step Two:

When the dialog appears, on the righthand side choose which printer you want to print to. Then in section 2, choose Picture Package from the pop-up menu.

Step Three:

In the third section down, choose the sizes and layout for your Picture Package from the Select a Layout pop-up menu. In this example, I chose Letter (2) 4x5 (2) 2.5x3.5 (4) 2x2.5, but you can choose any combination you like.

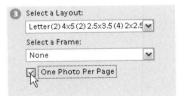

Step Four:

Even though you've chosen a layout, only one photo will appear in the layout preview in the center of the dialog. You'll need to click the One Photo Per Page checkbox to place your image multiple times.

Step Five:

Elements 3 automatically resizes, rotates, and compiles your photos into one document. This is a simple use of Picture Package, but it's actually more flexible than it looks, as you'll see in the next step.

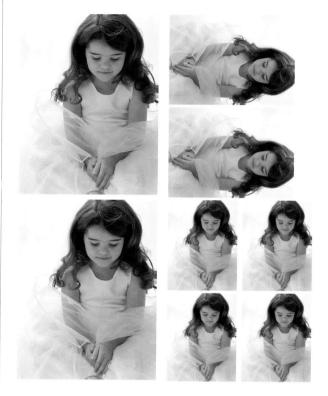

Step Six:

Another option you have is to add a custom frame around the photos in your Picture Package. To add a frame, just choose one from the Select a Frame pop-up menu and your choice will be immediately reflected in the preview.

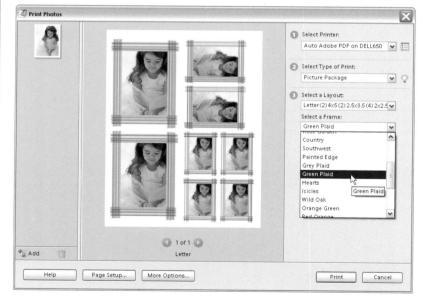

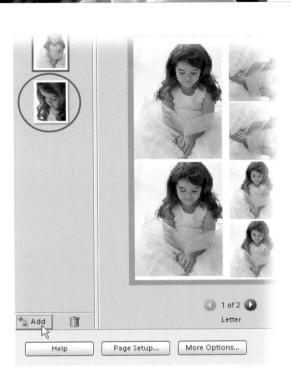

Step Seven:

If you'd like to create more Picture Package layouts using your same settings, all you have to do is import another photo. You do that by first clicking on the Add button near the bottom lefthand corner of the dialog. This brings up the Add Photos dialog, where you can find the photo you want to import from the Photo Browser, the Catalog, etc. Just click on the checkbox to the right of the image's thumbnail in the dialog, and click OK. Once imported, a small thumbnail of your photo appears in the list of photos on the left side of the dialog (you can see a second photo has been added in the capture shown here).

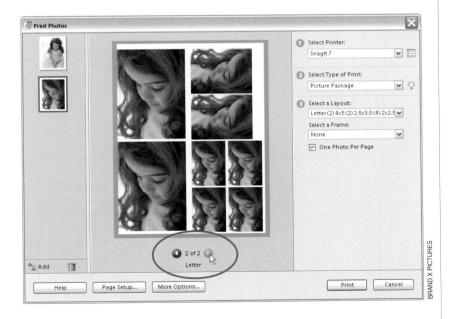

Step Eight:

To see the layout with your new photo, click the right-facing arrow button just below the large preview in the center of the dialog. It will toggle you to a layout for your second photo. If you import several photos, you'll be able to toggle to a layout for each photo.

Step Nine:

If you're a more advanced user who understands color management options and assigning color profiles, you can click on the More Options button, located directly below the preview, and assign a color space to your photos before printing. But if you're not comfortable making these choices, just skip the More Options button.

Step Ten:

Click Print and here's how your additional Picture Package output will look.

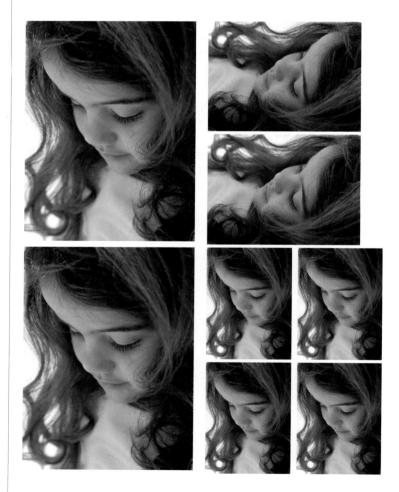

Although the Picture Package feature is most often used for printing one photo multiple times on the same page, you can substitute different photos in different positions, and you can customize their location. Here's how:

Using Picture Package Layouts with More Than One Photo

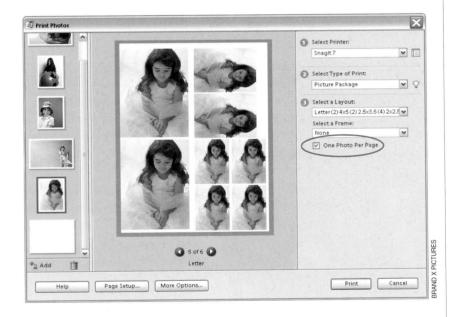

Step One:

Once you have the Picture Package dialog open (see previous tutorial), click the Add button (near the bottom left-hand corner of the dialog) to add additional photos from the Photo Browser, Catalog, etc., until you have a row of thumbnails appearing down the left side of the dialog. Make sure the One Photo Per Page checkbox (found on the right side of the dialog, just below Select a Frame pop-up menu) is turned on.

Step Two:

To add a new photo to your Picture Package layout, just click on the image's thumbnail on the left and drag-and-drop it onto the preview area in the center of the dialog on the position you want it to appear. (*Note:* As you drag, you'll notice a highlight around the preset picture positions in the preview window.)

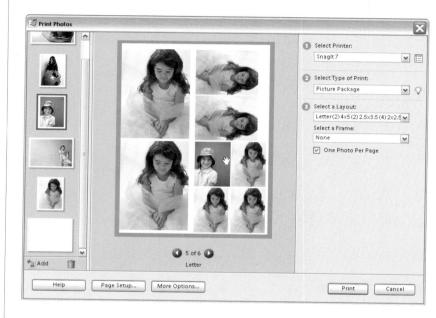

Step Three:

If you want to move a photo to another position, just click directly on the photo in the preview area and drag it to a new position. It will automatically resize if necessary.

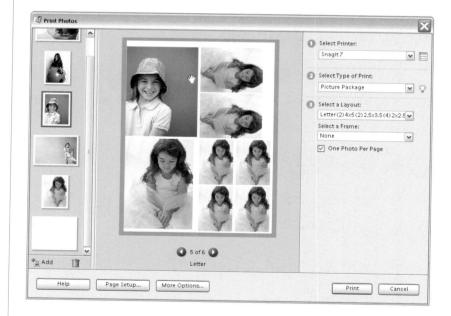

Letter

More Options...

Page Setup...

Add a

Step Four:

You can have as many different photos as you have positions in your layout, so just continue dragging-and-dropping thumbnails from the left side of the dialog into position within the preview area.

Step Five:

Print

Cancel

If you'd prefer to just have all your imported photos appear on the page at once (rather than dragging-and-dropping them), just turn off the One Photo Per Page checkbox and all imported photos on the left of the dialog will automatically flow into place.

Sending a PDF Presentation to a Client

In Elements 3 there's a feature that takes a group of images, creates a slide show (complete with transitions), and compresses it into PDF format so you can email it easily to a client for proofing. This is perfect for showing your portfolio to clients, sending clients proofs of wedding shots or portrait sittings, sending friends photos from a party, or one of a dozen other uses, none of which I can think of at this particular moment, but I'm sure it'll come to me later when I'm at the mall or driving to the office.

Step One:

Open the photos you want to use in your PDF presentation in the Editor, and then click the Create button. (*Note:* You can also Control-click images in the Organizer, and then click the Create button.)

Step Two:

This brings up the Creation Setup dialog. There's a list of different projects you can create on the left side of the dialog. Click on the top option (Slide Show), and then click the OK button in the bottom-right corner of the dialog.

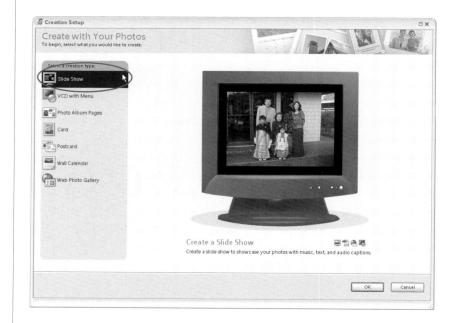

388

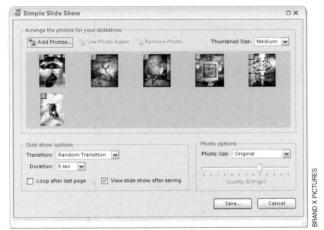

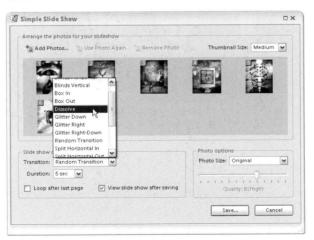

Step Three:

This brings up the Select a Slide Show Format options, where you choose which kind of slide show you want. In this case, choose Simple Slide Show on the left of the dialog, and then click the OK button near the right-hand corner of the dialog.

Step Four:

Clicking OK brings up another dialog. At the top of the dialog are thumbnails of all the photos that will be included in your Simple Slide Show. The thumbnails are numbered, meaning thumbnail 1 will be displayed first, thumbnail 2 will be shown second, and so on. If you want to change the order of your slides, just click on a thumbnail and drag it into the order you'd like it to appear. If you want to remove an image from the slide show, click on the thumbnail and then click the Remove Photo button in the top-center area of the dialog. And, of course, to add an image, click the Add Photos button in the top-left corner and browse for your image.

Step Five:

By default, Elements 3 will provide a random transition between your slides, but some of them may look cheesy or out of place, depending on your subject matter. So, if you prefer to play it safe and choose something that nearly always works, choose a transition like Dissolve from the Transition pop-up menu.

Step Six:

In the lower-right half of the dialog, in the Photo Options section, you can choose the size of the photos that will appear in your slide show. In the example shown here, I chose 640x480 pixels, but you can choose any size you'd like from the Photo Size pop-up menu, or enter your own preferred size by choosing Custom from the menu.

Step Seven:

If you choose any size other than the original size of the photo, you also get to choose a quality setting. Remember: The higher the quality, the larger your file size will be, so try and find a happy medium. Try a 7 or an 8. Only go higher if you know the person you're emailing this presentation to has a high-speed Internet connection.

Step Eight:

Click the Save button and choose where to save your PDF file. Elements 3 then creates a PDF file for you, ready to email to your client.

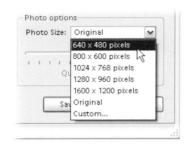

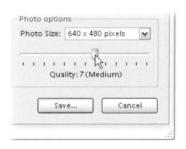

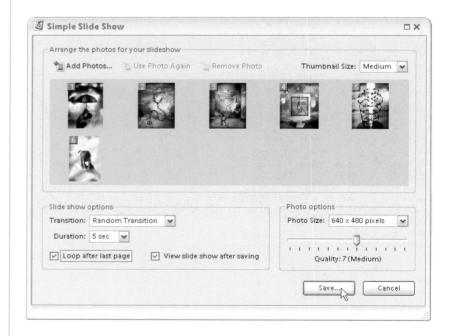

Step Nine:

When your client opens your emailed PDF, it automatically launches Adobe Reader in Full Screen mode (your photos appear centered on a black background), and the presentation begins. The capture below shows the first slide in a PDF presentation in Full Screen mode, right before it transitioned to the next photo. (Note: If for some strange reason your client/friend doesn't have Adobe Reader installed, he or she can download it free from Adobe's site at www.adobe.com/products/acrobat/readstep2.html.)

How to Email Photos

Believe it or not, this is one of those most-asked questions, and I guess it's because there are no official guidelines for emailing photos. Perhaps there should be, because there are photographers who routinely send me high-res photos that either (a) get bounced back to them because of size restrictions, (b) take all day to download, or (c) never get here at all because there are no official guidelines on how to email photos. In the absence of such rules, consider these the "official" unofficial rules.

Step One:

Open the photo in the Elements 3 Editor that you want to email. Go under the File menu and choose Attach to E-mail. (*Note:* You may get an Email dialog asking you to choose an email client as your default. Choose your email client [Microsoft Outlook, etc.] from the pop-up menu and click OK.)

Step Two:

This opens your photo in the Attach to E-mail dialog. The first decision to make is: Who do you want to email this photo to? (Adobe calls this simple task Select Recipients, because that makes it sound significantly more complicated and confusing.) To choose who will receive your photo by email, click on the Add Recipient button at the bottom center of the dialog.

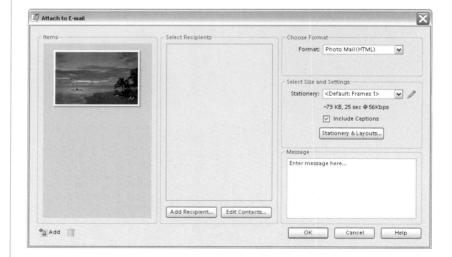

	Photo Mail(HTML)	Teal .
Format:	Photo Mail(HTML)	M
Select Size ar	nd Settings	
Stationery:	<default: 1="" frames=""></default:>	~ /
	~73 KB, 25 sec @ 56Kbps	
	Include Captions	
- 1	Stationery & Layouts	
Message		
Enter messa	age here	

Step Three:

This brings up a dialog where you add the person's first and last names and an email address. Enter the information and click OK. If you want to send this photo to more than one person, click the Add Recipient button again to add another name—keep doing that until you've added enough names that you feel like you're actually starting to spam people.

Step Four:

If you'd like to add a message to your email (like "Here's where I'm on vacation. The weather is here, wish you were beautiful," etc.), enter that in the Message field at the bottom of the dialog. Feeling a bit creative? Why not add a border to your photo, or an entire layout, complete with graphics, that will email right along with your photo. To do just that, click on the Stationery & Layouts button.

Step Five:

When the Stationery & Layouts Wizard dialog appears, you have just two simple decisions to make. The first question to ask is: What do you want the layout to look like? You choose this from the list of layouts (called Stationery) on the left side of the dialog. As you click on each choice, your layout is immediately reflected in the preview area on the right, so you'll see just what your "recipient" will see. If the basic layout looks good, click the Next Step button in the bottom righthand corner of the dialog.

Step Six:

Your second choice is really an option to customize your layout, which you do in the Layout panel on the left side of the screen. You can choose the size of your photo, the position of your photo, text options, etc. For instance, you can enter a message directly onscreen in the preview area and then control the font and color of your text in the Text category.

Step Seven:

Adjust the options along the left of the dialog to make your image look its best. When it looks good to you, click the Done button.

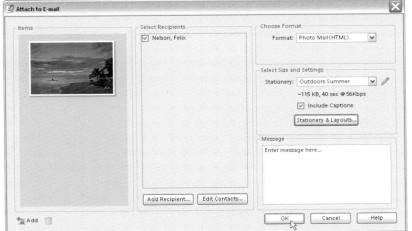

Step Eight:

When you click Done, since you tweaked the settings of your Stationery, it brings up a dialog so you can name your custom setting. Enter a name, click OK, and it's saved so you can quickly get to that exact layout in the future by choosing it from the Stationery pop-up menu. It then takes you back to the Attach to E-mail dialog again. Click the OK button.

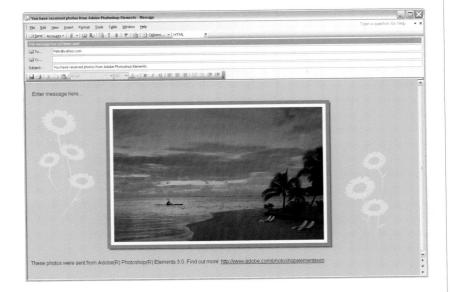

Step Nine:

Clicking OK launches your default email application and your photo and custom stationery are automatically attached. All that's left to do now is click the Send button and it's on its way.

Back in the old days, we'd edit a digital photo and then we'd just print it out. It was a simpler time. If we got the photo centered on the page, it was considered a minor miracle and people would come from local

Create (or Die) how to make presentations with your photos

towns and villages just to see our centered prints. But now, the young kids these days have these newfangled contraptions that let you take your photos and turn them into slide shows, webpages, wall calendars, and Video CDs. Some folks call this progress, but I say it's just not right! It's not what photos were intended to do. They're supposed to be still, lifeless, static and centered on a white piece of paper. But then along comes Photoshop Elements 3, with its new "Creation" features and all of a sudden every crackerjack with 2 gigs of RAM thinks he's Dennis Hopper (who coincidentally starred in the documentary Create [or Die], which was released in 2003 to a worldwide audience, many of whom own digital cameras, yet most of whom were not able to adequately center their photos on a page). Leave stuff like centering photos to the pros, I say.

Creating with Your Photos

There is an entire area of Elements 3 dedicated to creating projects with your photos. By projects, I mean transforming your photos from just prints into "Creations" like full-fledged slide shows, wall calendars, postcards, or Web photo galleries. Here's just one way to access Elements 3's Create feature.

Step One:

There are about half a dozen ways to get to the Create section of Elements, but the easiest and most visible way to get there is to just click on the Create button that appears in the Options Bar of both the Elements 3 Editor and Organizer. By the way, if you click the Create button in the Editor, it will just launch the Organizer for you, and then it launches the Create section, so if you're already working in the Organizer, you're halfway there.

Create button in the Editor

Create button in the Organizer

Step Two:

This brings up the Creation Setup dialog with a list of the creation options on your left, and a brief description of each creation in the main area of the dialog on the right. To choose one of these creations, first click on the one you want in the list on the left, and then click the OK button on the bottom right.

TIP: If you look in the bottom-right corner of the dialog, you'll see a row of tiny icons. These tell you what the final versions of each creation will be. In the screen shot shown here, the tiny monitor icon means it can be displayed onscreen; the Acrobat icon means you can make a PDF of your creation; the globe with an envelope means it can be emailed; and the monitor with a disc means you can make a video disc of your creation.

Making Full-Blown **Slide Shows**

Earlier in the book, we looked at how to create a simple slide show from selected photos in the Organizer, but if you really want to create a slide show masterpiece, this is where you come.

Step One:

Once you've clicked on the Create button and the Creation Setup dialog appears, in the list of Creations on the left, click on Slide Show, and then click the OK button.

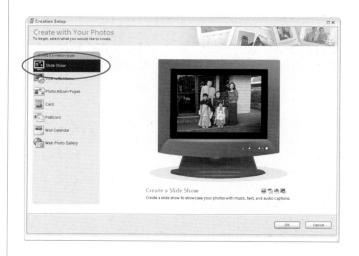

Step Two:

This brings up the Select a Slide Show Format window, where you choose if you want a Simple Slide Show (which is a PDF that you can email to friends, but it doesn't provide as many bells and whistles), or a Custom Slide Show (which is the full-blown version I was talking about). Click on Custom Slide Show, then click OK.

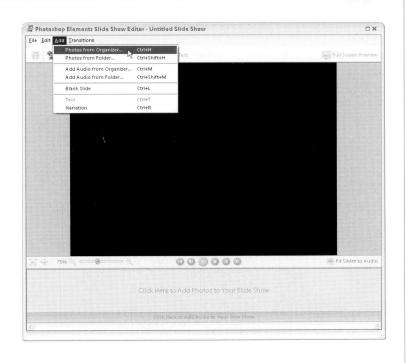

Step Three:

This brings up the Slide Show Editor, and this is where you'll create your magic (okay, "magic" is probably pushing it a bit, but this is where you'll "do your stuff"). If you selected photos in the Organizer before you clicked the Create button, these photos will appear in the Slide Show Editor's Photo Bin at the bottom (which means you can skip the rest of this step along with Step Four). If not, you'll notice a blank black screen is staring at you. It's waiting for you to choose which images will appear in your slide show, so go under the Add menu and choose where the photos to be used in your slide show are coming from.

Step Four:

Depending on where your files are located (mine are in the Organizer), this brings up the Add Photos dialog, which gives you access to the photos in the Organizer without actually taking you back to the Organizer itself. It lets you narrow your choice by browsing just one collection or even sorting by tag, but it's pretty easy to find the photos you're looking for. In the example shown here, under Tags, I choose a set of images I had tagged earlier. When your tagged photos appear in the window, just click on the ones you want to appear in your slide show, then click OK. When you click OK, your photos will appear in the Photo Bin (as seen in the capture in the next step).

Step Five:

To see the default slide show (meaning just straight cuts to the photos you imported in the order they were imported), press the Play button just below the preview window. To stop, press the Stop Preview button (the X button that appears next to the Play button while the slide show is in motion). Pretty boring, eh? Well, that's about to change because now you're going to start customizing your slide show.

Step Six:

The first thing to do is put the slides in the order you want them. To do that, just click on a thumbnail in the Photo Bin at the bottom of the dialog and drag it where you want it (the slides play from left to right, so if you want a particular slide to be first, drag that slide all the way to the left). As you drag slides around in the Photo Bin, you'll see a black bar indicating where the slide will appear when you release the mouse button.

402

Details

ted Jan 201

58

Custom...

Step Seven:

Now that the slides are in order, take a look directly beneath your photo thumbnails in the Photo Bin. You'll see "5s." That's telling you that this slide will stay onscreen for 5 seconds. If you want it onscreen for a shorter amount of time, just click directly on that number and a contextual menu of duration times will appear. If you want to apply a particular duration to all your slides (for example, you want them all to appear onscreen for 3 seconds), after you choose 3s for one slide, click on the time again for that same slide and choose Set All Slides to 3s.

Step Eight:

Finally, the fun part—choosing your transitions. By default, there is no transition; when one slide is finished, it will "cut" to the next slide. However, if you'd like a nice, smooth dissolve between slides—or some fancy-schmancy transition—change your slide's transition by clicking on the international symbol for "No!" that appears to the right of your photo thumbnail (it's the circle with the slash through it) and choosing a transition from the contextual menu. If you want all your slides to have the same transition, click on the transition symbol again and this time choose Apply to All. Now click the Play button again and see how much better your slide show looks. By the way, if you want to change the duration of your transitions, you select it the same way you do for a slide—just click on the number that appears below the transition and choose a length from the contextual menu.

Step Nine:

Now, on to titles. If you want to add a title to the beginning of your slide show, click on the first slide in the Photo Bin, and then click the Add Text button at the top center of the dialog.

Step Ten:

This brings up the Edit Text Properties dialog, where you can choose which font, style, and color you want for your text. You'll also see a field where you can enter the text you want to appear on top of your photo. As you enter your text, you get a live preview in the dialog so you can see how it looks. When you're done setting your text, click OK.

Step Eleven:

If you want your title to appear over a blank slide, rather than over a photo, you can create your title over a blank background by clicking the Add Blank Slide button in the dialog's Options Bar. This creates an empty black slide. Now you can click the Add Text button to create the text that will appear over your black slide. This blank slide will appear with the default transition (a hard cut), so don't forget to change the transition to match the rest of your slide show and/or reposition this slide in the Photo Bin.

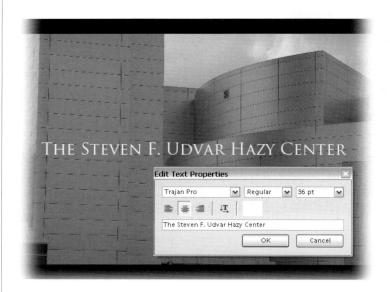

Step Twelve:

If you want to change the color of your slide (from the default black color), you can do that by selecting your slide in the Photo Bin, and then going under the Slide Show Editor's Edit menu and choosing Change Background Color. This brings up a dialog where you can choose a different color by clicking on a color swatch. Choose a color, click OK, and your currently selected slide's color is now changed.

Step Thirteen:

All right, the slides are in order, the transitions have been chosen, and the titles have been created. Now, for the finishing touch—music. To add some background music to your slide show, click on the Add Audio icon (it looks like music notes found in the Options Bar of the dialog) and choose Add Audio from Organizer. This brings up the Add Audio dialog, where you can browse for your own music files or choose from a list of music files in your catalog. To hear a song that appears in your catalog, click on its name in the list and then click the Play button within that dialog. When you find a song you like, click on its name in the list, and then click the OK button.

Step Fourteen:

Now it's time to see the finished slide show. Click the Full Screen Preview button in the top-right corner of the Slide Show Editor, then sit back, relax, and enjoy the "magic." If, while watching your full-screen preview, you see something you want to change, just double-click on your screen to return to the Slide Show Editor.

"Magical" Full Screen Preview

Step Fifteen:

When the show is tweaked to perfection (or your personal satisfaction, whichever comes first), it's time to output it into its final form. Go under the Slide Show Editor's File menu and choose either Output as WMV (to create a Windows Media Video Movie, in which case you'll get a dialog that lets you determine the quality setting) or Burn to Video CD (in which case you'll get a dialog asking you to save your slide show). That's it—you've made your first full-blown slide show. Now go have a cocktail (hey, it's what directors do!).

This is one of my favorite things in Elements 3 because Adobe did such a slick job with it. They've created some great-looking templates for photo album pages and digital scrapbooking—and all you have to do is choose which layout you want and it does the rest. Here's how to start using this way-cool feature:

Creating Photo Album Pages

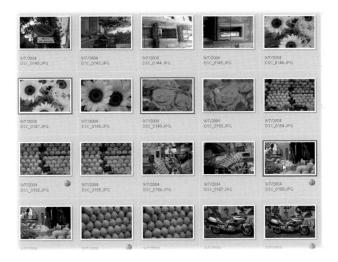

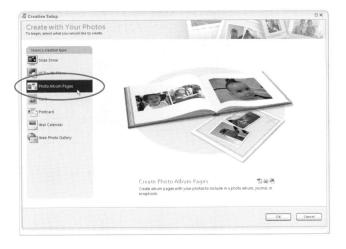

Step One:

Start by going to the Organizer and Control-clicking on the photos you want on your first photo album page. Then, click the Create button in the Options Bar in the top center of the Organizer window.

Step Two:

When the Create dialog appears, in the list of creations on the left side of the dialog, click on Photo Album Pages, and then click the OK button.

Step Three:

This is where you choose which layout you'd like for your album pages by clicking on one of the styles in the list on the right side of the dialog. As you click on a layout, it gives you a preview of that style on the left. Once you've chosen your layout, then choose how many photos you want to appear on your page from the Photos Per Page pop-up menu in the Options category on the bottom-left side of the dialog. Also choose to include any captions, a title page, etc., and then click the Next Step button.

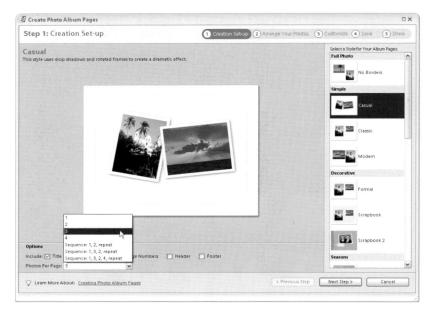

Step Four:

Now it's time to drag-and-drop the photos into the order you want them to appear. By default, the first photo imported winds up as the photo on the title page (if you chose that option in the previous step), so if you want a different photo on the title page, just click-anddrag it over into the first position. Once you have your photos in the order you want them, click the Next Step button.

Step Five:

The first page you'll see is the title page, and you can edit some text above your title page if you'd like later, but for now, click the arrow button to the right of the title page preview to jump to your first photo album page.

Step Six:

This is where you determine how your photos are cropped into their frames. If you click on one of your photos, you'll see a cropping border around the photo. You can move or resize the photo by grabbing one of the corner points.

Step Seven:

In the example shown here, I grabbed the bottom right-corner point of the cropping border and dragged outward, which crops the photo closer in. The transparent areas that appear outside the fixed border of your photo will be clipped off when the photo album page is printed. To see how your crop looks, just click on any other photo. If you don't like the order of the photos (let's say you wanted the daisies up top), then click the Previous Step button and drag the daises to the second position (just after the title page). When the photos are in order, click the Next Step button. (Note: If you want to edit your title page, now's the time to do it. Just click the Previous Page arrow button to the left of the preview window, doubleclick the placeholder text that appears, and enter your text in the Title dialog. Just click the right arrow button to return to your album page.)

Step Eight:

Now it's time to save your album page, so just give it a name (in the Album Pages Name field on the right side of the dialog), and then click the Save button. Just one more step...

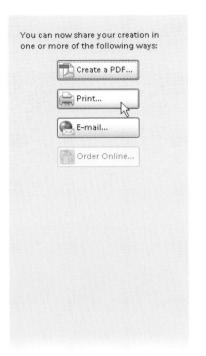

Step Nine:

Now you'll see a list of things you can do with your photo album page: create a PDF, print it out, or email it. Click on the one that sounds best to you, and you're done! By the way, if you want to edit or otherwise mess with your album page, you'll find it in the Organizer window (right now it's the first thumbnail in the window).

Creating Greeting Cards or Postcards

If you're interested in cheating Hallmark out of a few bucks, here's a great way to do it—create your own greeting cards. But it's not just about the money—it's about the personalization that can only come from using one of your own photos that makes the card really special (and cheap!). Here's how to do the holidays on a budget (kidding):

Step One:

Start by going to the Organizer and choosing the photo you want to use on the front of your greeting card. Then, click the Create button in the Options Bar at the top of the Organizer.

Step Two:

When the Creation Setup dialog appears, in the list of creations on the left side of the dialog, click on Card, and then click OK.

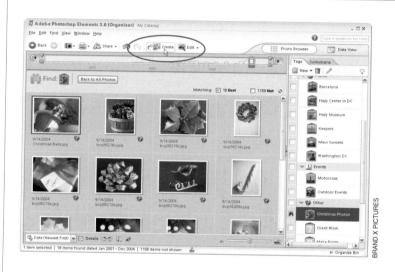

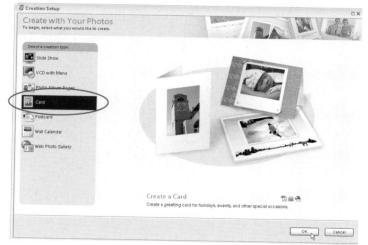

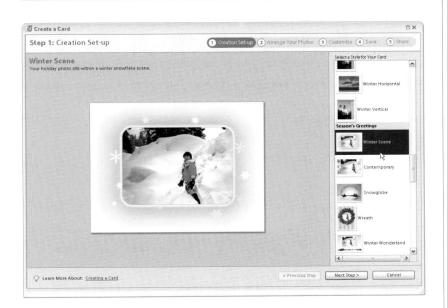

Step Three:

Here's where you choose your layout from the list of styles on the right side of the dialog. If you scroll down a bit, you'll find a variety of pre-made templates (like the one shown here from the section called Season's Greetings), or you can go with more traditional layouts by scrolling back up to the top (hint: go with the traditional). Once you've chosen a layout (please don't choose the one I chose here), click the Next Step button.

Step Four:

Here's where it asks you which photo you want to use. Why don't we use the one we chose earlier? (This is kind of a "Duh!" screen.) Click the Next Step button.

Step Five:

This section lets you customize the text that will appear on your card and it also lets you crop your photo within the border by dragging the cropping handles outward (the image will be cropped within the preset photo frame). To add your own text, double-click directly on the words "Double-Click to Insert Title" and the Title dialog will appear. After you've entered your text (and chosen your font, color, etc., in the Title dialog), click on the Done button. (Note: To add text inside your card, choose Inside from the View Page pop-up menu above the preview area, double-click the placeholder text in the preview, and enter your text in the Greeting dialog.) Now, click on the Next Step button.

Step Six:

In this screen you simply enter a name in the Card Name field, and then click the Save button, so if you need to edit it later, you've got the original.

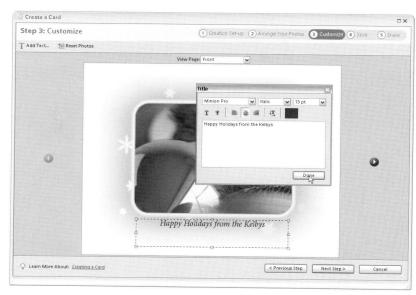

Step Seven:

On the final screen, you'll see a list of things you can do with your greeting card: create a PDF, print it out, or email it. Click on the one you want and it's on its way.

Postcards

Step One:

You create them the same way as creating a greeting card, so I won't put you through that whole thing again, just follow the steps above, except in Step Two choose Postcard instead of Card.

Creating Calendars

Okay, let's say you have 12 really great shots. Now what do you do? That's right—it's calendar time—and using the built-in templates (and auto-dating), it's really so simple that you almost have to create your own calendars.

Step One:

Open the Organizer and Control-click on all the photos you want to appear in your calendar. (I probably don't have to say this, but open at least 13 so you have one for the cover and then one for every month.) Then, click the Create button in the Options Bar at the top of the Organizer.

Step Two:

When the Creation Setup dialog appears, in the list of creations on the left side of the dialog, click on Wall Calendar, and then click OK.

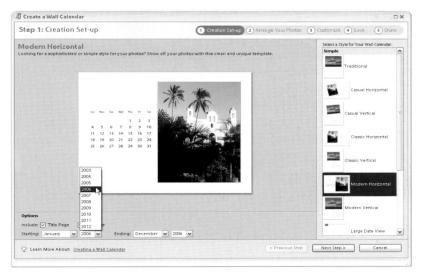

Step Three:

The Photoshop Elements 3 Book

Here you'll do two important things: (1) You'll choose the layout for your calendar from the list of calendar templates on the right side of the dialog, and (2) along the bottom-left corner you'll choose when your calendar starts and ends from the pop-up menus. By choosing those starting and ending dates, Photoshop Elements 3 will do the hard part (putting in the dates) for you. When you've made your choices, click on the Next Step button.

Step Four:

Here's where you'll decide which month gets which photo by simply draggingand-dropping your photos into the order you want (notice the month for each image appears in the top-left corner of the images' thumbnails). When they're in order, click the Next Step button.

Step Five:

The next dialog lets you add captions and crop your photos, starting with the cover. To add a caption, just double-click on the placeholder text that's already there and the Caption dialog will appear, in which you can add your own titles. Next, click the right arrow button to the right of the preview so you can go to and edit individual months. To crop your photos to size, just click on one of the corners of the visible cropping border and drag out until it fits in the preset frame the way you want it to. (Note: Transparent areas that fall outside the original border will be clipped away.) When it looks good to you, click the Next Step button.

Step Six:

In this next screen, you'll simply enter a name in the Wall Calendar Name field, and then click the Save button at the bottom of the dialog. In the final screen you can choose how you want to finally output your calendar on the right side of the dialog: by creating a PDF of it, printing it out, or emailing it. That's it—your first calendar.

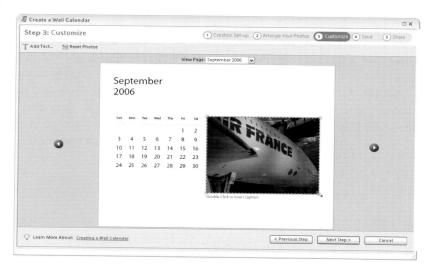

If you want to expand the reach of your photos to a wider audience, there's no better way than to create a photo website, and once again Elements 3 does all the hard work for you. All you have to do is basically choose which photos you want, which layout you want, and it does the rest. (I covered the Web Photo Gallery in detail earlier in the book, but I wanted to cover it briefly here as well, since it's one of the "Create" functions, and you'll probably come looking for it here in this chapter.) Here's how to go global with your photos:

Creating Your Own Photo Website

Step One:

Open the Organizer and Control-click on the photos you want to appear on your Web gallery. Then, click the Create button in the Options Bar at the top of the Organizer.

Step Two:

When the Creation Setup dialog appears, in the list of creations on the left side of the dialog, click on Web Photo Gallery, and then click OK.

Continued

Step Three:

This brings up a dialog where you make all of your most important choices, with the first choice being which layout you want for your gallery. You choose this from the Gallery Style pop-up menu at the top of the dialog. There is a preview of how each gallery looks, but you have to choose it first by name from the list, then when you release the mouse button, the preview of that Gallery Style appears in the dialog window.

Step Four:

If the Banner tab isn't active, click on the word "Banner" to bring up the options. This is where you get to add a name to your site and an email address if you like (this is especially important if you're having clients do their proofing from your website). At the bottom of the Banner tab (in the Destination category) is the location on your hard disk that your HTML file and image folder will be saved to, so click the Browse button and choose that now, so later you'll be able to find your gallery easily for uploading to the Web.

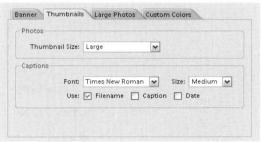

Photos		
Resize Photos:	Large	
Photo Quality:	Low	T High
Captions		
Font:	Times New Roman 🕶 Size: Me	dium 🕶

Step Five:

The Thumbnails tab and the Large Photos tabs are where you determine how large the thumbnail images will appear on your website, and how large the full-size photos will appear when a client clicks on one of the thumbnails. You can stick with the default sizes, or click on the Large Photos tab to choose a size and quality setting of your own. You can also choose whether captions will appear below your photos, and if so, you can choose the font and size, too.

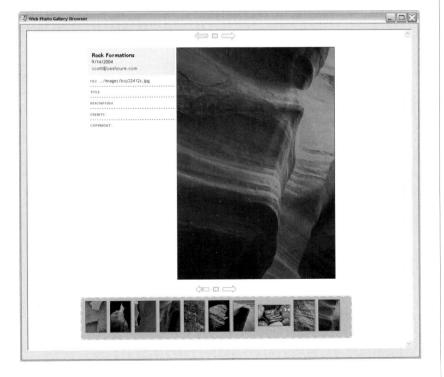

Step Six:

Hit the Save button at the bottom of the dialog, and your webpage will be created and saved. Then Elements 3 displays a full-size preview of your finished HTML webpage in the Web Photo Gallery Browser (as shown here). Now look in that folder you specified earlier, and you'll find an HTML document (named "index"), along with folders of your images, thumbnails, pages, etc., ready for you to upload to the Web (providing you have a place to upload them to, of course). *Note:* Everything in that folder gets uploaded: files, folders, and the whole shebang.

Creating a Video ČD

If you've created some slide shows (using the Slide Show feature mentioned earlier in this chapter), you can take those slides shows and transfer them to a Video CD, which will play on many DVD players (so you can watch them directly on your TV), and you do the whole thing right from within Elements 3. Here's how it works:

Step One:

First, you need to create your slide shows, so go ahead and do that first, because essentially what you'll create is a CD of slide shows with a default menu that's created by Elements. So if you don't have slide shows first, you can't create a CD, so start there (see the slide show tutorial earlier in this chapter). Once you have your slide shows created, go to the Organizer and click on the Create button.

Step Two:

When the Creation Setup dialog appears, in the list of creations on the left side of the dialog, click on VCD with Menu, and then click OK.

Step Three:

This dialog is where you choose which slide shows will comprise your Video CD. To add slide shows to your list, click the Add Slide Shows button in the top-left corner and a dialog will appear, where you can choose which of your saved slide shows will appear on your VCD by clicking on them. Then, click OK to add them to the main dialog.

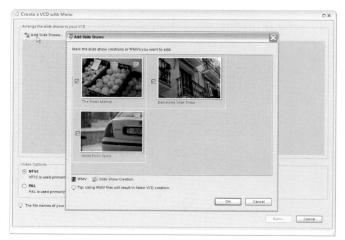

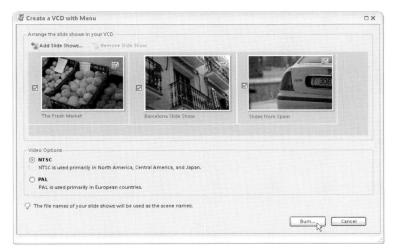

Step Four:

Once your slides appear in the main window, you can insert a blank CD into your computer's CD burner, then click the Burn button on the bottom right-hand side of the dialog to burn your slide shows to disc. *Note:* Be sure that NTSC is selected in the Video Options section of the dialog. Now you can insert your VCD into your DVD player and watch your slide show on your TV.

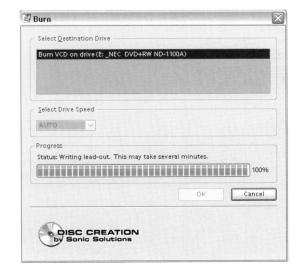

DAVID CUERDON

David Cuerdon has been a commercial photographer for more than twenty years. He was one of the first photographers to shoot digital fashion photography full time beginning in 1995. David is a two-time Mac Design "Crabby" award winner for photography. Currently, David is heading up one of the most advanced digital photography studios in the country for Value City Department Stores in Columbus, Ohio, where he now resides with his lovely wife and collaborator, Lisa, who is also a make-up artist, and his wonderful son lan.

JEANNIE THERIAULT

Jeannie Theriault is a photographer/editor/educator based in Jacksonville, Florida. She began her photographic career as a private detective in Boston and has since exhibited her work in Boston, Puerto Rico, and Jacksonville. Special places and people have always inspired her work, but she also enjoys capturing unusual aspects of ordinary objects. Her images have been published in Jacksonville and internationally, and her work also appears in *The Photoshop CS Book for Digital Photographers*. Most recently, teNeues Publishing Group published her "Great Escapes" box of greeting cards for worldwide distribution. Jeannie lives in Jacksonville with her husband and two young sons.

CAROL FREEMAN

Carol Freeman is a gifted photographer who combines her graphic design and photographic skills with her love and appreciation for the natural world. Her work has appeared in many publications including *The 2002 Audubon Wildflower Calendar, Kew Magazine, Nikon World Magazine,* and others. She is a Nikon-sponsored photographer and a guest speaker for Fuji Photo Film USA, conducting seminars on the many intriguing and mystifying aspects of nature photography. Carol's work has won numerous awards, most recently the *Graphic Design USA* award and the Bronze Summit award for her *In Beauty, I Walk* 2002 calendar. Carol is happiest when she is out in nature looking for her next photograph. She can be reached at 847-404-8508.

DAVID MOSER

Dave got his start in professional photography doing equestrian photography and had his work published in numerous equestrian magazines. He then studied biomedical photography at RIT, before becoming a pioneer in Internet news delivery as one of the founders of Web portal MacCentral.com. Today, Dave acts as Chief Operating Officer of KW Media Group, and Publisher of Nikon's *Capture User* magazine. Photography still remains an important part of his life as he now primarily shoots nature and concert shots. His work appears in numerous Photoshop books.

Index

/ (Forward Slash key), 77 [] (Bracket keys), 202 16-bit images, 147

Add Audio dialog, 405 Add Noise filter, 307 Add Photos dialog, 401 adjustment layers, 167 Adobe Reader program, 391 Adobe Web Photo Gallery dialog, 377, 379, 420 album pages, 407-411 Ames, Kevin, 112, 201 arm slimming technique, 266-267 arranging photos, 36-37 Attach to E-mail dialog, 392, 395 Auto Smart Fix command, 153

B

backdrops, 305-311 Background copy layer, 106 backing up photos, 3-5 batch renaming files, 31-34 black-and-white photos colorizing, 332-335 converting color photos to, 178-183 blank slide option, 404 blemish removal, 202-207 blurred lighting vignette, 270-272 body sculpting, 255-267 arm slimming, 266-267 buttocks slimming, 262-264 love handle removal, 260-261 slimming/trimming technique, 256-259 thigh slimming, 264-265 See also portrait retouching Bracket keys ([]), 202 bright areas, 117-118 Browse for Folder dialog, 378 Brush Picker, 128, 176, 196, 202, 241, 278 Brush tool

special effects and, 273 Burn/Backup dialog, 4 burning and dodging, 218-221 buttocks slimming technique, 262-264

calendars, 416-418 canvas area, 91-92 Canvas Size dialog, 316 captions adding to calendars, 418 finding photos using, 62 CDs

burning digital negatives to, 3-5 creating contact sheets for, 6-10 slide shows transferred to, 406, 422-423

circular selections, 186 classic vignette effect, 299-301 Clear Emboss effect, 372 Clone Stamp tool

body sculpting and, 263, 265, 267 photo restoration and, 342, 344-346 portrait retouching and, 202-204. 206-208, 240-242, 251

collaging techniques, 286-291 collections, 56-58 creating, 56

deleting, 58 icons for, 57

color

backdrop, 310 changing in objects, 280-282 emphasizing objects with, 273-275 noise reduction methods, 109-114 restoring to eyes in photos, 133-137 selecting areas by, 194-195 slide, 405

color correction, 149-183 converting images to B&W, 178-183 cooling down photos, 169-170 digital camera images and, 158-165 drag-and-drop technique for, 166-168

flesh tone adjustments, 171-173 Histogram palette and, 157, 164 multiple photos and, 166-168 problem areas and, 174-177 Quick Fix mode for, 152-156

settings for, 150-151 warming up photos, 169-170 Color Dodge mode, 313 Color palette, 154 Color Picker, 139, 159-160, 305, 317 Color Replacement tool, 280-281 Color Settings dialog, 150 color sketch effect, 312-315 Color Variations dialog, 303 colorizing B&W photos, 332-335 hair, 222-223 comparing photos, 68-71 contact sheets adding file names to. 9 creating for CDs, 6-10 Cookie Cutter tool, 84 cooling down photos, 169-170 copyright information, 374-375 Create feature, 398-399 creating projects, 397-423 calendars, 416-418 Create feature for, 398-399 greeting cards, 412-415 photo album pages, 407-411 postcards, 415 slide shows, 400-406 Video CDs, 406, 422-423 websites, 376-379, 419-421

Creation Setup dialog, 388, 399 Crop command, 89 Crop tool, 76

canvas area added with, 91-92 cropping photos without, 88-90 custom size options, 81-83 standard size options, 79-80

cropping photos, 76-92 body sculpting and, 258 canceling crops, 78 canvas area and, 91-92 custom photo sizes and, 81-83 gang-scanned images and, 87 pre-designed shapes and, 84-86 standard photo sizes and, 79-80 steps in process of, 76-78 without the Crop tool, 88-90 Cuerdon, David, 424

Custom Shape Picker, 84 Custom Thumbnail Size, 28-29

233-234

color correction and, 176

photo restoration and, 337

portrait retouching and, 212, 219,

fill flash technique, 128

D	Elements Editor, 11	refreshing, 37
Darken Highlights slider, 118	comparing photos in, 70-71	renaming individual photos in, 30
date information	copyright info embedding, 374–375	rotating photos in, 35
adding to scanned photos, 48	Create button, 398	searching for photos in, 38
finding photos by, 49, 62, 64-65	email feature, 392–395	sizing thumbnails in, 27–29
sorting photos by, 47	PDF presentation creation, 388–391	sorting and arranging photos in,
Date View, 64-65	Picture Package feature, 380–387	36–37
deleting photos, 39	watermark creation, 370–374	viewing photos in, 26–29
depth-of-field effects, 292-298	Web gallery creation, 376–379	See also Organizer
advanced technique, 295–298	Elliptical Marquee tool, 188, 270,	file names
quick and simple technique,	299, 309	adding to contact sheets, 9 batch renaming process for, 31–34
292-294	emailing photos, 392-395 Emboss filter, 361	changing for individual photos, 30
digital noise removal, 109-114	Eraser tool	extensions added to, 33
digital photos	photo restoration and, 242	fill flash technique, 126–129
arranging, 36-37	portrait retouching and, 245	finding photos, 38, 49, 61–65
burning to CDs, 3-5	special effects and, 274, 278, 293	fixing image problems, 105–147
collections of, 56–58	EXIF data, 59	16-bit images, 147
color correcting, 149–183	Expanded View, 27	bright areas, 117–118
comparing, 68–71	exporting tags, 55	digital noise, 109–114
contact sheets for, 6–10	eye retouching	fill flash technique, 126–129
cropping, 76–92	dark circle removal, 208-210	flash removal process, 119-122
deleting, 39	eyebrow/eyelash enhancement,	keystoning, 138–143
finding, 38, 49, 61–65	231–235	overexposed flash images, 106-108
fixing image problems in, 105–147	recoloring eyes, 133-137	RAW images, 144-146
info added to, 60 metadata info for, 25, 59	sparkle added to eyes, 228-230	red-eye removal, 130–137
moving between folders, 22	whitening eyes, 224–227	shadow areas, 115–116
previewing, 23–24, 46	Eyedropper tool, 151, 159–161,	underexposed photos, 123–125
renaming, 30	163–164	flash photos
rotating, 35	_	overexposure of, 106–108
saving to hard disk, 2	F	removing flash from, 119–122
sharpening, 349–366	facial retouching. See portrait	Flatten Image command, 182, 330,
sizing and resizing, 98–103	retouching	334, 365
sorting, 36–37, 47	Favorite Folders, 21	flesh tone adjustments, 171–173
stacking, 72–73	Feather Selection dialog	floating palettes, 15 folders
straightening, 93–97	body sculpting and, 264	moving photos between, 22
tagging, 50–55	classic vignette effect and, 300	saving as favorites, 21
viewing, 26–29	color correction and, 171	Folders palette, 21
displaying photos. See showing	image fixes and, 120	freckle or acne removal, 211–213
photos	photo restoration and, 340	Free Transform bounding box
Distort filter, 247, 260	portrait retouching and, 204, 225,	accessing hidden handles on, 101
DiVitale, Jim, 112, 201	237, 250 selection techniques and, 190, 193	body sculpting and, 257–258
dodging and burning, 218-221		keystoning problems and, 140–142
Duplicate Layer command, 270	File Browser, 1, 19, 20–39 accessing, 20	photo collages and, 287
Dust & Scratches filter, 336-338	batch renaming files in, 31–34	Polaroid snapshot effect and, 319
_	deleting files from within, 39	portrait retouching and, 251
E	getting metadata info in, 25	straightening photos using, 96, 97
edge sharpening, 360-362	navigating to photos using, 21–22	watermarking process and, 373
Edit Text Properties dialog, 404	previewing images in, 23–24	Freeman, Carol, 425
effects. See special effects	F	Full Color Management option, 150

G

Gallery Style pop-up menu, 420 gang-printed photos, 380 gang-scanned photos, 87 Gaussian Blur filter

color sketch effect and, 313 depth-of-field effect and, 292, 297 digital noise removal and, 112 photo backdrops and, 309 Polaroid snapshot effect and, 318 portrait retouching and, 211, 244 sharpening techniques and, 365 soft lighting vignette and, 272

General Fixes palette, 155 glamour skin-softening effect, 244-246

Gradient Editor, 305-306 Gradient Picker, 289, 296 Gradient tool

backdrops and, 305, 306 depth-of-field effect and, 296 montages and, 289–290 grayscale mode, 178, 182, 332

Grayscale mode, 178, 182, 332 greeting cards, 412-415 Grid, 96-97

Н

hair colorizing, 222-223 Hand tool, 71, 145 Healing Brush tool, 206, 209, 215, 346 Histogram palette, 157, 164 history, finding photos by, 63 hot spot removal, 240-243 Hue slider, 135, 191, 333 Hue/Saturation dialog B&W colorization and, 333, 334 color correction and, 172, 174-175, 179 image fixes and, 135 photo backdrops and, 310 portrait retouching and, 222, 225-226, 237-238 sepia tone effect and, 302

ı

icons, tag/collection, 57 Image Size dialog, 98-100, 102 importing scanned photos, 42, 48 Info palette, 93, 95

information

adding to photos, 60 copyright, 374–375 metadata, 25, 59 Input Levels slider, 127, 232, 341 Inverse command, 300

K

keystoning problems, 138-143

L

landscape orientation previews, 24 Lasso tool

body sculpting and, 262, 264, 266 color correction and, 171 image fixes and, 117, 120, 134 photo restoration and, 333, 334, 339 portrait retouching and, 204, 224, 237, 250 selection techniques and, 190, 199 sky replacement technique and, 283

layer blend modes, 363, 365 layers

adjustment, 167 Background copy, 106 duplicating, 270 selecting, 197 sharpening with, 363–366

Layout panel, 394 Levels dialog

blurred lighting vignette and, 271 color correction process and, 158–161, 163–164, 167 color to B&W conversion and, 180–181 eyebrow/eyelash enhancement

and, 232 flash removal process and, 120–121

photo restoration and, 341 Lighten Shadows slider, 116, 118, 153 Lightness slider, 226, 238

Line tool, 94, 95, 139

Liquify dialog

body sculpting and, 260-261 portrait retouching and, 247-248

Load Selection dialog, 198 love handle removal, 260-261 luminosity sharpening, 357-359, 364

M

Magic Wand tool, 194-195, 283, 308 Magnetic Lasso tool, 199 Magnifying Glass. See Zoom tool Maximize Mode, 15, 91, 139, 288 Merge Tags dialog, 54 metadata information, 25, 59 Midtone Contrast slider, 118 montages, 288-291 Moser, David, 425 Motion Blur filter, 277 motion effect, 276-279 Move tool

body sculpting and, 263, 265, 266 collaging techniques and, 289 photo backdrops and, 308 Polaroid snapshot effect and, 318 restoration techniques and, 341 watermarking process and, 373 Multiply mode, 106–107, 329 music for slide shows, 405

N

naming and renaming batches of files, 31-34

individual photos, 30 New Layer dialog, 218-219

noise adding, 307 reducing, 109-114 nose retouching, 250-252 notes

adding to photos, 60 finding photos using, 62 numbering photos, 33

0

Opacity slider, 128, 136
Organizer, 18–19, 41–73
collections in, 56–58
comparing photos in, 68–69
Create button, 398
Date View in, 64–65
finding photos in, 49, 61–65
getting metadata info in, 59
info added to photos in, 60
PDF presentations created in, 388
previewing photos in, 46
scanning images into, 42, 48
sizing thumbnails in, 44–45

slide show option, 66-67 sorting photos by date in, 47 stacking photos in, 72-73 tagging photos in, 50-55 Watch Folders feature, 43 Web gallery creation, 376, 419 See also File Browser Output Levels slider, 120 overexposed images bright areas and, 117-118 flash photos and, 106-108, 119-122 Overlay mode, 219 Palette Bin, 15-16 palettes nested vs. floating, 15 See also specific palettes panning photos, 70-71 panorama stitching, 321-324 Paste Into Selection command, 284, 287 PDF presentations, 388-391 pencil sketch effect, 312-315 photo album pages, 407-411 Photo Bin, 16, 401-405 Photo Browser button, 41 Photo Filter dialog, 169-170 photo restoration. See restoration techniques Photo Review dialog, 46, 66, 68 photographs restoring old photos, 327-347 scanning into Organizer, 42, 48 See also digital photos Photomerge feature, 321-324 **Photoshop Elements** changes to version 3 of, 14-17 File Browser vs. Organizer, 18-19

changes to version 3 of, 14–17
File Browser vs. Organizer, 18–19
Welcome Screen, 11–13
See also Elements Editor
Picture Package feature, 380–387

for individual photos, 380–384 for multiple photos, 385–387

Pinch dialog, 142 Polaroid snapshot effect, 316-320 Polygonal Lasso tool, 286 portrait retouching, 201-252 blemish removal, 202-207

colorizing hair, 222–223 dark circle removal, 208–210 dodging and burning, 218–221 eyebrow/eyelash enhancement, 231–235

freckle or acne removal, 211–213 frown into smile transformation, 247–249

glamour skin softening, 244–246 hot spot removal, 240–243 nose size reduction, 250–252 sparkling eyes, 228–230 whitening eyes, 224–227 whitening teeth, 236–239 wrinkle removal, 214–217 See also body sculpting postcards, 415 poster-sized prints, 102–103

poster-sized prints, 102-103 Preferences dialog, 29 presentations, 397-423

calendars, 416–418
Create feature for, 398–399
greeting cards, 412–415
photo album pages, 407–411
postcards, 415
slide shows, 400–406
video CDs, 406, 422–423
websites, 376–379, 419–421

Preview palette, 23-24 previewing

contact sheets, 9 digital photos, 23-24, 46 slide shows, 402, 406 Print Photos dialog, 6-7 project creation. See presentations Properties palette, 59, 60

Q

Quick Fix mode, 152-156

R

RAW files, 144–146
recoloring eyes, 133–137
Rectangular Marquee tool
cropping photos with, 88
photo restoration and, 339
Polaroid snapshot effect and, 317
selection techniques and, 186, 188
rectangular selections, 186–187
red-eye removal, 130–137
eye recoloring after, 133–137
steps in process of, 130–132

Reduce Color Noise slider, 109 Reduce Noise filter, 109-110 refreshing the File Browser, 37 renaming. See naming and renaming Resample Image option, 99, 100, 102 resizing. See sizing and resizing resolution, increasing, 98-100 restoration techniques, 327-347 B&W photo colorization, 332-335 damaged or missing parts, 339-343 rips and tears, 344-347 speck, dust, and scratch removal, 336-338 washed-out photos, 328-331 retouching portraits. See portrait retouching **RGB Color mode, 332** Rotate Canvas dialog, 95 rotating photos, 35 rulers, 98

S

Saturation slider

B&W colorization and, 334 color correction and, 172, 175, 179 portrait retouching and, 225, 237 selection techniques and, 191 sepia tone effect and, 302

Save Selection dialog, 198 saving

digital negatives, 2-5 favorite folders, 21 selections, 198 tags, 55

scanned photos

date/time settings, 48 dividing gang-scanned images, 87 importing into Organizer, 42

Search dialog, 38 searching for photos, 38, 49, 61–65 Select Image tool, 323 Selection Brush tool, 196 selections, 185–199 brushes for making, 196

brushes for making, 196 circular, 188 color-based, 194–195 layer, 197 odd-shaped, 190–191 rectangular, 186–187 saving, 198 softening edges of, 192–193

1 2 7 7 6		
selections (continued)	hard edges of selections, 192–193	website, 421
square, 189	sorting photos	Timeline, 61
tricky, 199	in File Browser, 36–37	Title dialog, 414
sepia tone effect, 302-304	in Organizer, 47	Toolbox, 14
Set Date and Time dialog, 48	sparkling eyes, 228-230	Type tool, 371
shadow areas, 115-116	special effects, 269-324	
Shadows/Highlights dialog, 116,	backdrops, 305-311	U
118, 192	classic vignette effect, 299-301	underexposed photos
shapes	collaging techniques, 286–291	fill flash technique for, 126–129
cropping photos into, 84-86	color changes to objects, 280-282	steps for fixing, 123–125
selection techniques and, 186-191	depth-of-field effects, 292-298	Undo command, 278
Sharpen palette, 154	emphasizing objects with color,	Unsharp Mask filter
sharpening techniques, 349-366	273-275	basic sharpening and, 350–356
basic sharpening, 350-356	montages, 288-291	luminosity sharpening and, 358, 364
edge sharpening, 360-362	motion blur effect, 276–279	portrait retouching and, 228–229
layers and, 363-366	panorama stitching, 321-324	sample settings, 352–356
luminosity sharpening, 357-359	pencil sketch effect, 312–315	sample settings, 332-330
portrait sharpening, 352	Polaroid snapshot effect, 316-320	V
sample settings, 352-356	sepia tone effect, 302-304	
Web graphics and, 354	sky replacement technique, 283–285	Video CDs (VCDs), 406, 422–423
Shear dialog, 318, 319	soft light vignette, 270–272	viewing photos, 26–29
Shift Pixels tool, 261	square selections, 189	vignette effects
showing photos, 369-395	stacking photos, 72–73	classic vignette, 299–301
copyright info for, 374–375	Stationery & Layouts Wizard dialog,	soft light vignette, 270–272
email rules for, 392-395	393–394	W
PDF presentations for, 388-391	straightening photos, 93-97	VV
Picture Package layouts for, 380-387	automatically, 93	warming up photos, 169–170
watermarking process and, 370-374	manually, 93–95	Warp tool, 247
Web gallery for, 376-379, 419-421	visible grid for, 96–97	washed-out photos
sizing and resizing	Styles and Effects palette, 372	fixing, 106–108
cropped photos, 79–83	styles and Effects palette, 3/2	restoring, 328–331
digital camera photos, 98–103	T	Watch Folders dialog, 43
poster-sized prints, 102–103		watermarking photos, 370-374
thumbnails, 27–29, 44–45	tags, 50–55	Web Photo Gallery, 376-379, 419-421
sketch effect, 312-315	adding/removing, 52	websites
skin softening technique, 244-246	assigning multiple, 53	creating for photos, 376–379,
sky replacement technique, 283–285	choosing icons for, 57	419-421
Slide Show Editor, 401–406	combining (merging), 54	sharpening photos for, 354
slide shows	creating, 50–51	Welcome Screen, 11-13
creating, 400–406	deleting, 58	White Balance tool, 145
Organizer feature, 66–67	finding photos using, 61	whitening techniques
PDF presentations, 388–391	sharing, 55	for eyes, 224-227
previewing, 402, 406	teeth whitening technique, 236–239	for teeth, 236–239
Video CDs of, 406, 422–423	Texturizer dialog, 314	WMV files, 406
slimming/trimming technique,	Theriault, Jeannie, 424	wrinkle removal, 214-217
256–259	thigh slimming technique, 264-265	
Smart Fix option, 152–153	Threshold dialog, 162	Z
Soft Light mode, 221	thumbnails, 26-29	Zoom tool, 71, 130, 145
soft light vignette, 270–272		
	rotating, 35	
	selecting, 26	zooming
soft light vighette, 270–272 softening techniques glamour skin softening, 244–246		

Colophon

The book was produced by the author and design team using all Macintosh computers, including a Power Mac G4 733-MHz, a Power Mac G4 Dual Processor 1.25-GHz, a Power Mac G5 1.8-GHz, and a Power Mac G5 Dual Processor 2-GHz. We use LaCie, Sony, and Apple monitors.

Page layout was done using InDesign CS. The headers for each technique are set in 20 point CronosMM700 Bold with the Horizontal Scaling set to 95%. Body copy is set using CronosMM408 Regular at 10 point on 13 leading, with the Horizontal Scaling set to 95%.

Screen captures were taken with TechSmith Snaglt 7.1.1 on a Dell Precision M60 and a Dell Precision Workstation 650 and were placed and sized within InDesign CS. The book was output at 150-line screen, and all in-house proofing was done using a Tektronix Phaser 7700 by Xerox.

Additional Resources

ScottKelbyBooks.com

For information on Scott's other books, visit his book site. For background info on Scott, visit www.scottkelby.com. http://www.scottkelbybooks.com

Photoshop Elements Techniques Newsletter

Photoshop Elements Techniques is a newsletter packed with practical, real-world tips and techniques from some of the leading Photoshop Elements gurus, including Dave Cross, Jan Kabili, Dave Huss, and Scott Kelby. Every issue of Elements will be a valuable resource for digital photographers. Visit the website to view subscription information.

http://www.photoshopelementsuser.com

Photoshop Elements Techniques Website

The ultimate source for Photoshop Elements users features tutorials, downloads, forums, and much more! The site also contains up-to-date Elements news, tips and tricks, and contests.

http://www.photoshopelementsuser.com

KW Computer Training Videos

Scott Kelby and Dave Cross are featured in a series of Adobe Photoshop and Adobe

Photoshop Elements training DVDs, each on a particular Photoshop or Elements topic, available from KW Computer Training. Visit the website or call 813-433-5000 for orders or more information.

National Association of Photoshop Professionals (NAPP)

http://www.photoshopvideos.com

The industry trade association for Adobe® Photoshop® users and the world's leading resource for Photoshop training, education, and news. http://www.photoshopuser.com

Photoshop Down & Dirty Tricks

Scott is also author of the best-selling book *Photoshop CS Down & Dirty Tricks*, and the book's companion website has all the info on the book, which is available at bookstores around the country.

http://www.downanddirtytricks.com

Adobe Photoshop Seminar Tour

See Scott live at the Adobe Photoshop Seminar Tour, the nation's most popular Photoshop seminars. For upcoming tour dates and class schedules, visit the tour website.

http://www.photoshopseminars.com

PhotoshopWorld Conference & Expo

The convention for Adobe Photoshop users has now become the largest Photoshop-only event in the world. Scott Kelby is technical chair and education director for the event, as well as one of the instructors. http://www.photoshopworld.com

PlanetPhotoshop.com

"The Ultimate Photoshop Site" features Photoshop news, tutorials, reviews, and articles posted daily. The site also contains the Web's most up-to-date resource on other Photoshop-related websites and information. http://www.planetphotoshop.com

Mac Design Magazine

Scott is Editor-in-Chief of *Mac Design Magazine*, "The Graphics Magazine for Macintosh Users." It's a tutorial-based print magazine with how-to columns on Photoshop, Illustrator, InDesign, Dreamweaver, Final Cut Pro, and more. It's also packed with tips and shortcuts for your favorite graphics applications. http://www.macdesignonline.com

You've seen our images in this book, now search the entire collection

online at BrandX.com

You'll find objects with clipping paths,

people.

textures,

locations.

and more.

royalty-free images

Brand X Pictures are

your Photoshop®

to manipulate

offer a world of

of all, Brand

available

backgrounds,

abstracts.

concepts

Unique

from

perfect for all

projects. Ready

or composite, they

possibilities. Best

X Pictures are

online right now.

Unique Royalty-Free Images

FINALLY, A NEWSLETTER JUST FOR PHOTOSHOP ELEMENTS USERS

Packed with practical, real-world tips and techniques from some of the leading Photoshop Elements gurus, including Dave Cross, Jan Kabili, Dave Huss, and Scott Kelby, author of the best-selling Photoshop Elements Book for Digital Photographers, each printed issue helps you unlock the secrets to this amazing program. Learn step-by-step how to do everything from color correcting and sharpening your photos, to creating the most requested photographic special effects and presentations.

A one-year subscription (8 issues) is only \$49 (U.S. only). To subscribe and start learning today, call **866-808-2793** or visit **photoshopelementsuser.com**

Photoshop® Elements 3 with a Wacom® Tablet

Here's a fun photo collage that we quickly created using the natural control of a Wacom pen tablet and Photoshop Elements 3.

We then selected the flower with the Lasso tool (again taking advantage of the natural precision of our Wacom pen). After selecting the flower, we copied it and pasted one flower "behind" the ear of each girl to show them having fun "in" the field.

Tirst, we combined the two photos by using the Lasso tool to select the girls so that we could copy and paste them into the field of flowers. The intuitive control of a Wacom pen makes selections like this fast and easy!

4 Next, we created a subtle shadow for each flower. We selected a softedge brush and used the pressuresensitivity of our Wacom pen to control brush-opacity to get just the right shadow for the lighting.

2 Next, we colored a flower to match the flowers in the field by adding a quick Hue Adjustment layer and hand coloring the petals. The pressure-sensitivity of our Wacom pen made it simple to visually blend the colors!

5 Finally, we applied the finishing touches by adding a few extra strands of hair. We used a small, soft-edge brush to create the hair using the pressuresensitive control of our Wacom pen to dynamically change the size of our brush strokes.

Visit www.wacom.com today for more tips and to select the Wacom pen tablet that's right for you!

intuos

Turn on Photoshop's power! Intuos3 starts at \$199

The Basic El#M#711.E DigitalPhotography

→ The Know How to Show How «

PHOTO - VIDEO - PRO AUDIO

800.336.7097 » 420 Ninth Avenue, NYC 10001

www.bhphotovideo.com

		,		
	16			
•				